PAT IN THE CITY

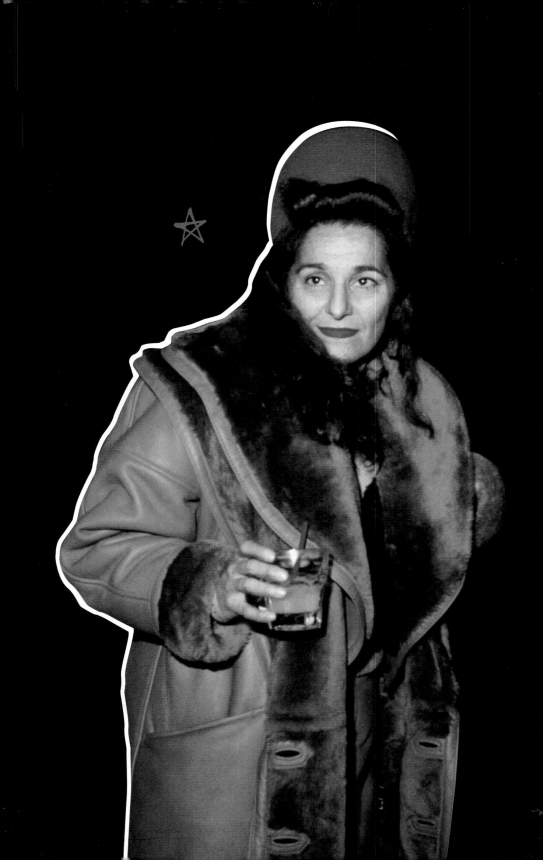

PAT IN THE CITY

MY LIFE OF
FASHION, STYLE,
AND BREAKING
ALL THE RULES

Patricia Field

WITH REBECCA PALEY

DEYST.
An Imprint of William Morrow

TO SULTANA, MY GRANDMOTHER, WHO
TAUGHT ME LOVE AND CONFIDENCE,
AND MY MOTHER, MARIKA, WHO TAUGHT ME
INDEPENDENCE AND AMBITION.

contents

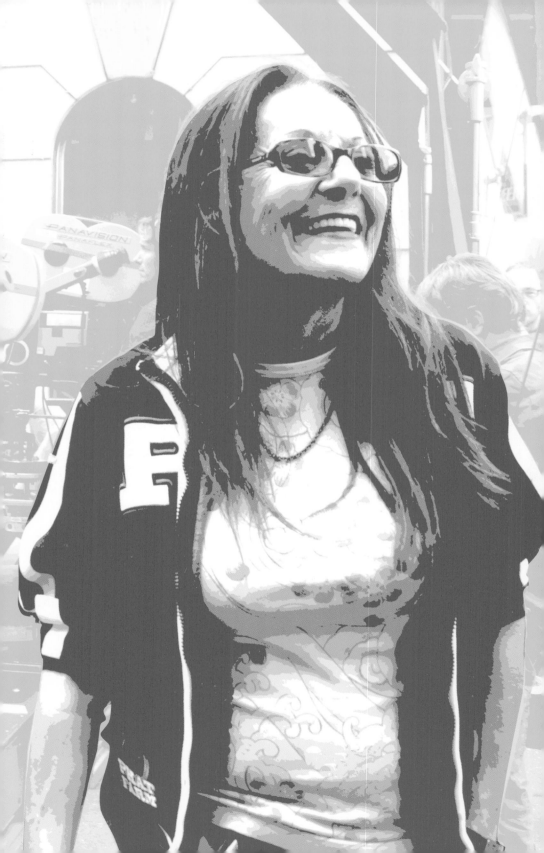

PAT IN THE CITY

introduction

FACING A WALL OF BOXY HOODIES, T-shirts, and sweat-pants, I started to get a not-so-great feeling. I was on a shopping trip for the men on *Run the World* in the lead-up to the second season of the Starz show, which was set to begin shooting in a few weeks. I was thrilled to be working again on the costumes for the half-hour comedy about smart, funny, and ambitious female friends living and loving in Harlem. Dubbed by the media as the "Black *Sex and the City*," the show was a fun and nuanced portrayal of independent modern Black women, who of course wore wonderful clothes.

For the women, we had already found some incredible things, including hot-pink mules for Sondi, a Vuitton purse for Whitney that was so tiny it looked like it had shrunk in the dryer, and for Renee, a fierce bodycon monochromatic robin's-egg-blue ensemble—including lace gloves, stockings, purse, and pumps. But for today's shopping trip, I was not feeling in-spired. I don't love men's clothes, because they are expensive *and* dull. The contemporary conventional man doesn't have many options when it comes to style. Most of them are stuck in a box—a cold gray, blue, or black box. Totally square.

I'm always trying to put men in color if I can. When Blair Underwood had a multi-episode arc on *Sex and the City* as Miranda's love interest, I wanted to put him in a pink shirt, but he thought it made him look too effeminate. I didn't fight it. I'm a costume designer, not a dictator. We compromised on red. But I've always wondered why men aren't allowed to enhance themselves. Why should being artistic with their form indicate something about their sexuality? In many other points in history, heterosexual men took pride in dolling them-selves up. During the Age of Enlightenment, straights like Mozart paraded around in wigs, powdered faces, lace jabots tied around the neck, high heels, and hats trimmed in braided gold or decorated with ostrich feathers. I feel badly for the

men of today. I would be bereft if I couldn't wear makeup. But all hope is not lost. Years after *Sex and the City* ended, Blair came running up to me at an event to tell me that he was the proud owner of a pink suit. I'm always pleased to have a positive influence on others.

Now I was the one in need of a little uplift, since not only were we shopping for menswear but we were doing it in a rigid, lifeless store. A few of us from the costume department had convened here because that's where *Run the World*'s costume designer, Tracy L. Cox, wanted to meet. Tracy—who had been an assistant costume designer on the final season of *Sex and the City* before becoming Sarah Jessica Parker's longtime personal stylist—is really good with men. No matter the actor, budget, or story, the look is always about the combo. Tracy is able to put wardrobes together creatively for men (and women as well) without falling into flamboyance, which is a tightrope act I don't always achieve. For Ola, *Run the World*'s Nigerian American doctor, Tracy had concocted the idea to cut his pants so they showed the ankle, in a subtle nod to the pants style typically worn by Nigerian men. An outfit, whether in real life or on the screen, sinks or swims by those little details.

Spying an orange Valentino hoodie for $1,150, I was reminded that Tracy also never looks at price. We all have our weaknesses. Wait until we get the bill, I thought as he pulled out a black hoodie with "Versace Jeans" written in gold.

"Too billboard-y," I said. "I don't think this floor is for us."

We took the escalator down, where the shopping went from bad to worse when I encountered a display of two-hundred-dollar jeans with oil splatters and holes. Nothing drives me crazier than paying a lot of money for jeans with holes in the knees. This stuff was pricey, generic, and not sexy: my least favorite combination. I would have rather gone downtown to Trash and Vaudeville—the shop dressing

rock 'n' roll stars and people who just wanted to look like them since the seventies, and where I used to buy jeans wholesale for my boutique. Or I would've headed uptown to Harlem to the luxury streetwear guru Dapper Dan. In order to have a look of one's own—which I wanted for each of these characters, what I want for *all* my characters, real or fictional—you need a mix of aesthetics, which means varying your resources.

"Matthew needs a slipper," Tracy said. "Do you see him in slides?" He was holding a light-blue terry-cloth Bottega Veneta slide.

"Sure."

"I don't want to push it if you are lukewarm."

Welcome to the glamorous world of costume design.

We kept walking, pulling and plucking as we went: a cashmere cardigan as light as air but that we wished was a hoodie; a terrific varsity bomber jacket that was right for absolutely no one on the show; a beautiful three-quarter suede jacket with a detachable fabric insert, only because I'm a sucker for pieces that function in multiple ways; and a stack of nondescript jeans that we would use like kindling for a fire. Most of this would surely be returned.

Feeling a little thrown off and, frankly, bored, I turned to my first love: women's clothes. Women's wear was not on the agenda, but I'm famously impossible to corral. I was fingering a slinky slip from L'Agence when a middle-aged man who had been sprucing up the section said, "Do you mind if I take an Instagram?" I shrugged my shoulders, *sure*, to which he pulled out his phone. He took a video of us; with his arm around my shoulder, he exclaimed, "This is the one-of-a-kind fashionista, Patricia Field!"

"Thank you," he said, "I love you so much. I want to be just like you when I grow up. I wish you threw big parties like you used to."

"I did have some pretty great parties."

It was true. For fifty years, I ran an eponymous shop downtown that was a clubhouse for trans people, club kids, emerging fashion designers, and other tastemakers. I was a fixture of New York's disco and club scene during its heyday—not to mention dipping a platform-wearing toe in ball culture. Then there was my late-in-life career as a costume designer. So, although I'm never sure how people know me, everywhere I go someone seems to recognize me. I'm happy with the fact that over my life I've made a lasting impression and, more important, made other people happy.

Back in my safe space of high-waisted flare jeans, shift dresses, and crop tops, I returned to something that had been bothering me for the last few days. There had been a change to the script, and now Renee—the colorful and comedic, Wharton-educated marketing powerhouse—was working from home after deciding to strike out on her own in season 1. But the showrunners still wanted her to dress up as if she were going into the office. I didn't agree; people don't get done up to work at home. They work in sweatpants, no matter how fancy or costly. While I don't deal with reality in entertainment, I also don't want to be totally inaccurate.

And yet, I didn't want to put Renee in leggings or sweats. It was too much of a departure from the foxy style we had already established for Renee. In the end, we compromised. While we dressed Renee down, you would never accuse her of looking casual. For a Zoom call, she appears professional in a red denim bustier and cropped jean jacket in a pink-purple wash. But when she stands up, her ass cheeks are hanging out of a pair of booty shorts that match the jacket.

In general, I dislike the rise of sweatshirts and sweat-pants, a trend made pernicious and widespread by the pandemic. Before costume-consulting on *Emily in Paris*, I told

its showrunner, Darren Star, "I'm going to take a look at the Parisian women to see what the hell's going on there." When I traveled there, all I saw from arrondissement to arrondissement was jeans, sweatpants, hoodies, and sneakers. "Forget French chic," I told Darren, who had originally hired me to do the costumes for one of his other shows, *Sex and the City.* "It's dead."

Instead of submitting to the standard-issue garb dictated by the zeitgeist, I chose to pack my bags with vibrant expression, which, in this case, meant a wild patchwork dress by Dope Tavio from my Lower East Side ArtFashion Gallery, which I paired with a vintage kelly-green Chanel jacket for Emily. I call myself the happy clothes expert, because no matter what's happening in the world—and, believe me, a lot has happened in my lifetime—I live in my own world of pretty pictures. Like the play of bright light and color in a painting or the thumping beat of a song that forces you onto the dance floor, a gorgeously vibrant garment raises my spirits and brings me joy.

one

MY LITTLE-
GIRL DAYS

BURST INTO THE LIVING ROOM with guns a-blazing. "Bang bang!" I shouted, startling my aunts right out of their chairs. For dramatic effect, I froze with my left hand on my hip and my right hand holding the little silver cap gun outstretched to the ceiling. I had come out all done up in a head-to-toe cowgirl outfit, and I didn't want my family to miss a single glorious detail. Atop the long-sleeved western shirt—with its pointed collar, contrast-embroidered yoke, smile-shaped breast pockets, and corded piping—was a fringed bolero vest in suede and matching miniskirt. The accessories were just as authentically fabulous. I stood sturdily in a pair of classic narrow square-toed cowboy boots, made of leather as tough and smooth as a baseball glove. My gun holster was fitted snugly around my hips for a quick and easy draw, as I had just demonstrated to my captive audience. To top it all off, a white felt cowboy hat framed my then-black pigtails in a jaunty homage to the radio and matinee idol Gene Autry.

After receiving the cowgirl getup from my aunts—who knew how much I loved Roy Rogers, Dale Evans, and the Lone Ranger—I never took it off. Even at five years old, I understood that fashion and costume were one and the same. I wanted to be a cowgirl. But if I couldn't ride off into the sunset on a horse in New York City, where I was born and raised, I could at least dress the part.

All the women in the living room of my grandparents' apartment in Astoria had burst out laughing when they saw the source of the startling noise. My three unmarried aunts, who lived there, always enjoyed my comical theatrics. So did my grandmother, Sultana, whose eyes shone particularly bright whenever she saw that I was happy. She smiled at me, sitting erect in her chair, like a beneficent queen. And in my eyes, she had all the glamour and poise of royalty.

Already in her seventies by the time I was born, my grandmother was a classic beauty and a stern but loving matriarch. She didn't adorn herself with jewelry or makeup. With her white hair worn in a no-nonsense bun, her only accessory was the glasses on her face. Despite her simple attire, she always stood straight with perfect posture, her nose slightly in the air, almost aristocratic in her presence.

My grandmother spoke in pure Greek. She rarely broke into dialect, not even when gathering with her girlfriends to drink Turkish coffee, have a sweet, and discuss the political and cultural affairs of the day. Sultana came from an educated family. Her sister, my great-aunt Vasiliki, who also lived in Astoria, was an actress, mainly performing in local theaters in Queens. The sum total of her Hollywood career was when

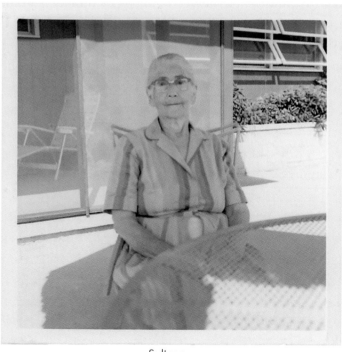

Sultana
PAT'S COLLECTION

she played the mother of the priest in *The Exorcist*. She was discovered by the film's director, William Friedkin. My grandmother's brother, Dimitrius, worked for the Greek Orthodox Church, translating Byzantine texts into modern Greek. Sultana remained close to her siblings throughout their lives, physically and intellectually.

My grandfather John Yimoyines was not educated, but he was an ambitious self-starter. As a teenager in the late 1800s, he came to the States, where he volunteered to fight in the Spanish American War and by doing so, earned American citizenship.

He returned to Greece a young industrious American citizen, and got to work. He planted groves of olive trees on my grandparents' native island, Lesbos. That impressed my grandmother, and the two married. Once they moved to the United States, where my grandfather essentially had to start over as a peddler, my grandmother was a lot less impressed with him. Taking any opportunity to deride him, she warned me from going into his closet in their two-bedroom apartment that held all his wares. "It has cockroaches!" she would say in Greek. "Don't go there!" Or when she heard his heavy footfalls as he came up the stairs of the building after an entire day of selling, she mocked him, moaning in Greek, "Oh, my back." She never forgave him for being unable to match the quality of life they had back in Greece.

Sultana's heart and soul were always back in the old country, with its ancient history, poetry, and philosophy. The names of her children were a testament to her love for its long and storied culture. They ran the gamut from my uncle Constantine, after the Roman emperor who converted the empire from paganism to Christianity and ushered in the Byzantine era, to my youngest aunt, Lesvia. She was named for Lesbos, the birthplace of my family and, more famously, of Sappho, known in ancient Greece simply as The Poetess for her songs about

the pleasure and pain of love. "Once again Love, that loosener of limbs, bittersweet and inescapable, crawling thing, seizes me." Although only fragments remain from the poems she first performed while playing the lyre in the seventh century BC, Plato called her the "tenth muse." In "Ode to Aphrodite," the only poem of hers completely intact, Sappho calls on the goddess Aphrodite to "be my ally" in her romantic battles. My grandmother named one of her daughters Aphrodite, but we called her Aphro. Lesvia, when learning what her name meant to most Americans as a teenager in Astoria, quickly changed it to Les, which is what she went by for the rest of her life.

My grandmother was the foundation of my cultural identity and helped to foster my love of all things Greek. As a kid (and to this day), I appreciated how the Greeks created their

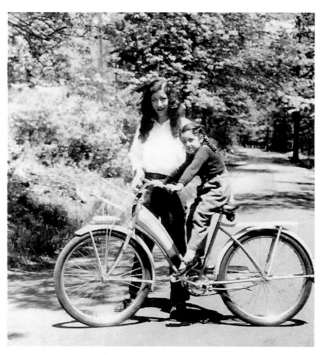

Young Pat on bicycle with Aunt Lesvia
PAT'S COLLECTION

gods in the form of humans. They had jealousies; they held grudges. These characteristics made them partners in the human drama as opposed to merely critics. More than the allure of its mythology, I associated the charm of Greece with my grandmother, who loved me unconditionally and always made me feel special. Sultana may have been harsh toward my grandfather, but she doted on me. Whenever I needed affection, I headed straight for Astoria and my grandmother—hopping into a taxi by myself from my parents' apartment on the Upper East Side.

My mother, Marika, gave me a lot of independence because she was very independent herself. I was free to roam our neighborhood, Yorkville, bouncing between our apartment on East Seventy-sixth Street, my public elementary school right across the street, the New York Public Library on Seventy-ninth, and my parents' dry-cleaning business three blocks away, where my mom spent most of her time.

Assertive, independent, and ambitious, Mom possessed a lot of traits that were considered stereotypically masculine back then. She was way ahead of her time, something I didn't understand until I was much older. My mother's strong will was obvious from an early age. When my grandparents emigrated from Greece to New York, they first came with their four sons and my mother. They later sent for their four other daughters, who were left behind in the town of Ploumari on the island of Lesbos to be raised by their eldest daughter, Amerisoutha (Aunt May, as she was later known in America). It was clear from an early age that Mother—who left school and went to work at a laundry almost as soon as she arrived in the US—wasn't going to listen to anyone.

Where my mom was forceful and driven, my dad, Henry Haig, was handsome, sweet, and mild. An Armenian born in Turkey, Henry Haig wasn't his real name. He arrived at Ellis Is-

land at nineteen years old with the name of Haik Tschurdishan, which so boggled the mind of the immigration officer trying to read it, he gave him a new one on the spot. My dad, a tailor, met my mother, who pressed clothes, at the laundry where they both worked.

I arrived on February 12, 1942. My mom, who had been expecting a boy, planned on the name Billy. However, I didn't turn out to be a Billy. When she left the hospital, I still didn't have a name. Having arrived not long before St. Patrick's Day, she found inspiration in the Irish holiday and decided to name her new daughter Patricia Haig.

My mother didn't let having a kid get in the way of opening up her own dry-cleaning business. She poured herself into developing the business, and worked there continuously, even after my little sister, Joanie, was born, four years after me. Arriving at work at 5:00 a.m. and returning home at 7:00 p.m., she never once wavered from her clear goal of making enough money to move into a solidly middle-class existence.

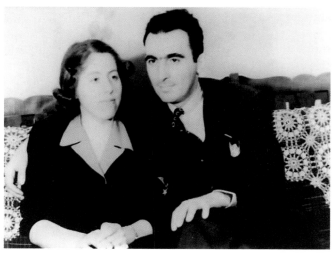

Marika and Henry
PAT'S COLLECTION

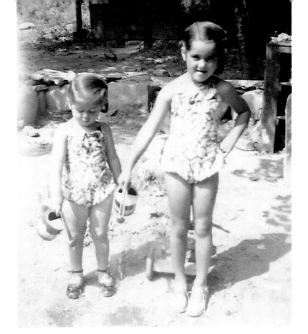

Pat and sister Joanie

A smart businesswoman, she took great satisfaction in the service she offered her high-end clientele from Park Avenue and nearby limestone town houses. She had an encyclopedic knowledge of the chemicals and methods needed to treat specific stains on luxury fabrics. But above all, Mom was tenacious. When she discovered that federal price-control legislation at the time meant she couldn't charge higher prices for her superior service, she took the matter to court. She represented herself, explaining to the judge how her labor-intensive services should not be lumped in with ordinary laundries. As evidence, she brought in the silk blouses she had hand-finished. "I won!" she declared victoriously when she came home that night. I was so proud of her and could tell she was proud of herself.

It was clear to me how much my mother loved her work when I stopped off at my parents' dry cleaners every morning before school. They would set out for the shop before I had woken up, so I would stop at the bakery on my own for a roll and coffee, which I would eat sitting on a little stool while

my parents dealt with customers, inspected stains, pressed, mended, and performed other tasks. My mother took any opportunity she could to give me lessons in fabric and its treatment. "This is a bloodstain on peau de soie, so you need to use this organic chemical to get it out," she would say, pointing at a bottle. "All silk must be pressed by hand and not machine," she'd demonstrate, taking a hot iron to a creamy blouse. She taught me to appreciate quality garments and the value of an unrelenting work ethic.

Her drive and determination meant that she kept the business humming even after my father fell ill with tuberculosis. I was about six years old when Mom explained to me that Dad was sick and had to stay away from us so that we wouldn't catch what he had. I didn't even get to say goodbye to him; he had already left for one of the isolation wards on Staten Island when she told me the news. While I might not have understood the nature of the highly communicable disease, for which there was no vaccine, I knew TB was something the adults around me feared. Joanie and I went to our pediatrician on a regular basis, where my mom had us fluoroscoped to make sure the deadly bacteria hadn't infected our lungs.

It was about a year later that I got to see my handsome and sweet father once more. He was staying at his aunt's house in the Catskills. After driving several hours north of the city, we got out of the car, and I saw Dad on the porch of the house. But he was so far away. "Hi Daddy!" I shouted, waving. It was hard not to be able to get close to him, but I understood why. I didn't understand, though, that this was goodbye.

My father died shortly after our visit, but through the years my mom kept him alive for me by talking about him admiringly and reminding me that I looked just like him. When he died, she did not let his family die along with him. She fostered relationships with my father's first cousin Paul, a teacher, and

my father's aunt and my godmother, Gadarina, also a teacher of French at a public school in the Bronx. My mom employed her husband, Hovan, who had once been a bishop in the Armenian Church. I loved to sit by the window of their perfumed twelfth-floor apartment on Riverside Drive and watch the lights of the Palisades amusement park across the Hudson River.

Although my mom had loved my father deeply, that didn't stop her from getting remarried about a year after his death. She loved men, was still young, and enjoyed being married. But with Lou Field, as with all her husbands (there would be three), she was the boss. My stepfather, who my mom met through the dry-cleaning business, was intelligent when it came to technical things, but he was mild-mannered like my dad. When he legally adopted my sister and me, I went from Patricia Haig to Patricia Field.

Without a big personality, Lou faded into the background, where most of the men in my life resided. I grew up in a world of women. My dad died when I was young, and my four uncles were peripheral figures. They went into the service during World War II and then after, one by one, left Astoria. My universe revolved around my mother, my grandmother, and my aunts, strong women all of them. It wasn't that I didn't like men; I just didn't have very much experience with them. They were simply something strange. Whether it was examining a spot of gravy on lace with my mother at the shop or piling into the big bed my aunts shared to go to sleep in my grandmother's apartment, I trusted and felt close to women.

There was nowhere I didn't feel safe with the women in my life. My mom used to take me out to the Greek clubs, even though I was a kid. My mom, who liked a good time and good cocktails, taught me to walk into any one of the Greek and Middle Eastern cabarets on the two-block stretch near Penn Station like there was nothing to it. The two of us en-

joyed watching the belly dancers at places like the Arabian Nights and the Grecian Cave that dotted Eighth Avenue between Twenty-eighth and Thirtieth Streets. At the Egyptian Gardens, my mom clapped as heartily as any of the fedora-wearing men seated around us while belly dancers, cigarette girls, and flower sellers maneuvered between the café tables. My mother smoked and drank highballs and Manhattans that she let me sip while the men, on their bouzouki, mandolin, violin, and other instruments, struck up a Greek tune.

My aunts also let me tag along when they were out and about in the city. Young and single, Van, Aphro, and Les would go to dances or the movies in the grand old theaters of Times Square like the Paramount—vaulted art deco and beaux arts places with red-curtained stages, live orchestras, and gold-trimmed balconies. At the Paramount, there was a live floor show before the featured movie. Inside the massive theater, I saw some of the leading musical acts of the day, like Frank Sinatra and Billy Eckstine. After the bands stopped swinging and the lights went down, but before the movie came on, there would always be a moment when the theater's gilded and domed ceiling murals were hidden in darkness. I was enveloped by the ultimate glamour of atmosphere and Hollywood, and I loved every second of it.

They also took me shopping on the Lower East Side, which in those days was lined with made-to-order tailors. Van, Aphro, and Les all loved to get dolled and dressed up. But my aunt Van (short for Evangelia), the oldest of the three but younger than my mother, was the real glamour-puss. She was much more "fashion" than all of her sisters. The fact that she worked in my mother's dry-cleaning business didn't stop her from coloring her hair red or getting custom-made suits on Orchard Street.

I loved my aunts, and tagging along with them was always a treat. Shopping was a pleasurable and lighthearted activity

for them, so that was my association, too. (Though the best part was often lunch afterward at Aunt Van's favorite Chinese restaurant.)

I wasn't the typical girly girl, but a tomboy whose favorite outfit was my Annie Oakley look. I never played with dolls; I didn't know what to do with them. While Aunt May's daugh-

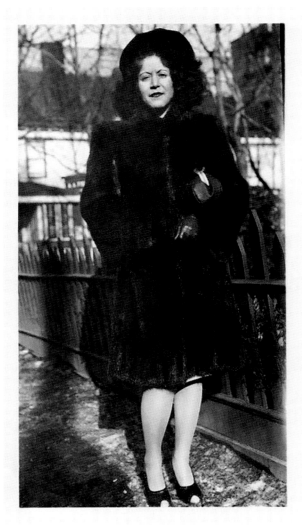

Aunt Van
PAT'S COLLECTION

ter, my cousin Helen, who I used to run around Astoria Park with, was fanatical about her dolls, the few I received had their heads torn off or their hair a mess after a few days. I much preferred to shoot things, real or imagined, with my cap gun.

Still, I always had beautiful clothes. My mother made sure of that. For herself she shopped at Sears and Roebuck. She was a gray-flannel woman, whose style was as practical and no-nonsense as her way of running her dry-cleaning business. But for me, only the best would do. She worked hard and wanted to enjoy her achievement, which to her meant Madison Avenue boutiques, Bloomingdale's, and lots and lots of cashmere sweaters.

Cashmere was the ultimate status symbol for my mom, who got a thrill from buying me Pringle of Scotland cardigans or Barbara Lee pullovers. But our tastes were different. I didn't particularly like cashmere sweaters, Mary Janes, A-line coats with Peter Pan collars—none of that was my style. At the shoe department in Bloomingdale's—where you stepped up on a platform to get your feet x-rayed for proper sizing—I refused to even look at a ballet slipper. I wanted loafers or boots.

My favorite piece of clothing was a Burberry raincoat with woven leather buttons that my mom bought at the British outerwear company's boutique on Madison Avenue. My style, inside and out, was not girly girl but cool and fierce. And that's exactly how I felt in that miniature version of its classic trench with my collar popped like a spy in Vichy France. I didn't have my own money, but I had my own mind. If I wanted cowboy boots, not Mary Janes, that is what I got—along with a cashmere sweater. My mother just couldn't help herself. Although I wasn't excited, I didn't put up a fuss about wearing them. Instead I toned down the prissiness of a Pringle cardigan with pearl buttons by pairing it with my trench and boots, the very beginning of my life-long passion for unlikely mixes of different styles.

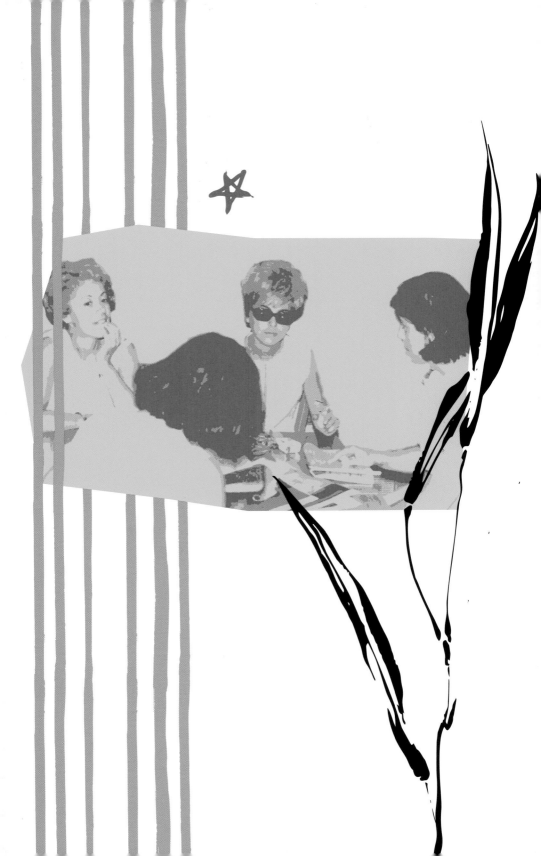

two

WEARING
THE PANTS

'M A MAN"—BO DIDDLEY'S FAMOUS RIFF brimming with slow sexual power—was playing when I experienced love at first sight. I had come after school to Ronnie's, an independent store off Main Street in Flushing that not only played great music but also had all the most up-to-date clothes, shoes, handbags, and makeup. That was my go-to place as styles began to change from the neo-Victorian corseted silhouettes and excess of the 1950s to something a little slimmer, and in my eyes, cooler.

"I'm a man, I spell M-A-N . . . man." Diddley crooned over the store's speakers as I pulled off the rack a new kind of pants, *my* kind of pants. These weren't the toreadors or pedal pushers that were a mainstay of the fifties. As opposed to a line cut for the female figure with a side zipper, the pants I was looking at had a front fly and men's-style tailoring with a slim leg but were meant for gals. The label said it all: Sir for Her.

Sir for Her and Mr. Pants, which made a similar look, became my favorite designers for pants, which I paired with pointy white Keds that I bought for $2.99 at Miles Shoes, a chain of budget shoe stores later bought by Thom McAn. They were cheap and cheerful, unlike the cashmere sweaters that Mom continued to buy for me and I begrudgingly continued to wear. The pants—high-waisted, tapered leg, with a flat front or single-fold pleat, and cuffed at the ankle or not—brought the whole look together.

I wore a lot of pants at Flushing High School, the local public high school that I attended now that we lived in Queens. Several years after Lou married my mom, they bought a house in Whitestone, the neighborhood right next to the Whitestone Bridge on Long Island Sound. Lou might not have been a powerhouse, but he was a veteran. In those days, if you were a veteran, you got benefits. Thanks to the GI Bill, Lou got a low-interest mortgage on the fifteen-thousand-dollar home in

Queens, and, as his adopted children, my sister Joanie and I received a check from the government every month that my mother put away for college.

My mom hadn't done so badly for herself, either. She had grown her business into a mini dry-cleaning empire, six drop-off stores with two employees each and a factory where most of the clothes were treated, which employed another ten pressers and cleaners. Moving to Whitestone, an area newly transformed from farmland to suburbs, was a sign that we had arrived. There we had a house with a backyard, where Mom planted nut trees. (She was very proud of her nut trees. Greeks love their nuts!) She also bought a deep freezer for the basement, where we stored meat that she bought at Food Fair Supermarket and rewrapped to store in the freezer once she got home. I complained whenever we had meat again for dinner, but a freezer full of steaks was her epicurean version of the affluence of a cashmere sweater.

Even at that age, I was more of a city person, and I would have preferred to live in one of the town houses that her original clients owned. But as my mother explained, those town houses cost upward of fifty thousand dollars, and we didn't have that kind of money. The good part of moving to the suburbs, though, was that I could ride my bicycle all over the place. I always had an ability to make my own fun. I turned our breezeway in the back of the house, which attached to the garage, into a mini bazaar where I would sell anything that my family members or I were no longer using. It wasn't a high-traffic area, but making a little store where I merchandised a mix of clothing and homewares was something to do.

The best part about moving to Queens was our new car. I loved our car—a 1958 Ford Thunderbird. Before the war, only rich people had cars. But the industrialization that had ramped up to fight the Nazis was now trained on putting out

high-quality, affordable consumer goods for Americans, which changed the design landscape. Today it's all about standardization, but back in the fifties, everything people made was infused with optimism. In those days, they made colorful cars that looked like rocket ships; banks and offices were grand places of marble and brass and double-height windows; and when it came to clothes, it was dress-up time.

I see fashion in terms of history. Fashion is a mirror of the culture and current events of the time. Shapes, textiles, and accessories tell a story of how economic and social forces are making us feel in our personal lives. In the thirties, it was the faded colors of the Depression. The clothes of the post-WWII years did their part for the baby boom by accentuating gender norms. Bullet bras, tight sweaters, and big skirts with small waists sent the Victorian hourglass shape into overdrive for the industrial age. They also had a sense of humor, expressed through bright colors or poodle appliques.

I'm happy in beauty and color. As a girl, I loved to see women in those bright skirts with crinolines as big as circus tents. They were fun. One trend I picked up from that time and never let go of is hats. To this day, I am a hat person. If an outfit is the sentence, the hat is the punctuation. Later in my life, when I began doing costume design, I was frustrated that whenever I put characters in hats, the director would invariably take them off. They always used the excuse that the brim creates shade on the face. When the director of the TV show *Emily in Paris* even took off the berets, I made friends with Steven Fierberg, the director of photography, and explained my philosophy so I could keep them front and center.

By the time I was in high school, the fifties were moving into a new, freer decade, and clothes were following suit with a space-age mentality. Swing and pencil skirts were giving way to A-line skirts and men's-style pants for women from

my favorite designers, Sir for Her and Mr. Pants. Ribbed poor-boy sweaters were the liberating successor to the sweater set. The new look, which I discovered at Ronnie's, reminded me of fashion transitions past, like how the body was freed from the corseted Victorian period during the Roaring Twenties, with flapper dresses that moved to the music.

For me, music and clothes have always gone hand in hand. I grew up with rhythm and blues, soul, and jazz. They spoke to me as much as the Greek music at the belly-dancing clubs near Penn Station. I was introduced to Ray Charles, the Coasters, Ruth Brown, and others when I'd hear the music that Harry and Earl played at work at my mother's dry-cleaning factory in Long Island City. The young Black pressers, who would come to the house regularly for dinner, were basically like uncles to me. My mom's employees were like family. She understood you can't have a business without a team.

When I got into high school, I traveled into Manhattan with my school friends Clyde and Patty to hear jazz greats like Sarah Vaughan, Chris Connor, Julie London, and Dinah Washington at storied spots like the Village Vanguard in Greenwich Village, the Five Spot Café on the Bowery, and Birdland in midtown. While my middle school in Whitestone had been pretty much all white, Flushing High was a much more racially diverse environment. My friends Clyde and Patty, who were Black, initiated me into all sorts of cultural activities. In addition to frequenting jazz clubs and visiting Manhattan museums and art galleries, we took acting lessons at the Henry Street Playhouse—the Lower East Side theater school, famous for its avant-garde productions and its embrace of the likes of Martha Graham before she was well known.

Perhaps my favorite outing was our trips up to Harlem on Saturdays. We would hang out while Patty's mom, Mrs.

Granger, hosted her radio show on WBLS. During one broadcast, Billie Holiday was her guest. Not long before the death of the legendary jazz singer, we sat on the floor at her feet as she delivered her haunting vocal style live into the mic. After Patty's mom was done with the show, we'd always go for chicken and waffles at the original Red Rooster.

In high school, I had an eclectic group of friends. They weren't actually a group, but an assortment of individuals with no relationship to one another. I didn't pick friends because they were from a specific scene or hung out together. Instead, I chose them like I did my clothes, according to instinct and interest. In addition to Clyde and Patty, I was friendly with Emily, a precocious girl who smoked pot at a time when people thought the movie *Reefer Madness* was real. My Italian American friends Mary and Harriet were straitlaced, following the prescription of the day when they married their high school sweethearts.

Going steady and getting married early was not my style. I didn't have any fixed ideas or big plans when it came to romance and sex. Again, I went wherever my fancy took me, which at fourteen years old was my first boyfriend, Yianni. He was an unusual choice: a Greek American thirteen years my senior. I met him while I was working at one of my mom's drop-off stores.

I always helped out in the business. During Christmastime, I took the initiative to paint the windows with Santa Claus, Christmas trees, snowmen, and other holiday motifs. In the summertime when her employees went on vacation, I opened up and ran the drop-off stores on my own. My mom didn't need to give me any instructions. Growing up in the business, I knew how to take in the clothes from customers, create a ticket, and send the items to my mom's factory, as well

as process and hang the cleaned clothes for pickup. I never made any mistakes. In fact, I even caught on to the fact that some of the employees were scamming Mom when I went over the ticket records. The tickets were in triplicate: one for the customer, one attached to the finished dry-cleaned garment, and one for the store's records. If a customer returned and there was no record of his ticket in the book, that meant the person who worked there most likely had never recorded the sale and pocketed the cash. When I figured this out, I immediately told my mom. I wasn't vindictive and took no pleasure in employees getting fired, but I always had a sense that fair is fair and have never abided stealing.

I met Yianni when he came into one of my mom's stores to drop off his shirts. He was hot stuff—tall, dark, and handsome—and my first fuck. Although Yianni was stereotypically macho, during high school, I had boyfriends with a range of personalities, from the very masculine to softer types. Andy, a blond of Cuban descent, introduced me to foreign movies that he'd take me to in the city. We bonded intellectually more than we did sexually. We enjoyed each other's company watching French New Wave movies more than we did in bed. When I was seventeen I had another Greek boyfriend, Gus. My mother was aghast, because he was born in Greece. Never mind that he was a florist with a very good business and his own home in Rockland County. As an immigrant, to her, he was a "greenhorn." Whenever he called the house, she would shout so that he could hear, "Pat, the jerk's on the phone." In her mind, she hadn't worked hard her whole life to make us solid middle-class American citizens for me to blow it with some Greece ball. In light of all she had given us, my mom didn't keep her feelings to herself when it came to what she expected of my sister and me.

More than our choice of dates, my mother put her foot down when it came to our education, insisting that we were both going to earn college degrees. My mother drilled it into me ever since I was young, not that I did much about it. I didn't find school up to that point very inspiring. As a teacher remarked on my report card, "Patricia talked her way through class." Although I didn't put a lot of effort into school or studying, I got good enough grades, and in my high school yearbook my fellow students voted me "Most Likely to Succeed."

My mom and most of her siblings didn't have much experience when it came to American universities, since most of them had skipped college in order to make a living. My uncle Dimitrius, my grandmother's oldest son and an engineer, was the only one of his siblings to attend college. When I was in high school, he drove me up to the University of Connecticut for a tour, but I didn't see myself there. Instead, I settled on NYU, so I could live in the city while I went to school.

I never once considered studying business, which was in my blood from watching my mom since I was old enough to remember. Nor did I think about pursuing a degree in fashion. I liked clothes, and style came easy to me. By college I had fully left behind any hint of the exaggerated femininity of the fifties. While the nation was racing against the Soviets to see who'd get to the moon first, I did my part by embracing the new space-age look that designers like Pierre Cardin and André Courrèges ushered in, with white leather go-go boots, lots of black, white, and silver, and astronaut-ish accessories such as helmet-style hats and goggle-like sunglasses. My androgynous pants and ribbed sweaters, which I first started buying at Ronnie's and now found at the little privately owned stores along Eighth Street near campus, had come full circle and were right on point. The only holdover from the previous

decade was my white '58 T-Bird, which I inherited from my mother and drove from Whitestone to NYU.

College opened me up to subjects that I found really interesting and hadn't been exposed to in my high school education, especially government and philosophy. I took a philosophy course with Sidney Hook, the head of the department and a major political philosopher and democracy advocate. Professor Hook was a proponent of "the pragmatic account of knowledge," which says mainly that all proposed truths correct themselves over time if they are open to inquiry. A big critic of moral absolutism, like the kind you get in religion or some political institutions, he started out as a Marxist in his early years, but eventually became anti-Communist. I also had a much-admired English professor who excused me from taking the final because I had all A's. "There's nothing to prove," he said. We were on the same wavelength.

College also opened me up to my first affair with a woman. My relationship with Susan was not a big pronouncement that I was now gay. My mind didn't work like that. I've always chafed at labels and still do. I hadn't had any lesbian situations before I met Susan. Our friendship simply turned romantic. It was as simple as the fact that we were attracted to one another and willing to go with those feelings. Our relationship lasted a couple of years until ultimately our differences became too much. She was a conservative Jewish Goldwater girl from Parkchester, the Bronx; her values were different than mine. Around the same time she started to grate on me, Susan met some guy and wound up marrying him. The timing was right; it was over for us.

A serial monogamist, I went back and forth between men and women after I graduated from NYU. Case in point, I was dating a sexy Iranian-Assyrian guy when—surprise—I fell in

love with Jo Ann. We met at a small dinner party of couples, mostly gay men, in a beautifully designed Kips Bay apartment. The host, Joe, was head of displays for Abraham & Straus, a major Brooklyn department store.

I was also working in retail by that time. When I finished college in 1963 with a dual degree in philosophy and political science, I wasn't exactly sure how to put my education to work. My studies reflected subjects I found interesting to read, write, and think about. It was true liberal arts education that had no practical application in the world outside the ivory tower. I had no plan to pursue a career in politics, government, or academia. That wasn't my cup of tea. I don't believe in swimming upstream, especially when it comes to work. I didn't need a career counselor to tell me that I would make a horrible bureaucrat.

When I saw an ad in the paper for a job with Alexander's discount department store in the South Bronx, I applied immediately. Fashion was easy for me. From the time of my cowgirl outfit, I always had a style of my own, which varied depending on what was available to me in my price range. For example: I ruled the infamous "back room" at Loehmann's, a discount designer store on Fordham Road in the Bronx that offered overstock from the season's collections at cut-rate prices. Because I knew the difference between quality and junk— thanks to my mother's early-morning lessons in the shop—I would often find beautiful designer clothes on the cheap.

This skill came in handy for my new job. I bought designer suits at Loehmann's to wear for my new position on the sales floor of the accessory department at Alexander's. I found some pieces by Wragge, an American designer famous for introducing mix-and-match separates. The collections—in "families" of color meant to be combined as each customer

saw fit—were of such exacting quality that Wragge put the year of manufacture on the labels as a point of pride. I might have looked like a fish out of water as I exited my red Sunbeam Alpine sports car (the same car Elizabeth Taylor drove in *Butterfield* 8) in a dark-green-and-black, big-houndstooth woven silk suit, Charles Jourdan heels, and wide-brimmed straw hat parking on the street of the rough neighborhood outside the large, windowless-box store in the Bronx. But I was dressed for success.

I didn't just dress the part. My outfit was an outer manifestation of what I felt about myself on the inside. I knew I could achieve success by showing some initiative, putting my natural instincts for fashion and business into practice. Whenever it rained outside, I ran to the stockroom in my spike heels (even when I was a kid I could run around in them). There, I filled up a shopping cart with umbrellas that I quickly displayed for an instant boost in sales. I also made friends with the floor manager, who gave me additional retail real estate to play with. I took the tables and counter space that weren't assigned to a department within the store to better expose the merchandise in accessories. I didn't think about it any differently than I did when creating my little store outside my house in Whitestone. I focused on what I liked and put it out there.

I enjoyed my job and did it well, which was clear to me and soon to the store managers, who promoted me to an open position in the blouse department. I wasn't the buyer; my job was to make everything look appealing to customers. When I arrived all the blouses were wrapped around cardboard inserts and shoved in plastic bags, as they had arrived from the manufacturer. Then they were piled up on a table, like chicken breasts in individually wrapped Styrofoam containers in the meat section of the supermarket. I set to work freeing the

blouses from their plastic prison, pressing them expertly as my mom taught me in the dry-cleaning store, and bringing them to life on bust forms I purchased for the department. The effect was immediate. Women started buying blouses.

After a month or so, an army of executives marched into the blouse department wanting to know why the sales were climbing like never before. I had simply styled the blouses so that they would look enticing to me if I were shopping at the store. That led to my promotion as an assistant to the buyer. Moral of the story is: Do what you're good at and success will find you! Me? I love to make everything beautiful, be it a $3.99 blouse, a Payless shoe, or a Chanel tweed jacket.

My promotion didn't last long, however, before office politics got in the way. The merchandise manager did not like my boss, the buyer, and wanted me to replace him. I don't like nastiness and am confident enough in my abilities that I never want to succeed at someone else's expense. Plus, the buyer was a nice guy. So I started looking for another job, which I found at Petrie Stores—a chain of hundreds of cheap, trendy clothing shops, mainly found throughout the Midwest—where I was hired as an assistant buyer, helping to find fashions that young women on a budget would want.

That's where I was working when I walked into Joe's dinner party and met Jo Ann, my girlfriend of the next fifteen years. Having arrived that afternoon in New York from Philadelphia, she was running away from an engagement, from her family, and from the belief that she was straight. She didn't know what to tell her Catholic parents about why she broke up with her fiancé, so she got out of town without telling anyone and without a plan of where to go. Joe, who had grown up with Jo Ann in Philly, told her she should come stay with him in Manhattan.

CITY THE IN PAT

26

Jo Ann knew exactly what she felt when I walked into the Kips Bay apartment. For the twenty-five-year-old medical lab technician, it was love at first sight. She also knew the shock to her heart was nothing like anything she'd experienced with her fiancé, a funeral parlor director in Philadelphia. She had suspected something wasn't right with their relationship long before we met. Jo Ann—who came from an Italian American Catholic family and received a parochial education—went to confession to get some clarity on her dulled feelings toward her fiancé. "I can't do this," she told the priest. On Mother's Day, she broke off her engagement and escaped to New York, leaving a letter for her parents. She stayed with Joe for about a week and a half before she returned to Philadelphia to face the music. With or without permission from the church, she began commuting back and forth from Philadelphia to New York so we could be together.

Our backgrounds were very different. At one point, I think she had toyed with becoming a nun. That couldn't have been further from my reality. My mother got into the Greek Orthodox Church for a little bit, but she didn't make me attend. Our family wasn't against religion per se; we were just too willful to adhere to any kind of dogma. For me, church was a cultural experience as opposed to a religious one. My mom was a strong, independent woman, whereas Jo Ann's mom, Helen, was a traditional nurturer. She showered affection on her daughter, with whom she had a loving relationship. Whenever we visited her home, she cooked up a big pot of delicious crabs and pasta.

What we both inherited from our families, however, was a strong work ethic and sense of self-reliance. As my mother had done with dry cleaning, Jo Ann's father had built up a solid business in construction. Jo Ann made fun of her mother's

Depression-era thriftiness, such as reusing tinfoil, even as she admired it. And she liked that I was a hard worker, too.

When Jo Ann left Philadelphia and moved into my family's house in Whitestone, I could tell this relationship had potential to become a permanent situation. I enjoyed my previous partners, but with Jo Ann our connection was about more than sex. While we didn't have major conversations or big talks about the future, we instantly started to build a life together. It was natural, positive, and mutual.

For the six months we lived together in Queens, I worked all day at Petrie's while Jo Ann took lab courses in the city (as an excuse to live with us), so dinner was the only time we saw one another. Neither of us was out to our family. Being a homosexual was not something you talked about back then. Lesbians and gays didn't walk around on the street hand in hand. For Jo Ann and me to introduce ourselves to our families as lovers was too extreme for either of our personalities. Luckily, they didn't question anything or put us through the wringer.

I would call our arrangement live and let live—that is, until my sister Joanie walked in on Jo Ann and me in one of our house's upstairs bedrooms. Instead of quietly closing the door and moving on with her life, she told Mom exactly what she'd seen. I don't know why my sister did that. Maybe she was jealous of me. Although we had the same parents, we were brought up very differently. My mom's growing business and a post-WWII America flush with cash meant that Joanie had nannies taking her to and from Central Park at an age when I was traveling by myself to Astoria to be with my aunts and grandmother. By thirteen, I was opening up and running my mom's drop-off locations in the summer; Joanie, on the other hand, never worked at all in the dry-cleaning business. I always went to public schools, while she went to private ones.

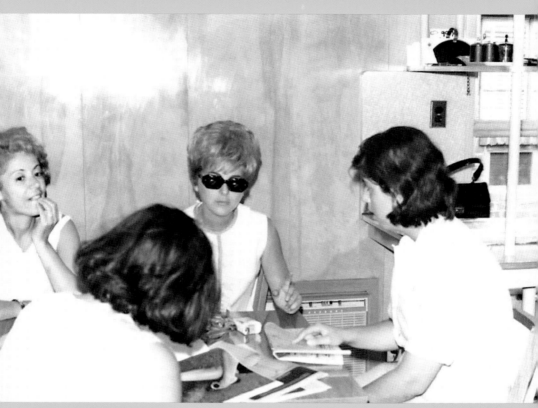

Aunt Van, Jo Ann, Joanie, and Pat

Whatever the reason, she put our mother in a terrible position when she told her about Jo Ann and me in bed. I had learned to assert my independence and get what I wanted without bothering other people, including my mom. I'm sure my mother would have preferred that I didn't have a female lover, especially living under her roof, but the idea of policing me went against her entire personality. She had no interest in confronting me about my sexuality. So when she sat across the kitchen table from me and asked me about what Joanie had told her, I lied to get her off the hook.

"I don't know what she thinks she saw," I said, "but she didn't see anything."

The issue was forced on her, and I denied it. I didn't see any point in going any further, and neither did she. We never talked about it again.

After that, Jo Ann and I found our own apartment on NYU's campus. I was doing well at Petrie's as an assistant buyer. From the moment I arrived, it was clear that my presence was a breath of fresh air for the buyer and merchandise manager I worked alongside. Both middle-aged women who had been in the business a long time, they weren't threatened by my taste, even if they didn't always understand it. When I brought them a "Ponderosa" shirt with a leather lace up the front and billowy sleeves, they weren't so sure. "It's weird," one of them said.

I disagreed. Although it took me back to my cowgirl days, it wasn't actually to my personal taste. It was too covered up and not sexy enough for me. I didn't have any specific customer in mind when the shirt caught my eye; in fact, I consider the whole concept of "the customer" as a distraction when buying. Instead I rely on my instinct for finding a unique take on an old reference. The Ponderosa nodded to the adventure of the Old West that resonated with the new freedom and romance

of the sixties. It had a classical element that gave it a through line to the past, without looking dated.

"Okay, let's try it," the head buyer said.

The Ponderosas wound up galloping out the door. They were a huge seller, earning me my stripes. I was grateful to those ladies at Petrie's for giving me the room to follow my instincts. Not only did I gain experience in the wholesale fashion market, I was also able to see how my ideas were received by thousands of real-life customers. Even if I had no idea at the time, that practical education and freedom to play would prove invaluable for what was about to come.

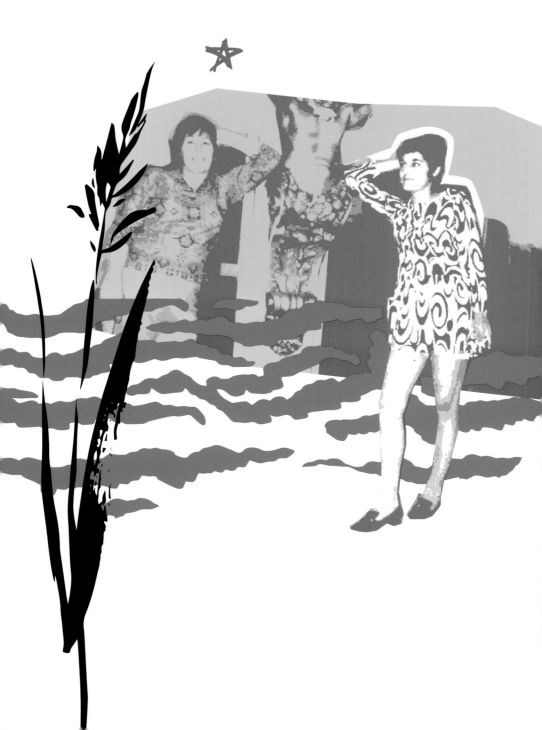

three

THE BIRTH OF MY FIRST CHILD

Pants Pub, 14 Washington Place

JO ANN WAS SANDING THE WALL with some kind of steel brush and stood back to examine her work. Having learned to distress wood from Jimmy, the Greek carpenter who was helping us renovate the small Greenwich Village storefront, she had really gone to town with the technique. The result was that the thirty-by-twelve-foot space looked kind of like an old Irish pub. It was an odd choice for my vision for our new boutique. I wanted a happening and modern place that catered to young and trendy women—just like Ronnie's in Flushing, where I began my lifelong affair with pants. But this was where we were with what we had.

Jo Ann and I, who had each put in four thousand dollars, were adjusting to being business partners. I was in charge of the fashion side of the store, while Jo Ann mainly dealt with the construction. Her dad, Richard, a builder from Philadelphia, drove up electrical equipment and other building supplies we needed and helped install the hanging fiberglass lighting fixtures. I didn't have a strong image of what it should look like—I was more focused on getting the store open as quickly as possible. So I hastily agreed to all the renovation decisions—some of which I liked and others not so much (e.g., the decorative antique beer tap). We named our store, at 14 Washington Place, Pants Pub, a name that reflected the weird marriage of its décor and inventory.

As successful as I was in my first two jobs out of college, at Alexander's and Petrie Stores, I always knew I wanted to work for myself. Mercantilism was woven into my DNA. Trading ships have sailed the waters of Lesbos from the Greek, Roman, Byzantine, and Ottoman empires up until the present day. This instinct was nurtured in me by the example of my mother, then honed by my experiences in retail.

My experience at the department stores—in merchandising on the floor as well as learning the wholesale fashion

system—gave me enough confidence that I felt I could successfully run my own boutique. In the fall of 1966, I found a commercial space that only cost $111.50 a month because it was off the beaten track, tucked on an anonymous, sleepy street in Greenwich Village. I knew, however, that the block was actually in the heart of the NYU neighborhood and crossed many times a day by students (the store's target audience) on their way to class or the bookstore.

For Jo Ann, opening a store was just one part of the life we were building together. We lived together and were making a circle of friends together. Now we were going into business together. Jo Ann was interested in the shop because I was interested in it. She loved me and would have done anything for me, but she also believed in me. The timing was right; the location was right; the partner was right.

Almost everything was right, except when we ran out of money before we finished the renovations. Jo Ann and I had spent every dime we had in savings—including the money from a small trust fund established for me when my dad died. But we still needed fifteen hundred dollars to install a new floor. So I did something I had never done before and never did again: I asked my mom for money.

From the time I was thirteen, I always worked, starting by filling in for my mom's vacationing employees. But I didn't necessarily just want to work for her. At fifteen, I got a job wrapping meat in a supermarket, which my mom did not approve of. She had no problem with me working; she just didn't want me working in a supermarket meat department. Considering it beneath me, she came into the supermarket and demanded that the manager fire me—which he did. My goal was to make my own money and achieve the independence my mom claimed for herself. I didn't care if it was by wrapping meat or dry-cleaned blouses.

My mother was the boss, not just at her dry-cleaning stores but also in her relationships with her husbands. At least that's how it started out with my dad and Lou, who had died by the time Jo Ann and I were opening up the store. Mom was on to her third husband, or as I called him, George the Third.

Lease for 14 Washington Place
PAT'S COLLECTION

She started out in control with George III, a traveling sales-man twenty years her junior, putting him to work in her dry-cleaning business. But, over time, she lost her dominance as he inserted himself in her decision-making.

I was never really a fan of George III. It might have par-tially been a case of husband fatigue, as well as a lack of respect for this guy in particular. He was always singing and fancied himself a real charmer. But to me he was just a jerk with no-where near my mother's level of achievement. I didn't see any real integrity in him. My mother, on the other hand, adored and trusted him. And so when he told her not to give me the money for the new floor, she let him call the shots. It had noth-ing to do with whether or not the floor was a good investment, or about the odds of whether or not I would pay back the loan. Instead, it was about coveting my mother's money. He didn't want her spending a single cent on me because that meant less for him when she died. (Although, in the end, he died first.)

I wasn't so much bothered that George III didn't want to help me out or invest in my future. What really hurt was that my mother listened to him and refused me. I felt betrayed, but I never said anything to her about it. Instead, I just let it go. Or at least I told myself I did. It was similar to when my sister tried to out me to my mother—I didn't want any confronta-tions. It wasn't worth it. Better to let it slide, I thought.

My solution to moving on was to tell myself that I had other plans, and they didn't include my mom. Those plans were Jo Ann and the store. Jo Ann was solid. The store—which we opened in 1966 with no fanfare, just literally opening the doors and hoping people would come in—was a question mark. It wasn't a great sign when a neighbor, who popped her head in to ask what we were doing and heard a clothing store, replied incredulously, "In *this* location?"

I got a little uptight, but Jo Ann told me not to worry. In those early days, my world was my boutique and my girlfriend. We found an apartment in the same building that housed Pants Pub. I've always lived above my stores (except in the case of my last boutique on the Bowery, where I lived next door). I guess it's the old-fashioned merchant in me.

The first apartment Jo Ann and I shared was a one-bedroom with a sunken living room on the fifth floor of 14 Washington Place, which became infamous when Ed Koch didn't move out of his rent-controlled one-bedroom on the twelfth floor after he was elected mayor in 1977. Apparently, he liked the place a lot more than Gracie Mansion uptown. I don't blame him. "I know where everything is," Koch told the *New York Times*, just before he took office, about the $250-a-month apartment he didn't leave until twelve years later. "I don't care what anybody says: I won't give it up." When Jo Ann and I moved to the pent-

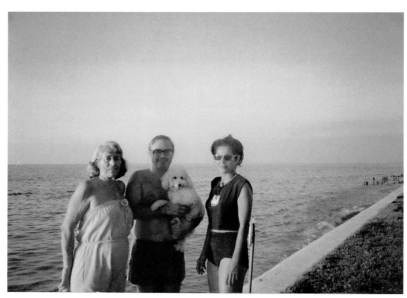

Marika, George III, and Pat
PAT'S COLLECTION

house on the fourteenth floor, I'd see the mayor in the elevator and say, "Hi, Ed."

When Jo Ann and I moved in, anything outside of the NYU neighborhood was a mess. The Broadway of today—a retail juggernaut where every national normcore retailer from H&M to Crate & Barrel has a presence—did not exist. At night, the area was like a ghost town. Dark and empty.

Despite the poverty around us, Jo Ann and I lived a very bourgeois existence. When we weren't working, we socialized with a small circle of friends, who were all gay. It was who we gravitated toward, not a political statement. Our friends were all professionals. There were two girls right in the building: Joanie, a nurse with a PhD, and her lover, Nancy, a banker at Chemical Bank. Howard was a doctor who, with his boyfriend, John, had a beautiful house near Nyack where we spent many weekends. We would have intimate dinner parties or go out for drinks together, too. I am a city girl and was happy to be back where I belonged. These were my people, and this was my scene.

When we first moved in together, around the same time we opened the business, Jo Ann got me a poodle that I named Bianca, because she was white and I had studied Italian. I love animals. It's only in my current age that I like little babies, who I *now* find so cute—at the time, not so much. But I always enjoyed animals. When I was a little girl I had a cocker spaniel, but my mom got rid of it one day without explanation. She decided she didn't want me to have a dog, so it came and went. By the time I was twelve, I was old enough to make my own money and decisions, so I got a boxer that I named Skylos, which means "dog" in Greek.

A couple of years after I got Bianca, I met a guy in Washington Square Park with another poodle and decided to mate them. But the dog was very tiny and had trouble mating with

Bianca, who was much taller. It was funny to watch the male dog chase her around the store, where they eventually did work it out. Bianca had a litter of seven puppies in my apartment.

During that era, Jo Ann and I did the things that couples do. Go out to dinner, entertain, get a pet. Nothing out of the ordinary. Mostly, though, we worked in the boutique. We enjoyed it because we were building something together. We were striving, and we did all right by doing a little at a time, not overdoing anything.

During Pants Pub's first years, I kept a day job, designing separates for a friend in the business. I didn't draw or sew—even though my father was a tailor and home ec was a requirement when I was in junior high school. Whenever I got a sewing assignment in school, I took the pattern to my mother's dry-cleaning store and had the tailor make it for me. I had no interest in sewing and never regretted missing out on learning those skills. I'm scrappy. If I don't have a skill to bring my vision to life, I am always able to find somebody who does. In designing for my friend Bob, I would do things like find a collar on one shirt I liked and a body on another and ask the tailors to combine them. As usual, I trusted my instincts and made it up as I went along.

Designing is in the details, and that's where originality can really shine. For example, David Dalrymple, who would later design our collections, used sequins (an item I have often looked down upon as a cheap trick) under a jacket so that when you popped the collar you got an unexpected and delightful surprise. But there's a fine line where originality crosses into absurdity, such as pants with zippers all over the place that have no purpose. The first thing I do when assessing any garment, however, is to touch it. The lessons about the importance of quality fabric I learned as a young girl left a lasting imprint. I'm interested in how it will feel on the skin.

Will it flow nicely? Then I try it on. Even if it isn't for me, but for my store, I want to know how it feels and looks on the body.

I already had a handle on fashion when we started Pants Pub and knew I could pick winners. But despite my previous experience, I still wasn't sure how well I'd do in the wholesale and chain-store market when it came to my small store. It's one thing to buy thousands of blouses for four hundred stores across the Midwest and quite another to go into a factory for half a dozen pants to stock a shoebox of a store on NYU's campus.

I didn't worry about the issue of scale. Half a dozen pants was a big order, at least for me. My goal for the store had been to get the freshest, most exciting and up-to-date styles to my customers, and for that I needed to go straight to the manufacturers I loved for my collection. When I discovered that the factory and headquarters of the pants company Sir for Her were located in Philadelphia, I decided to take a field trip.

That train ride to North Philly was worth it. They had all kinds of stock there that hadn't yet made it to their showroom. I got to choose stuff fresh off the line. More important, I hit it off with the boss. We built a great relationship over the years and came to look forward to our visits. I would call him up to say I was coming and ask if he had any more of a particular style that had been a huge hit. "They're waiting for you here," he'd reply. It was so much fun to choose pieces on the spot in the factory as opposed to ordering in advance, and useful toward my aim of getting fashion in the moment.

I also built up relationships with a handful of small but good sportswear manufacturers—including the head of the sales department at Mr. Pants, whose son keeps in contact with me to this day—and that allowed me to see, purchase, and even influence more options than I would have if I focused only on the clothes and not the people behind their produc-

Marika and Pat in Philadelphia
PAT'S COLLECTION

tion. Personal relationships have always been a crucial element of my professional success.

It took about a year for Pants Pub to make enough money to sustain itself, as well as Jo Ann and me. As I predicted, we had a captive audience with the NYU college girls, who made up the bulk of our clientele. Occasionally a member of the faculty came into the shop. One professor stood out because he was a man. Jo Ann, who had never seen a cross-dresser before, was blown away that he wanted to try on women's clothing. In my book, a customer is a customer. During sessions where we closed the doors so he could try on clothing in private, I helped him find pieces that were quite attractive.

It was at Pants Pub that I discovered I was a born seller. It wasn't just that I had a good eye and knew how to buy well for my store; I also found it rewarding to put people in clothes

that they looked and felt good in. It boosted my self-esteem to take care of customers like Betty, a slightly overweight Italian girl from Howard Beach who loved to shop at my store. It was thrilling for both of us when I would find her the right pair of Sir for Her pants. She and her husband, Lou, both teachers who became friends, would have Jo Ann and me over for dinner, for which Lou always baked excellent Italian bread.

The moment I felt the store had truly arrived was when Yetive became a regular customer. I had no idea how the sexy dark-haired woman had found our tiny boutique. She wasn't a student or office worker from the neighborhood; she was a fancy woman whose boyfriend owned an entire building in Murray Hill, where she lived with her young daughter. The fact that Yetive, who could have shopped anywhere, always found things she loved when she came into the shop with her daughter in tow was a huge vote of confidence in those early days that I could cater not just to young trendy girls but to customers with their own taste and glamorous image. While staying up to date on the latest in fashion is an important ingredient in any retail operation, I have never been motivated by following trends. My real inspiration is timelessness and quality, whether that's the Doric columns of the Parthenon that still rise under a blue Athens sky or continental-cut velvet pants showing a little ankle.

four

MAKING A NAME
FOR MYSELF

AMONG **SO MANY BEAUTIFUL THINGS** I bought for my shop during my first trip to Paris in the seventies, the army-green wool coat was the one thing I bought for myself. The loose-fitting cape-shaped coat was practical and timeless, warm and sublime, innovative and elegant, a marvel by this new Japanese designer, Issey Miyake. In it, you could really move (movement was a preoccupation in his clothing throughout future decades), which was good because Little Michael and I were everywhere. Michael, a firecracker with an eponymous shop on Madison Avenue carrying a higher price range than mine, had encouraged me to accompany him to the mythical mecca of style, where we dropped our bags at our hotel on the Left Bank and followed our fashion fantasies. Two young kids, we were anonymous to the Paris fashion elite. Yet we worked our way into trade and fashion shows by day and fashion hot spots like La Coupole and Café de Flore by night.

This wasn't long after Jo Ann and I moved the store to 10 East Eighth Street, in 1971. Five years after its opening, Pants Pub had outgrown the small space on Washington Place, not to mention its name. I had never liked the name, but the new location provided an impetus to change it. Jo Ann suggested we call it "Patricia Field" and use my signature as the logo. I wasn't convinced. Why my name? We could have as easily used hers. "Do you want to shop at a store called Salvucci's?" Jo Ann asked. She had a point.

Despite the change of name and address, Patricia Field was still a shop where you could find the latest fashions, which by the seventies had moved away from the earnest optimism of the mod look to something more decadent and devious. I danced lightly over the hippie style, which was way too messy for me. I couldn't stand the ripped bell-bottom jeans dragging along the ground that were all the rage. I nodded to the trend

when I found a manufacturer in Chinatown who made high-rise jeans with a full leg that I liked. The jeans—more sailor than Age of Aquarius—were hippie-adjacent and a huge hit.

More to my taste was disco. As social constraints loosened in places like New York City, people wanted to go out and have fun. Slinky sensuality was the order of the day, even in clothes that weren't intended for the nightclub. The new silhouettes were less structured. Whether it was a soft wool Karl Lagerfeld skirt or leather boots that slouched around the ankle, everything had movement.

The disco era also inspired women to invest in their wardrobe. I returned from Paris with a new ingredient: yes, more designer, and yes, pricier, but definitely worth it. My trip represented a big shift in the way I presented my shop. It wasn't just about a higher price point but also a more refined fashion sensibility, as I began carrying newer high-end designers such as Issey Miyake, Claude Montana, and Thierry Mugler.

Still, price was a factor, and an important one. In retail, it always is. When Michael told me about pleated, full-legged, high-waisted gabardine trousers by the New York designer Alice Blaine, I went to see them and liked them a lot. The pants, in a luxurious blended wool, were flattering, different, and accentuated the waist. So I bought a half dozen for my shop, but at $120 a pair they were a huge jump in price from Sir for Her or jeans made in Chinatown. I wasn't sure if they would languish on the rack. This new silhouette wound up doing fabulously, so much so that I kept on running back to Alice for more.

The new run of designer inventory on Eighth Street attracted a more sophisticated clientele than the college coeds who had filled Pants Pub. Not long after I came back from Paris, Patti Smith walked into my store. When she first descended the shop's steps, my impression was of a magical hobo

or royalty who'd fallen on hard times. Her hair was disheveled and her clothes were all a wrinkled mess, but she had on a full-length olive-green mink. She dropped that marvel of a coat to the floor like it was a rag. That day she walked out with a two-hundred-dollar chiffon blouse that I had purchased during that first trip to France. A resident of 1 Fifth Avenue, right around the corner, the irreverent singer and poet became a very good customer. "I bet you don't know where I wear all these clothes," she said one time. I was curious. "I wear them in my shows. Come to my show." I did, and there she was in the two-hundred-dollar chiffon blouse, looking all wrinkled and crappy.

The nouveau glamour of the seventies was reflected not only in my professional life but in my personal one as well. In addition to inviting me to Paris, Little Michael had invited me to a new club, Studio 54. A gay Persian whirlybird, he was ambitious and bossy and fit right into the high-octane crowd of the legendary club. It was a happening, a place where everyone wore their best and no one stood around. I was at home immediately. I would get on that dance floor and dance there all night—except when I went to the ladies' room, which wasn't only for women. Next to the toilet stalls, there was a large and luxurious powder room in pale pink. With plenty of plush upholstered furniture, soft lighting, and big mirrors, the powder room was the perfect place to check your makeup, lounge around, and do your drugs. In a club of many delights, it was a hangout destination.

Studio 54 was unlike any other place. It went down in history for the cocaine, sex, and celebrities, but there was also an animated flow of ideas happening in that space. The VIP room was like a throwback to Plato's *Symposium*. Instead of Socrates and Aristophanes, it was all these gay guys with varied talents, engaged in a lot of talk about *eros*. So classic and yet modern.

That's where I met Halston, who became a good friend, and Andy Warhol, too.

Up until that time, my life had been my shop, Jo Ann, and our small group of gay friends, with whom we went on trips to the beach and country or ate quiet dinners in the apartment. I was in my thirties, and I was bored. I wanted to have some fun. We had earned it. But I couldn't convince my business partner and lover of fourteen years to come along with me.

"Listen, I can't force you, Jo Ann," I said, "but I'm going."

I did, and that was the beginning of the end of us. It took us another twenty years to completely separate our financial entanglements, but we always remained friends. To this day, I would do anything for her, and I know she feels the same.

———

Studio 54 was just the start of New York City's great clubs. The seeds planted in the seventies flourished throughout the eighties into such beautiful and exotic flowers as Paradise Garage, 12 West, Area, Boy Bar, Pyramid, and Sahara—a chic lesbian bar located in an elegantly decorated Upper East Side duplex. These were places where no one was caught dead without a full look! And Patricia Field was *the* meeting spot, *the* mecca, *the* platform for all kinds of creative types putting together their image for that night.

The shop offered much more than clothes. We had accessories as well as a fully stocked makeup department that I created around the same time I started traveling to Paris with Michael. Debbie, who ran the makeup counter, was its inspiration. Her personal makeup as flawless as her taste, Debbie began coming with me to Europe to source unusual products such as those made by Kryolan, German theatrical makeup that you couldn't find anywhere else in New York but at

Patricia Field. We had a matte-red lip color from Shiseido made from real crushed flower petals. You had to dip your brush in the water and paint the wax-based pigment onto your lip. We sold so much of that product, a classic geisha formula that I still use today.

As a result of Debbie's talent for finding unique brands, almost every professional makeup artist became a regular customer. That was a good thing since Debbie, who saw herself more as a beauty curator, didn't care for applying makeup and wasn't shy about letting customers know:

"I don't apply. I supply!" Debbie used to say.

My shop on Eighth Street was part of a small constellation of places pushing the boundaries of fashion. No longer was it only about what was trendy in Paris. Throughout the seventies, heavyweights such as Saint Laurent dictated the trends; when he was into Russia, everyone got on their Cossack coats. Karl Lagerfeld's diaphanous dresses with matching headscarves for Chloé on the runway made bohemian nomads out of Upper East Side ladies who lunched. As the decade changed, so did trends, which began to move to the pulse of street fashion.

It's hard to imagine now, but at the time there weren't many cutting-edge fashion boutiques downtown. Uptown, there were Charivari and Barneys, where you could get your Azzedine Alaïa and Jean Paul Gaultier. In SoHo, there was Susanne Bartsch's boutique on West Broadway, which featured avant-garde English fashion, and IF Boutique, a hub of new designers, also on West Broadway. My boutique was on Eighth Street, where in high school Clyde, Patty, and I would shop in the small privately owned stores that for the most part were no longer there. Down the street on St. Marks Place was Ray Goodman's punk rock, new wave shop, Trash and Vaudeville, which I considered my sister boutique. It was always me and Trash!

By the early eighties, my shop had evolved to reflect the burgeoning ethos that fashion is not in a magazine or on a Parisian runway but wherever you are—and those making it can be equally eclectic. Because I had a reputation for push-

With Debbie in Paris
PHOTOGRAPH BY BILL CUNNINGHAM

ing looks from small designers, young people started coming to me with their creations to see if I'd take a chance on them. One of those was Andre Walker, who at thirteen was selling his fashion designs in Brooklyn the way most kids run lemonade stands. I marveled when I saw how he shaped his garments, laying the fabric flat and cutting it like a piece of dough or paper. Then he sewed the garment, and as soon as it took form on the body, it came alive. That's how much of a genius he was; he didn't need to drape or do alterations on a form. Andre was the epitome of eighties scrappy street couture. At fifteen, he showed his first runway collection at a nightclub in his Brooklyn neighborhood. Three years later, he presented his one-of-a-kind creations, like my dark green jacket with lapels that looked like wings, on Eighth Street, up and down in front of my shop. The sidewalk was his runway: his friends, the models. (I still frequently pull out my Andre Walker one-of-a-kind pieces to try on actresses I'm working with.)

I took to heart the philosophy of nurturing talent as my own business grew. I often helped young designers—like Carmel Johnson-Schmidt, Millie Davis, and Isabel Toledo (the designer of Michelle Obama's yellow inauguration dress ensemble, whose first collection, presented at Danceteria in 1984, I bought for my shop)—navigate the practical side of the business, such as consistency in their product and delivery.

I also took a very broad definition of who qualified as a designer. Fine artists who hung out in the store became part of the mix. Keith Haring, Kenny Scharf, Jean-Michel Basquiat, Isabel's husband Ruben Toledo, Jonathan Bressler, and others created a variety of pieces including wall paintings and murals. I celebrated inventiveness of any kind. Artistry and clothes as a way to delight your clients bound the group together.

Jean-Michel would sit on the floor of the store, painting on Tyvek jumpsuits. He created one-of-a-kind garments by draw-

Andre Walker creating a window with his designs for Eighth Street, 1985
PHOTOGRAPH © TINA PAUL

With Asia Love and Keith Haring at the Artist's Sound Factory ACT UP benefit
PHOTOGRAPH © TINA PAUL

ing with a permanent marker on the white synthetic material that's used to protect workers during construction and people against lethal viruses. At no more than twenty-five dollars a pop, they moved. Imagine, a Basquiat for twenty-five dollars. That was the early eighties.

This was, of course, before fame caught up with Jean-Michel, who in those days called himself "Samo" (pronounced SAME-oh). He had his first art show in the store. It was of painted-on found objects, including a man's sport jacket and a TV screen. An old painted typewriter caught my eye. "How much do you want for this?" I asked him.

"Ten thousand dollars," he answered.

I laughed at him. Artists are like that. They just don't have a clue about what to do commercially. But maybe that's part of their genius. In the end, Jean-Michel went through the roof, and his works went for much, much, much more than that.

Keith Haring's famous "Free South Africa" T-shirts came from the store, where we held an exhibition to celebrate and support the anti-apartheid movement. His T-shirts depicted a large black figure stepping on a small white one. The show didn't cause any kind of big cultural reaction, but we sold a lot of T-shirts.

He had painted the Free South Africa image on the store's large window, which I decided to save by removing the large plate glass after the show was over. When I offered to bring him the window, he said, "Keep it. You don't have a big piece of mine." Keith was always a generous sweetheart like that. Unfortunately, the massive piece of glass disappeared somewhere along the line. I didn't realize it was missing until years later when I moved stores. But for ages, its fate remained a mystery, since nobody would fess up to taking or breaking it. The cat got out of the bag when I was talking to an employee, Mars.

"Oh!" he said. "That painted glass was broken in a move." No one had the balls to tell me.

Patricia Field was a curated buffet of many different looks at many different prices. It was always important to me to have a wide array of price points, because I wanted young people without much money but a lot of style to be able to afford shopping with us. In an effort to get this range, I would buy end-of-the-season stock that hadn't sold from high-end designers where I had a connection and sell it at prices our customers could afford. There was no Century 21 at the time, so a lot of this kind of stock went right into the garbage. Not everyone loved my attempt to become a mini outlet for the people. To convince the rep at the Zoran showroom to offload pieces from previous seasons, I had to agree to clip the labels out of the garments before selling them in my shop. Armani wouldn't even hear of it, choosing instead to burn those beautifully cut silk, wool, and linen garments rather than let them get in the hands of such Eighth Street miscreants.

Not all designers were opposed to seeing my kids and their friends in their fine creations. When Stephen Sprouse dissolved his business, he tipped me off to the liquidation sale. Stephen was a master, hand-painting silk, engineering Velcro attachments, overlaying traffic-light yellow or green dresses with black graffiti and shining clear paillettes, and pairing them with matching tights. His creations were genius, but old people with money wouldn't wear them—the major problem with his business model. When he closed, Stephen wanted the young people, who would be the prime candidates for his clothes but couldn't afford them, to get them, so he called me. There was a gorgeous maxi coat that looked positively princely on Richard, a Bronx native and talented artist who I recruited in 1981 to work in my shop after meeting him in Danceteria.

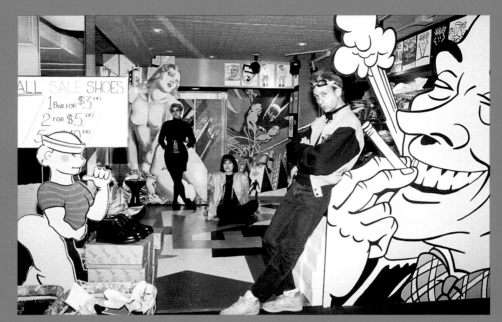

Suzan Pitt's work at Eighth Street, 1986
PHOTOGRAPH © TINA PAUL

Eighth Street, 1987
PHOTOGRAPH © TINA PAUL

The simple, single-breasted coat in dark red wool that dramatically swept the ground hit him beautifully. Originally two thousand dollars, the couture coat's price tag was a hundred dollars when it hit my bargain basement. Still, that was too much for Richard, who calls passing on the coat "the greatest regret of my life."

A hundred bucks was a lot of money back then for Richard and other kids just like him. They crossed states, bridges, tunnels, and whatever to cram themselves into dilapidated apartments with cheap rent and work minimum wage jobs in order to live creatively and crazily. These masses yearning to

Richard
PAT'S COLLECTION

be free with cool clothes knew they could come to Pat's and find something in their budget. There were undershirts with the Bundeswehr eagle. Madonna wore one of the white crew-neck tanks with the German army logo in a series of iconic Richard Corman Polaroids taken in the East Village in 1983. I carried cotton long underwear I bought in bulk for nothing. Originally army green, I took them to get dyed in black at a place in Queens that charged by the pound. Pairing the long underwear I sold for $9.99 with the Bundeswehr tank, you could conceivably walk out with an outfit for less than twenty dollars.

For me, fashion has always been the expression of my values and views on how to exist in the world. The scene at Eighth Street was lush and young. Whether working behind the counter, designing clothes for the store, or shopping there, everyone was trying to invent trends and impress each other with them. The whole ethos, which I approved of, was individuality. It was a place where you could express yourself and be who you wanted to be. It was not the norm, and we were appreciated for it. Age, gender, identity did not matter. Only how you pulled it off.

The point was to look good but not to look like anyone else. There was no danger of that when it came to the people I hired to work in the store. JoJo Americo, a Patricia Field original, was your classic extreme dresser. A Yonkers native, he started making earrings in high school and sold them at a club in Mount Vernon called the Left Bank. After years combing items in the *East Village Eye* and *Village Voice* and looking at Patrick McMullan's party pictures on the back page of *Interview* magazine, he arrived at my shop with his little portfolio of earrings. Like nothing I had ever seen before, the earrings were hand-painted fabric interwoven with rubber tubing from

Canal Rubber. JoJo was shocked when I ordered a bunch. He sold jewelry to the store for the next several years until he moved to the city after graduating from Pratt. One thing led to another, and soon he joined our circus.

JoJo
PAT'S COLLECTION

JoJo would get a look and go to town on it. During a period where he was into his legs, he couldn't go to work without gold leggings layered under a pair of little Daisy Dukes (because he needed pockets) and a baby tee that showed some skin. On the bottom, he wore heavy boots, and on the top, something he called his Ronnie Spector wig: a French twist with a teased top and two flips at the sideburns. Like a cherry on a sundae, a pair of sunglasses perched at the top of his bangs. Daytime, nighttime, JoJo was wearing that look, or a variation of it, because if there was one rule in this world, it was that you didn't wear the same thing twice.

Even if he'd been wearing a Brooks Brothers suit, JoJo would have stood out. He's just one of those people. That's why he fit in on Eighth Street alongside Codie Ravioli, a Cyndi Lauper impersonator working in Vegas, who used to come to the store biannually. All the girls, drag queens from across the US, would come through the store to stock up on their stuff: new gowns, new shoes, new wigs. I developed a relationship with Codie after she bought a one-of-a-kind, hand-painted Suzan Pitt raincoat. The traditional trench, covered in juxtaposing comic-book panels and bright pop-culture imagery—think Roy Lichtenstein by way of Barbour—was a major purchase for such a picturesque person. Like me, she was a Queens girl. Once upon a time, Codie had been a guy from Ozone Park, who married his high school sweetheart and had three sons. When she came to work for me, Codie was among her own. Like the other gay or trans people in my shop, she could be comfortable just as she was.

Some people called Eighth Street a circus, others a stage. What the kids who worked there called it was "the fag freak store." For these gays, who knew exactly who they were, there was no passing. Whether they wore dresses or not, they were

screamed at or beat up for simply walking around. Forget about getting a job.

People called me Mother of Trannies, because I gave transsexuals and transgender folks jobs back when they were still called trannies and nobody else would employ them. Back then, trans and drag were not separated, and for both groups there were only three options: incarceration and death; find a stage and perform; or find a corner and sell it.

When Connie Girl, who worked in the shop, started to gain success as a model with small downtown designers, she had to hide who she really was when she walked the big European shows. A model of color, she was exotic enough in Paris and Milan. Tracey Africa, the first African American trans model to make it big, had been one of the faces of Clairol in the seventies—until she was outed at a photo shoot and every box of hair dye with her image on it was pulled from the shelves.

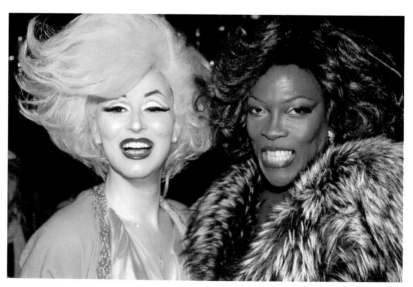

Codie Ravioli and Princess Diandra
PAT'S COLLECTION

Although Patricia Field was a place where trans people were celebrated for their authentic selves, the truth is I was never thinking about their gender journey when I hired them. I found individuals like Amanda Lepore—the winner of the award for most surgically enhanced employee—interesting, entertaining, and creative. Equal parts Jessica Rabbit, Barbie, Jayne Mansfield, and Vargas girl, Amanda was someone you couldn't take your eyes off. (She couldn't take her eyes off herself, either, and would spend most of the day gazing at herself in the mirror in the makeup department.) The way she literally brought art to life through the transformation of her body and application of makeup later attracted the attention of the photographer David LaChapelle, who made her his muse.

My formula for hiring was: if you caught my attention and impressed me in whatever individual way, I would give you a chance. When I saw beauty and talent, I wanted to give it room to grow, regardless of what society thought. My shop, therefore, ended up offering a lot of folks an education. Many shoppers who walked in had never even seen a trans person, and then—wow—there was Amanda gazing at her gravity-defying face in the makeup mirror, or JoJo dressing mannequins in the window wearing a thong and thigh-high boots.

In case anyone got confused, I made it clear that Patricia Field might be a "freak fag store," but it was no freak show where you came to deride those under the tent. No one was permitted to degrade any employee on my turf. If anyone, no matter their money or fame, came into my store and was rude to my children, they had two options: leave on your own, or be thrown out! Those who called out or laughed at one would get read to filth. That included America's prince, John F. Kennedy Jr. He came in with his then-girlfriend Daryl Hannah, who the girls at the shop went gaga over. Drag queens love a good mermaid.

They were making a fuss over the *Splash* star and completely ignoring her boyfriend, which I guess pissed him off, because he looked around and announced, "Bunch of freaks."

If JFK Jr. was looking for attention with his comment, he got his wish. All the queens at the shop were more than ca-

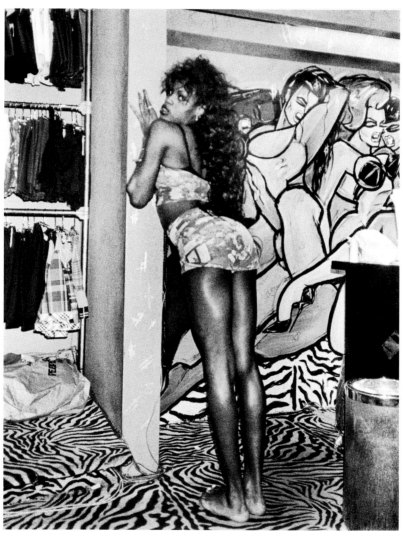

Connie Girl
PHOTOGRAPH © TINA PAUL

pable of dismissing anyone who acted up, but in this case it was Codie who spoke up.

"If you don't like it here," she snarled to JFK Jr., "get the fuck out."

There was no room for misinterpretation. He went to wait outside while his girlfriend got the royal treatment.

Codie might have been the one to read JFK Jr. to filth, but no one could destroy a human quite like Connie Girl. She could be so sweet and docile, but if someone got out of line, she was ready for war. Connie had the striking look of a high-fashion model, with a mystery to her expression that fascinated, like the *Mona Lisa*'s shy smile. Her experience demanding respect as a trans woman of color behind a store counter provided a unique skill set that translated into a successful side career as what she called "a door bitch from hell." JoJo helped Connie get her start when he asked her to be the door girl for a room he was doing at the Limelight. As they say, a star was born. "At a door, if you blink, go apply at McDonald's, because you are done," she'd always say. Connie Girl worked the door for a weekly party at the Supper Club called Poop. "You have to be able to command and say 'No, you and your fifteen friends can't come in.'" Connie became a famous doorperson through the years, currently presiding at the Standard in the meatpacking district.

I loved when my staff at Eighth Street moonlighted at nightclubs or were fêted at them. The shop was all about letting them shine. Anyone who worked at the boutique had to set an example for customers looking for that outfit to make their night magical. The image of my kids wasn't something they took off during the day to be plain. It was who they were. Not a costume. If you didn't have a look, then you didn't belong.

The eighties were the halcyon days of New York City's club scene. Those of us who loved to dance were spoiled for choice,

but there was no place like Studio 54 or the Paradise Garage. Whether we started at Area or the Roxy, we usually ended at the old SoHo garage turned after-hours club, which didn't open its doors until the early hours of the morning, after all the bars were closed. No liquor was served, only drugs. The draw was the music. The Garage had the most talented DJ, Larry Levan, and the best sound system, by Richard Long. It was the temple of house music, where you came to dance. The crowd was diverse, not filled with famous people like Studio 54, but lots of young artists and designers and creatives, anyone who wanted to worship at Larry's altar, including Keith Haring, who designed a famous tank top for the club.

One of those people was Michelle Saunders, who had moved to New York from Paris in the seventies and found herself at the Garage. She became part of a dedicated group of dancers, who every week coordinated low-budget, glitzy disco costumes and dance moves that always had a theme. Michelle, an expert skier and all-around athlete, was already forty when she started occupying the Garage's dance floor with her troupe, but she's like me: Age doesn't address us the same way it does other people. We do as we like.

Keith introduced Michelle to the performer Anthony Malloy, and overnight, she became his manager. Now she needed a new look to go with her new profession. She knew a G-string with a little glitter wasn't professional enough, but she also wasn't about to start wearing suits.

Then one night—or, actually, morning—she met Mitchell, who worked for me, while streaming out of the Garage at noon on a Sunday. They ended up walking to Washington Square Park, where they smoked a joint until Mitchell announced, "Oh, it's one p.m.! I have to go to the shop."

"What shop?" Michelle asked.

"Just come on."

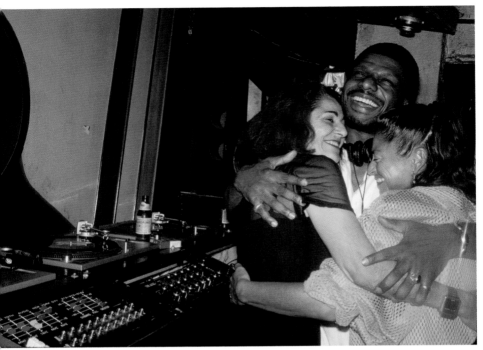

Pat, Larry Levan, and Michelle Saunders at the Paradise Garage

Michelle found a motorcycle outfit that worked for her better in her role as a manager than sequins and feathers—and made a lifelong relationship with the shop and me.

Groundbreaking, fun, and unpredictable: no club like the Garage existed before and none ever will again. I remember taking JoJo for his first time in the winter of 1986. There we were in the middle of the dance floor, the music washing over us, bodies crowded all around heating the cavernous space to a sweaty ninety degrees. Just then Larry Levan mixed a new song, and the industrial fans that ran across the wall opposite the dance floor started to whirl. These gigantic fans opened to the outside world, so as the beat changed the winter air blew

in and snow drifted across the club, more gorgeous than any glitter drop.

"This is the best club ever," said JoJo, twirling around to the house beats.

I should mention I had also given him mushrooms.

If the Garage was a religious experience, Thursdays at Boy Bar were utterly profane.

Boy Bar, a tiny club on St. Marks, had a long narrow hallway that opened onto a room with a pool table and bar. Beyond the pool table was a postage-stamp-size stage where they put on drag number after drag number. In the basement, there was illegal dancing. If the cops came, a red light went on in back of the stage, the door would close, the music would shut off, and everyone would stop dancing and be quiet until the cops left.

But the shows—the funniest, most amazing things you ever saw—were the real draw. The look was a pastiche of the fifties and sixties aesthetic. *Valley of the Dolls*; *Ciao! Manhattan*; *Faster, Pussycat! Kill! Kill!*; every John Waters film; lounge singers from the sixties—these were the references that inspired the girls to cut Nerf balls that turned their bras into torpedoes and helped them become bona fide stars below Fourteenth Street.

In Boy Bar's early days, the pool table was moved to the side to accommodate the audience. As the Boy Bar Beauties—the drag queens who performed at the bar and for the most part worked at my boutique—grew in popularity, it became clear they needed more room. The bigger they got, the bigger their productions. The owner of Boy Bar (and the whole building on St. Marks) was the famous hairdresser Paul McGregor, who invented the shag, which he gave to Jane Fonda, and on whom Warren Beatty said he based his character in the film

Shampoo. He opened up the floor right above the ground floor, so that the Beauties not only got the entire basement for their shows, they also got dressing rooms.

On Thursdays (and holidays, Fridays and Saturdays as well), everyone from the store would meet up at Boy Bar, either as an audience member, getting drunk and having the best time, or as one of the performers in the revues or pageants organized and run with an iron fist by impresario Matthew Kasten. The shows ran the gamut from a new interpretation of Frankenstein, where Connie Girl in the part of the Bride of Frankenstein lip-synced Grace Jones's "I'm Not Perfect," to Perfidia, another Boy Bar Beauty who worked for me, performing the songs of her idol, the Peruvian star Yma Sumac. Codie did lots of Cyndi Lauper in the beginning because that had originally been her thing (until she got her boobs done and stopped doing Lauper).

In the eighties, getting into clubs was a big deal. If you worked at Patricia Field, you got club courtesy, which meant you didn't have to stand in line or pay to get in. Because my kids got carte blanche to a secretive world, the shop became the place you went to find out where the party was that night. In the time before the Internet, when the answering machine was a cutting-edge technological innovation, you had to seek out information in person. Smack in between the East and West Village, we became a hub for all the kids crisscrossing the city. Whether they were heading west to the piers or east to Washington Square Park, Eighth Street was the stop in the middle to spend an hour catching up and making plans. It was a daytime clubhouse, but not everyone was welcome.

The historian Lord Acton's maxim, "absolute power corrupts absolutely," was as true on Eighth Street in the eighties as it was in nineteenth-century England. The shop became

fearsome to enter as those who worked there—emboldened by their pride of nighttime place—graded friend, foe, tourist, or anyone who dared walk the length of the store. Once passing through the door, you were on a stage and would be read to filth if the queens didn't like what you were presenting. No one was immune from catching attitude. Not even Marc Jacobs. Back when the designer was just beginning, he would come into the store and catch hell because his uniform back then—a turtleneck, mom jeans, and ponytail—was deemed too conservative. Shows how much they knew; Marc wound up doing okay for himself.

As much as I wanted my kids to feel the shop was a place for freedom of expression in whatever shape that took, there were limits. I really hated it whenever I learned that an employee had been rude to a customer for no justifiable reason. It wasn't just that intimidation is not good business. I wanted Patricia Field to be a welcoming place to anyone who wanted to be there, whether a hungover queen behind the display case thought they were cool or not.

Even some of the kids who I eventually hired were subject to this hazing. The first time Armen Ra arrived at the shop as a fourteen-year-old (rich) kid from Boston in search of creepers and stud bracelets, it had just started to rain. A queen behind the counter turned around and, after looking Armen up and down, declared, "Whenever it rains, all the rats come in." Too entitled to take that kind of crap, Armen walked right out, and a lot of money walked out with him.

He returned as an employee after I discovered the sixteen-year-old androgynous drag queen in Florent wearing an off-the-shoulder top and super long earrings. He shared my love of classic Hollywood glamour in the vein of Hedy Lamarr and Ava Gardner, an aesthetic he translated into this own immac-

ulate look. With "Makeup Debbie" long gone, I offered him the makeup department after he had started working for me. Armen protested, "I don't know anything about makeup."

"Yours always looks good," I said.

"That's because I'm pretty!"

"You'll figure it out."

He did. Creative types, like Armen, are flexible and unpredictable. That's what makes them great. It's also what makes them hard to control. Add youth and access to attitude and you've got a situation. When a bunch of twenty-two- and twenty-three-year-olds worked in the coolest store in the world, yeah, it got a little messy.

Of all the shenanigans my kids engaged in, the most troublesome was drugs. I did my share of drugs, in the dance bars: a popper or a couple of lines of cocaine. It was just like a dessert, or a treat. But I was no druggie. It wasn't anything regular or a way of life for me. I did nightlife, but then I was in my store in the morning, in my office, paying my bills. I could stay out till 4:00 a.m. and still be at work and functioning at 9:00 a.m. Meanwhile, the kids working in my store, who were a generation younger than me, couldn't get up in the morning. "Why do I have so much energy, and these kids that are so much younger can't come into work on time?" I wondered naïvely. It was because they were getting crumped out of their minds, sometimes showing up for work still fucked up from the night before.

I gave them a lot of slack. When everyone complained about the smell of Armen smoking pot in the store, I relayed it to him directly.

"Pat, I need to smoke pot in the basement," he argued. "How else am I supposed to deal with these random people walking in from Eighth Street?"

He was a gorgeous snob.

"If I let you smoke then I have to let everybody smoke," I said.

"You smoke."

"Cigarettes."

"So?"

I gave him the keys to my office and told him to do it there. I am solution-oriented. Socrates said emotions are thoughts gone wild. I'm aware of the difference. As a result I try not to deal on an emotional level. Smoking pot was not the same as snorting coke and heroin off the counters when I was out of the shop. The staff knew I didn't go in for the hard stuff, mainly because I found that the people who did those drugs lied. At least, they lied to me. One of my employees with a bad habit stole thirteen thousand dollars out of my filing cabinet. Although the person never admitted to it, I knew who it was and why he did it. He needed the money for drugs. I was very fond of him and had given him very big opportunities that he deserved because of his talent, but I don't accept lying and had to let him go.

If I wanted to give a chance to a kid whose dress and attitude inspired me, I did it. That was my name on the door. There are fuck-ups among all kinds of people, and my shop was no different. Some of my kids worked out, and some didn't. I wasn't often wrong.

That doesn't mean there weren't mishaps, like when Armen accidentally set fire to a gorgeous old drugstore on Sixth Avenue that I converted into a second boutique for a bit. He had emptied an ashtray into a wastebasket in the broom closet with a cigarette that he later described as not "as extinguished as it should have been." Returning to the closet later, he was greeted by huge flames when he opened the door. People did

not stop shopping as smoke quickly engulfed the store. (New Yorkers are not easily fazed.) "Get out of here!" a panicked Armen shouted at a customer going through the panty rack.

Armen tried to lift the fire extinguisher, but it was too heavy for little him. Then he tried rolling it, but fire extinguishers, with their handles, don't roll very well.

"Get out of the way," ordered John, the manager, a big, strong guy. He picked up the extinguisher and used it to put out the fire in the closet that melted the brand-new alarm system installed in there, which had cost three thousand dollars.

I was in Miami at the time and received a call from John, who was standing with Armen.

"There was a fire in the trash can," John said. "It did a lot of damage."

"Who was it?" I asked.

"Armen."

"Oh, god," I said. "Tell him not to smoke in the store anymore."

Having set the store on fire, Armen was ready to pack it in. But I don't believe in making more out of things than they are. This wasn't even my first fire. While my twin nephews, then seven years old, were visiting Eighth Street, they were having fun chasing my cat around through the shelves downstairs where it was dark. In an effort to see better, they took my lighter . . . and set the place on fire. Like my nephews, Armen had been careless, not malicious. I would rather not have had a fire in my store, but we survived. And he never did anything like that again. It was just a mistake.

It's not easy for others to understand why I give some people third, fourth, even twelfth chances. Even those in my store family had a hard time with it. Fights would break out between the employees who were interested in selling and be-

ing security and those less so. (One ended in a heavy ashtray being thrown at someone's head and smashing a glass jewelry counter.) Because they didn't work on commission, getting paid whether they served clients or fixed themselves up all day, they squabbled amongst themselves about issues of fairness or who they thought was my favorite.

I was the parental figure to this motley crew. For some of my kids, Patricia Field was a family away from their family. For others, we were their only family. We celebrated Christmas and birthdays up at my loft on the top floor of the shop's build-

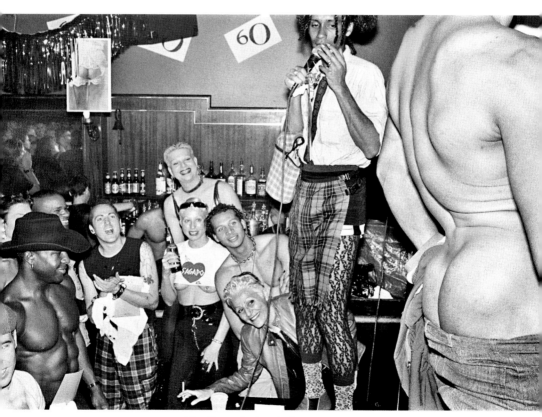

The Booty Ball at Jackie 60
PHOTOGRAPH © TINA PAUL

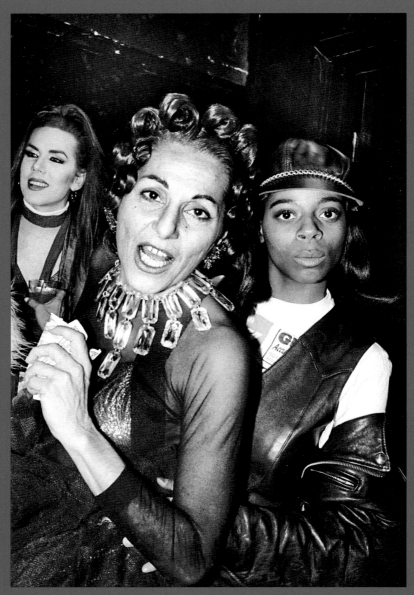

Birthday party at Boy Bar

ing. The staff crawled up there after work. I'd make dinner, put on some music, and it was a party. Cousin Paul, my father's first cousin—certainly gay, although we never discussed it—used to come down from his home in the Bronx to visit and take the drag queens to the ballet. Everyone loved him. He was part of the family.

I tried to teach my children many things, but one of my most important lessons was: if you do something special, people will follow you—and then you can sell it right back to them. Who are you more likely to buy lipstick from, some basic girl or the mesmerizing Ms. Lepore? I offered these castaway kids a chance to sell not just stuff but themselves, and as time passed they did not disappoint.

five

THE WORLD IS MY BAZAAR

WHEN MYRA AND I WALKED UP to the Obermeyer booth at the Las Vegas sporting goods show, we turned more than a few heads. My signature poppy-red hair—a color I think works well with my olive complexion—usually stands out and makes me easily recognizable. Wearing a black catsuit on her five-foot-nine-inch frame, accessorized with knee-high black patent leather boots, Myra *really* stood out from the sporting goods manufacturers and coaches at the show.

You would have never known that Myra was a nice white girl from a traditional upstate Catholic family. I liked her from the moment we first met—at Paradise Garage. She was assertive in a way I appreciated. "I work really hard. I am really smart. And I want to work for you," said Myra, who at the time was in her first year at Barnard. "Come tomorrow at noon," I said. She did and that was that. After her freshman year of college, she decided not to go back.

In Vegas at the sporting goods show, we didn't set out to shock anyone. But to quote Myra, who was often mistaken for a trans person because of her height and heckled alongside her drag queen pals, "It's better to be noticed than ignored."

It was the late eighties, and I was drawn to the Obermeyer booth because of the skiwear's Day-Glo colors of chartreuse and orange. There we met the company founder, Klaus Obermeyer, who looked amused as Myra wiggled a neck gaiter down until it became a miniskirt, then grabbed one of the jackets and, like that, was suddenly wearing an outfit that the kids back on Eighth Street would think was cool. Klaus, a famous optimist who still skied at one hundred years old, went crazy. He loved the transformation of his skiwear to sportswear. So did I; we put the Obermeyer outfit in the window when we returned to New York. The look eventually wound up as a magazine spread after stylists spotted it.

78

The world is my bazaar. If something excites or entertains me (my qualifications for what I want to sell), I don't care where it comes from. I want to present and share it. That's why I'm always open, paying attention, and gathering information wherever I travel. That's how I create my own world. Now we live in a culture of collage, but back then fashion had fixed boundaries. No other Manhattan boutique owner would ever dream of attending the sporting goods trade show for their fashion shop. They limited themselves to fashion-industry trade shows. This gave me an original palette.

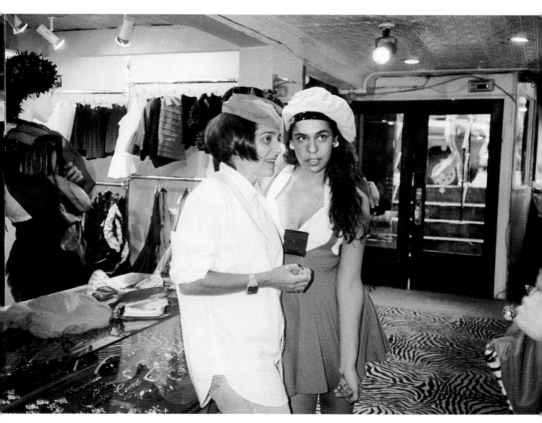

Pat and Myra in the shop
PHOTOGRAPH © TINA PAUL

Expanding my horizons was how I innovated. Like merchants of old returning from long sea voyages to distant lands, we brought many treasures from the deserts of Vegas to the island of Manhattan. We had Rollerblades before the rest of the world was zipping around the city in them. Myra showcased the newfangled skates by hitting the dance floor in them and a tiny pair of sequin hot pants. I call it branding.

When I did the costumes for Disney's production of *Mother Goose Rock 'n' Rhyme*—a made-for-TV movie featuring a cast of comedians, musicians, and actors as nursery rhyme characters—I returned to ski clothes for Ben Vereen. The legendary dancer, singer, and actor played Itsy Bitsy Spider, so I got him a Spyder-brand downhill-racing suit, a black skintight one-piece decorated with a large Day-Glo yellow spiderweb. He loved the audacity of the costume so much that when he put it on he threw his arms up and shouted, "Yeah!"

We made sporting wear trendy by interpreting it with a fashion twist. Color was trendy at the time, but we led the pack by pushing the most powerful visual looks. I stocked long-sleeved racing shirts covered in bright advertisements for motor oil or tires. An even bigger trend for us was scuba for the street. I helped put Body Glove on the map when I carried its neoprene miniskirts and zip-front crop tops, which Paulina Porizkova wore on the cover of *New York* magazine. It didn't take long for what had been a specialized brand to become a staple of eighties fashion, at one point gracing the covers of three major fashion magazines in the same month. Kids were off to the club looking like they were about to explore the shallow reefs off Grand Bahama, even though synthetic rubber isn't the ideal material for a space packed with other hot, sweaty bodies. That's why when I decided to carry motocross boots, I didn't worry that the stiff knee-high boots with thermoplastic and an involved buckle system to protect

riders from breaking their ankles were too uncomfortable for our style-conscious consumers. "Who's going to wear this to go dancing?" Richard said, holding up a hard boot when they first arrived at my shop.

"They'll wear it," I said, and I was right.

Under my fashion label, we were always reinventing sporting wear as club wear and underwear as ready-to-wear. Richard Cruz designed our famous halter bra out of Power Net, a corset fabric, which we hawked as a boob job for eighteen dollars and the "best investment you'll ever make." We sold *a lot* of those. Our official house designer, David Dalrymple, created many collections of sexy separates using the same corset fabric as the base. That was the beginning of corsets as fashion.

As far as trade shows went, however, my favorite, by far, was the Las Vegas Surplus Show, or what I affectionately called "the junk show." It was the ultimate bazaar. From wrought-iron patio furniture to rainbow scrunchies, you never knew what you were going to find, so when you found it, it was a great surprise—at a great price as well. That was where I bought the Tyvek jumpsuits Jean-Michel Basquiat scribbled on. One year I found white high-tops with a red patent leather trim that everyone went nuts for. I paid two bucks apiece for them and sold them for ten. Another year I bought a truckload of puffer jackets (this was before they were a staple of street style) that I sold for twenty dollars. People went crazy for these jackets, and I sold a lot of them, but however many I sold, I still seemed to have more inventory. That truck had been huge. So I dropped the price to ten dollars to entice a whole new crop of customers. The puffers were endless. I dropped the price again to five dollars so that, as Connie Girl put it, "Everyone and their girlfriend's cousin had one."

That was only one of the many ideas I plucked from the gutter and incubated at the shop into a full-blown fashion mo-

ment. As the decade wore on, Patricia Field solidified its reputation as a mad-scientist laboratory cooking up cutting-edge trends.

Out of all the trends that began on Eighth Street (including see-through bags—mine manufactured by a luggage factory in upstate New York in six varieties, including a bowling bag and a backpack), perhaps the most lasting and wide reaching has been leggings. I claim to be the inventor. The style of a lot of pants up to that point in the eighties had been loose and flowy, which has never been my bag. I had a favorite pair of pants by Norma Kamali, whom I love and respect, which were tailored *and* stretchy, almost like a tight ski pant. At three hundred dollars, they had been an investment piece. When I found some shiny Spandex material, I was inspired to make a much more accessible version of my skinny pants that stretched every way. And that was the birth of leggings.

I had them made at a small lingerie factory on Twenty-ninth Street. They were simple, no tailoring, just pull-on stretchy pants. I sold them in my store, and Henri Bendel bought them, too. Shortly after, *Grease* came out. In the movie's final scene, Olivia Newton-John appears in shiny black body-skimming disco pants that were instantly iconic. The timing was perfect for me, because I had *those* pants. They flew out of my shop. They cost me seven dollars and change (including the fabric) to produce. Giving away my secrets, I sold them wholesale for fourteen dollars and in my shop for twenty-eight dollars.

Everybody jumped on these leggings, and soon enough other manufacturers were copying them. We were always being copied. Low-priced retail chains like Strawberry and Rainbow constantly tried to rip off our original in-house looks. I startled Connie Girl—no easy thing to do—once while she checked out two men with about two thousand dollars' worth

of stuff. She had just picked up a fake-fur coat to ring up when I put my hand on hers, returning the item to the counter.

"Get out," I said, staring directly at the two guys.

"What?" one of them said.

"Get out. *Now.*"

"Can we just have . . ."

"No."

"Wait a minute."

"Get out!"

After they left, Connie was incredulous: "They were going to buy thousands of dollars in merchandise!"

"They're Strawberry spies," I said. The men from marketing didn't think I knew who they were, but I recognized them from a trade show at the Javits Center.

It wasn't only mass-market retailers cribbing from us. We also had high-end copycats. We knew we had been the victim of some haute couture espionage when, the season after we did a window featuring short, colorful fake furs, nearly the same exact styles were worn down many a runway.

We were the first to update bullet bras and corsets, a style that became integral to Madonna's look, beginning with a custom bustier with gold-and-black nipple tassels that she wore on her 1987 Who's That Girl world tour and the iconic conical Jean Paul Gaultier bra costume she wore for her Blond Ambition tour three years later. We were doing that look way before, with lingerie sourced from a Hasidic shop on Orchard Street and reinvented for my store. It was a natural offshoot of the undergarments that were must-haves for our trans and drag queen clients—as well as the occasional "Bundy." Those were schlubby white men—à la Al Bundy from the show *Married . . . with Children*—who entered Eighth Street solely to try on corsets. The staff did not appreciate these customers, but they

knew we did not discriminate at my shop. And occasionally a Bundy dropped five hundred bucks on a corset, and then the kids were cool with them. In addition to the Bundys' embrace of the corset, Domenico Dolce and Stefano Gabbana, the designers behind Dolce & Gabbana, produced a ready-to-wear corsetry collection, which I believe was inspired by their many visits to my shop.

There's not much one can do about stealing in fashion. You cannot copyright a design, which makes legal action practically impossible. Ask Diane von Furstenberg, who is always trying to sue someone for copying her famous wrap dress, to very little effect. Artists get inspiration from other artists; that's the name of the game. First they make fun of it. Then they copy it. As long as my ideas are in the world and appreciated, I'm happy.

I was far from the only one whose talents made Eighth Street's star rise by the end of the eighties. Armen—who, as the assistant jewelry buyer for the shop, did a lot of its displays—could take a piece of plastic and make it look like Cartier. The women's-wear buyer Robbie introduced the stripper look with sheer crop tops, wet-look wear, and fishnet dresses. Although exotic dancers came from across the country to shop at my boutique (when she was still a stripper, Cardi B shopped with us, paying for her purchases from a huge stack of singles), the look appealed to a much larger audience. The stripper shoes, with a long skinny clear heel and slot in the platform to house dollar bills, were a longtime hit for us.

From drag queens to strippers to socialites to celebrities, you never knew who was going to be at Patricia Field. The famous people who came to the store were as eclectic as the stuff we sold. Ronnie Spector was a regular. The former front-woman for the Ronettes, one of the most popular girl groups of the early sixties, always bought silver-white eye shadow and

ruby-red lipstick. Armen always made sure he had a dozen of each held together with a rubber band and a piece of paper that read, "Ronnie Spector ONLY." One time, though, the Spanish Harlem native also bought a floppy fedora-style hat by Ray Hans from Paul, one of my longtime employees who, with JoJo, did our legendary windows. And then she expected the hat to be there every time she came, too.

"Do you have this hat?" she asked Paul.

"No, I'm sorry, we don't have that anymore," he said. "These are the hats we have now."

During her next visit to the store, it was the same thing: "Do you have this hat?"

At least we had the makeup. All kinds of fierce, she spent hours shopping while her second husband (her first, the record producer Phil Spector, had famously kept her prisoner in their Beverly Hills mansion, where he housed a glass-topped gold coffin as a reminder of his threat that he'd kill her if she left) patiently waited in the white Lexus until she was finished. Then he came into the store to pay and bring the bags out to the car.

As the shop's notoriety grew, performers and other kinds of celebrities, who make their living in part by cultivating an interesting look, flocked to us for the same reason NYC club kids did: we had unique items you wouldn't find anywhere else.

Supermodel Paulina Porizkova and her husband, the Cars front man Ric Ocasek, would come in every weekend to my second store, on West Broadway. Tina Louise, aka Ginger from *Gilligan's Island*, was also a regular customer. Tracee Ellis Ross liked to browse when she was a student at nearby NYU. Sigourney Weaver got her face painted by Armen for Halloween the year she went as David Bowie. Lady Gaga, Miley Cyrus, Missy Elliott: they were usually no different than any other of our clients, who, when going out, said, "I've got to stop at Pat's." And we treated them as such.

Once a customer with a thick Queens accent asked a staff person if she could try on a pair of Japanese shoes we had recently got into the store. "They're really expensive," the salesperson said with his back to the client. "But if you really want to try them on, I'll go get them."

"I can afford them," said the shopper, who turned out to be Cyndi Lauper.

Sometimes stars would have their handlers call with ridiculous requests, like closing down the store while they shopped. I might have considered opening early or staying late, but my staff enjoyed nothing more than putting a celebrity assistant in their place by telling them their boss would "shop with everybody else." Codie Ravioli loved to recount the story of how she made Madonna, who had arrived at the store at 10:00 a.m., wait outside for an hour because we opened at 11:00 a.m.

Perhaps because we didn't discriminate—whether you were gay or straight, famous or not—Patricia Field was a place celebrities could let their hair down. In his gorgeous heyday, Matt Dillon came in one day to shop for denim. I wasn't there, but apparently, he tried on jeans with no underwear so that everybody—or at least everybody who was looking, which *was* everybody—saw his bush on full display. Whether the actor did that in every store or had heard the rumors that the dressing room in Eighth Street was a free-for-all where many a straight guy was blown, I'll never know.

My kids took pride in helping people (they liked) find *the* thing that would help them express themselves. Lenny Kravitz used to come in whenever he had a break from touring and pick up a pair of these big sunglasses that were a reproduction of German motorcycle goggles from the thirties. They were quite bold and funky—and Lenny loved them. He returned over and over, buying them in every color. At one point he brought in

his mother, Roxie Roker, who played Helen Willis on the long-running seventies and eighties sitcom *The Jeffersons*.

They were having a mother-son day, and he wanted to show her his favorite store—and his favorite sunglasses. Paul, who usually worked with Lenny, showed them what we had. She didn't care for the goggles, but Paul found her a pair she loved, big white square-framed ones. Lenny bought them for her.

The next time Lenny came into the store, his mother, who had been ill with cancer, had passed away. When Paul expressed his condolences, Lenny said, "She wore those sunglasses that you picked out for her in the hospital. She felt like they made her glamorous. They were her favorite thing before she died." That type of comment is what makes all the hard work worth it.

If I see someone has talent—like Paul's styling, JoJo's windows, or Armen's jewelry displays—I point out their ability to the person, because they might not recognize it themselves. Conversely, I tell them when they aren't contributing. That was the case when Perfidia was spinning his wheels in the T-shirt area. I had no idea, however, that when I moved him to the makeup counter he would turn it into one of our biggest departments.

We always stocked some wigs, but they weren't big sellers for us—that is, until I discovered Perfidia was a triple threat in styling, customer service, and merchandising. People tend to dismiss merchandising, but it can make or break a shopping experience. Done well, it elevates the customer's mood. But browsing in a messy shop gives you the same uneasy feeling as visiting a messy home. Perfidia made the makeup and wig area look like a million bucks. He began custom dyeing the wigs in bright colors and styling them so that they were one of a kind.

The original inspiration for the salon's style came directly from drag culture, which wasn't a monolith. Drag queens

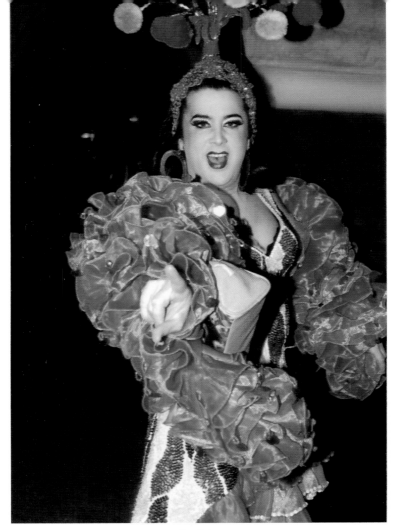

Perfidia

weren't always trying to look like women. Pyramid, for example, featured punky, hairy-armpit drag queens. Boy Bar, however, was all about over-the-top sixties looks, à la the 1968 documentary *The Queen.* These were the biggest, brightest hairdos you ever saw, and they all hinged on teasing. I sent Perfidia—who could look at a catalog of beige cancer wigs and find the fine print that read, "also in cherry red"—to beauty

school in Times Square, where he honed his teasing skills. All he had was drag queen training and I wanted him to diversify.

If I recognize talent, I not only say something; I also take action to foster it. That could be buying paintings by my artist friends or sending a budding hairstylist to beauty school. The wig section continued to grow and grow, so I decided to create a salon. We opened a salon on Eighth Street after I was able to rent the space above the store. The huge windows, dating back to the early 1900s, faced out onto a beautiful courtyard with a big garden. There's no better place to do color than in natural light.

Wig World brought in everyone from club kids to Park Avenue ladies. RuPaul—who brought the art of drag into American homes with her multiple Emmy Award–winning reality show *RuPaul's Drag Race*—didn't have two pennies to rub together, according to Perfidia, when she first started frequenting the salon. Four years before exploding onto the scene with her hit song "Supermodel (You Better Work)," she got her first big exposure in the B-52s' music video of "Love Shack," wearing a giant Afro Perfidia had styled. Cindy Wilson, a singer in the band, was also a client at the salon. The band's name, B-52, was slang from their hometown of Athens, Georgia, for the beehive bouffant that Cindy and the other female singer, Kate Pierson, often wore as part of the group's retro look.

"Experience nightlife. Wear our costumes. Wear our wigs," read the flyers publicizing the salon. I hired Tina Paul, famous for her photographs of New York nightlife in the eighties, to create advertisements that combined her images of our crew in my fashions for a subversive but commercial message. Before the Internet and social media, physical flyers and ads published in downtown magazines like the *East Village Eye* were still important for picking up the metronome of cool.

Our celebrity customers ranged from Naomi Campbell to Ivana Trump to Carol Channing. Howard Stern was a regular of the hairdresser Danna Davis who, according to Danna, had a crush on her. Danna, a striking blond trans woman, used to boast that although her hometown of Jackson, New Jersey, was also home to Great Adventure, "I was the great adventure in Jackson . . . until they kicked me out."

The reimagined sixties girl-group look birthed at the store eventually made its way to middle America. The campy style of Deee-Lite's Lady Miss Kier (another one who frequented Wig World), with platforms, Pucci-esque dresses, and flip wigs, was mainstream enough to inspire a how-to segment on *Oprah* with Perfidia, who would eventually go on to become a legendary wig artist for Broadway.

Eighth Street had become a global destination for freaky fashion. People came from all over the country and abroad to see what tricks we had up our neoprene sleeves. Despite the success of Patricia Field, we never stopped being weird. That was the not-so-quiet secret to our success.

Case in point: when Perfidia, flipping through a wig catalog, happened upon a page of merkins, he immediately ordered a bunch. In case you don't know what a merkin is, it's a wig for the pubic area.

"They're so cute," cooed JoJo, who decided to pair the pubic wigs with low-rise pants and sexy bras on mannequins for a window display where the fake tufts of hair peeked out from over the top of the pants. It was just ridiculous, harmless fun. But people weren't having it. "You can't put that in the window!" the president of the block association or PTA of a nearby school complained. "What about the children?"

We paid attention to nobody; the merkin display stayed.

I was first introduced to the ballroom scene in the seventies by a Singaporean trans client, who invited me to a ball up in Harlem that she was walking in. "Come late," she purred. "It won't start until four a.m." The performances actually didn't start until 6:00 a.m., but I didn't care. I loved the mix of style and theatrics, humor and antagonism, attitude and camaraderie that I witnessed—a disco-era evolution of an underground tradition that began uptown in the nineteenth century and continued through the Harlem Renaissance. By the sixties, however, performers of color, marginalized by their white counterparts, created their own, new and vibrant scene.

Although my client was the first to invite me to a ball, Myra was how the shop entered into the culture. Like Myra, contemporary ballroom culture was very competitive. There were different houses, close-knit groups who competed under the same name, battling for trophies in different categories. One of those categories that later became popularized was voguing. The series of poses, emulating postures and attitudes from fashion magazines such as *Vogue*, is a dance of self-admiration and style.

Ball queens from various houses came together on common ground in the Crystal Room at the Paradise Garage. There, the best of the best struck the fiercest poses and sometimes one another when tempers erupted. Civilians dared not walk into the Crystal Room. Except for Myra. Those queens *read* that white girl who let herself into their clubhouse. Instead of running out of there crying, she was hooked. Their harsh reading only made her stronger.

The balls were beyond mere entertainment; they were a special place, offering an outlet for expression to oppressed minorities. In the eighties, before trans people had any home in mainstream culture, places like Escuelita, Boy Bar, and Sally's Hideaway were much more than fun venues to dance or

watch a drag show. If you wanted to go for a hormone replacement, you couldn't just walk into a doctor's office and ask for it. You had to know where to go, when to walk in, and who the right person to speak to was. When AIDS was still a nameless epidemic, word spread about the mysterious threat in gay bars and discos. In the pre-Internet era, these were spots for community meetings. As Connie Girl put it, "We weren't just partying, but sharing information about the world that was crumbling around us."

My first experience with AIDS was with Little Michael, the store owner who had opened my world by inviting me to Studio 54 and Paris.

"Pat, I have the gay disease," he told me.

"What's a gay disease?" I said.

"I'm going to die."

Sure enough, a year later, he was dead. He was only in his twenties, and the disease didn't even have a name. AIDS quickly began to claim all kinds of people, from acquaintances to good friends.

One of the most devastating losses to me was that of Halston. Having met him at Studio 54, I occasionally hung out at his home, on Sixty-third Street right off Park Avenue. The modern steel-and-glass town house had a garage that opened right onto the street, but he didn't use it for cars. As with a lot of people, his garage had become a catchall—except the stuff I saw in that garage wasn't the typical jumble of bicycles, old lamps, Christmas decorations, and power tools. His held treasures like couture dresses and works of fine art, including more than a few Andy Warhols lying around. Halston must have seen my amazement at what was in his "garage," because he joked, "Get that. Andy left this here. He leaves his shit everywhere. I think it's because he's such a cheapskate he doesn't want to pay for a storage space." The truth was, Andy left his

stuff at his house because Halston was a really generous person. He was kind and positive but also humorous enough to make fun of his famous pop artist friend's thriftiness.

In the mid to late eighties, the AIDS epidemic was rolling hard and taking people by the day. I knew a lot of people who died. My store manager Tim Bailey. The wizard DJ Larry Levan. As HIV and AIDS ravaged the community, New York's underground ballroom scene reached the height of its popularity. The houses were surrogate families that provided shelter from a cruel world. The balls offered Black and brown LGBTQ youth a glamorous break from the everyday struggles of homophobia, transphobia, disease, racism, and poverty. At night, they were walking for trophies and bragging rights uptown. During the day, many came downtown to the store.

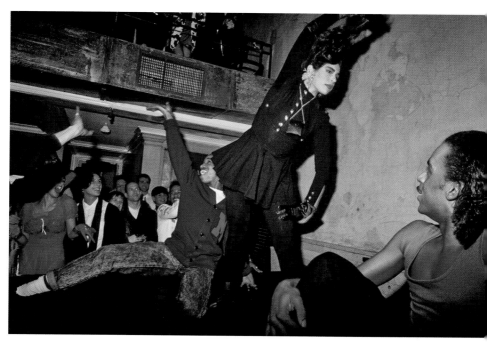

Myra voguing with Willi Ninja
PHOTOGRAPH © TINA PAUL

When they were supposed to be on the sales floor, I would often find the staff voguing their butts off in the big mirror we had in the back. Myra—who learned the moves from the grandfather of vogue, Willi Ninja, a "butch queen" and mother of the House of Ninja who wore a skirt with his suit jacket and Doc Martens—decided we needed to compete in the balls.

Princess Myra, as she became known, named us the House of Field, and I was the father. Each house had a mother or father, older members of the family or leader types who took on the role of parent in terms of support, advice, and discipline. Even before the whole ballroom thing, some of the kids in the store took the last name of Field—not legally but figuratively. They were more proud to carry my name than those of the families who had rejected them.

This was normal in drag culture, where there are drag mothers and daughters, but it was completely foreign to mainstream culture. So when Perfidia called me his "mother" in an interview for a big publication's Sunday insert, it went completely over the head of the reporter, who wrote that I was literally his mother. A week later, the legendary nightlife columnist Michael Musto picked up and made fun of the straight magazine getting mixed up. But the idea that I had a grown gay son went on forever.

I was the father of the House of Field, not the mother, anyway. (Tim Bailey, who designed my House of Field line before his death from AIDS, was the mother.) I used to joke that I was more dad than mom because I paid for everything. I did love when they called me on Father's Day.

While I might have financed the house, "my children" provided for me, too. They made my life fun and interesting, bringing me to exciting places like the Imperial Elks Lodge on 129th Street, where a couple of hundred people in the audience screamed and pounded on the floor as participants took

to the stage to compete in categories like Leather vs. Suede or Models Effect. Talk about exhilarating.

As the only white family in ballroom culture at the time, the other, all-Black or Latino houses referred to us as the "punk rockers." Willi Ninja was the first ally of the House of Field, which was no small feat in such a competitive environment. Shady queen activities, such as snatching wigs off people's heads, did happen from time to time. But many balls and many fights later, we begrudgingly gained respect.

Willi Ninja voguing for House of Field
PHOTOGRAPH © TINA PAUL

House of Field snatched its share of trophies. Myra won a lot when she walked in the beauty categories (there was no voguing for females). In Body, the judges were looking for structure and definition. After Myra lost some weight, Danni Xtravaganza (a founding member of House of Xtravaganza, the first Latino house in Harlem) exclaimed, "Oh, Miss Myra girl,

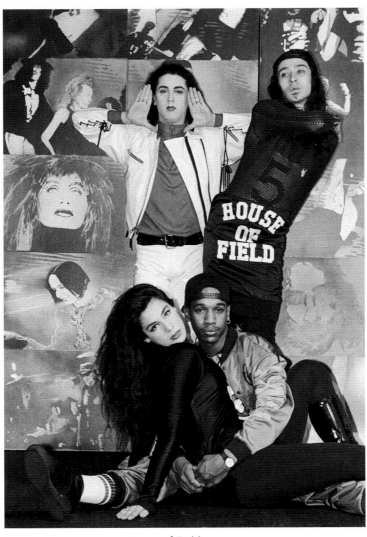

House of Field voguers
PHOTOGRAPH © TINA PAUL

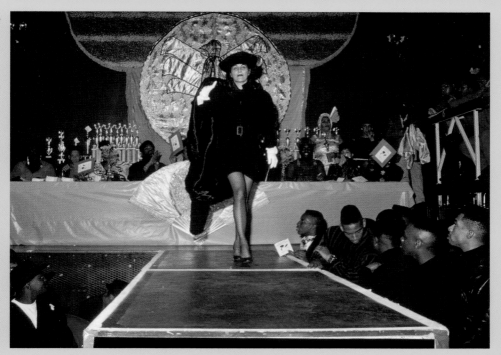

Pat walking for "Best-Dressed Gay Woman"
PHOTOGRAPH © TINA PAUL

At Paris Dupree's ball at Trax
PHOTOGRAPH © TINA PAUL

the party is coming together!" For the Face category—where competitors had to push their hair back to show off their bone structure and wipe their face with a cloth to see if they were just as pretty without makeup—Myra had a leg up because her hair was real. Her winning move was to hold her hair stretched up high to the ceiling as she walked up to the judges' panel in a big snap to everybody else's weaves.

A lot of houses mimicked conventional beauty. It made sense in a world where how well a trans person passed could be the difference between getting beat up or simply walking down the street. In a time before *RuPaul's Drag Race*, when the idea of a TV show glorifying femme queens was unfathomable, impeccable makeup meant survival.

The House of Field, however, wasn't going for conventional beauty. We were the freaks on Eighth Street and in Harlem ballrooms. We had fake lashes for days, plastic see-through clothes. If we went for glamour, it was over the top and with a twist. Think Jessica Rabbit meets Iggy Pop. In a competition where Connie Girl walked for Fashion, she wore a La Coppia minidress and big picture hat. Both the hat and dress were trimmed in ostrich feathers. Connie stole a couple of plumes and turned them into ostrich eyelashes. Needless to say, she snatched the trophy.

House of Field was the Fashion house with the fiercest Fashion performers, and although the community continued to throw shade at us, eventually we brought fashion to the ballroom and were appreciated for it. I later introduced ballroom culture and families to the New York fashion industry by inviting big names in the business to judge the Grand Street Ball, which we hosted in September 1988. I enlisted *Vogue's* André Leon Talley as well as various designers and personalities, such as Giorgio di Sant' Angelo, Malcolm McLaren, Mary McFadden, and Betsey Johnson. We called it "A Ball to

With André Leon Talley at House of Xtravaganza ball
PHOTOGRAPH © TINA PAUL

Remember," but people remember it as the Grand Street Ball because we held it at a large hall on Grand Street.

Myra, who emceed the fashion industry's first experience with style as competition, introduced voguing first, explaining what it was to newcomers in attendance like Debbie Harry and Lauren Hutton. In addition to traditional categories (like Banjee Realness for the contestant with the best macho street look), she created eight new ones. There was Search for the New Designer; Face with a Distinction (it had to have a flaw); Saloon Whore (twenty of Betsey Johnson's kids came out as the ultimate saloon whore, with bustiers and boas); and Garage Dance. The event went on forever. I think it was six hours long.

Whatever Myra did she did to the hilt. And if things didn't go her way, she'd let you know it. No matter who you were. At

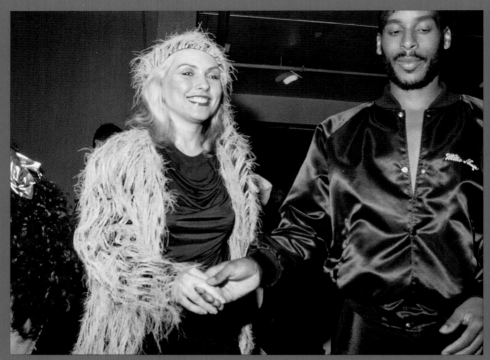

Debbie Harry and Willi Ninja at the ball
PHOTOGRAPH © TINA PAUL

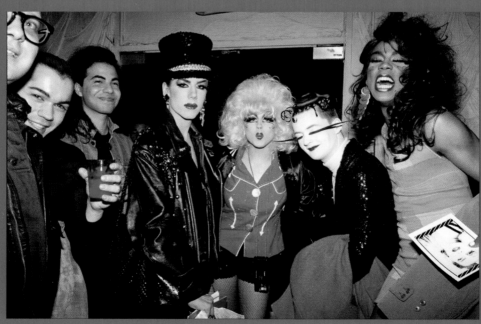

Johnny Lewis, Martine, Miss Guy, Lauren Pine, and RuPaul at the ball
PHOTOGRAPH © TINA PAUL

our ball, Susanne Bartsch, by then considered club royalty, got an angry earful from our emcee when her kids stood in front of the stage. Susanne, who had turned her focus from being a boutique owner to an event planner, threw weekly parties at the club below the Chelsea Hotel, where she had an apartment, and monthly ones at the Copacabana. Cultivating a crowd that mixed uptown and downtown, gay, straight, and everything in between, wild and Wall Street, she hosted what the *New York Times* labeled as "orgiastic parties."

I liked Susanne and invited her to the ball. I also told her to get a table, but she said she didn't need it. That's how she

PHOTOGRAPH © TINA PAUL

found herself being read to filth by Myra, not something the Swiss-born nightlife impresario was at all accustomed to.

"Susanne, get your kids out of here!" Myra yelled at her over the mic. "We're getting notes that nobody can see because your kids are blocking the stage."

Even I was shocked, but Myra was always very much a dominant presence, whether Rollerblading down Eighth Street, running a ball on the Lower East Side, or being an emergency room doctor—which is what she eventually became after returning upstate a year later, marrying a fellow med student, having a few kids, and leaving behind her unconventional past.

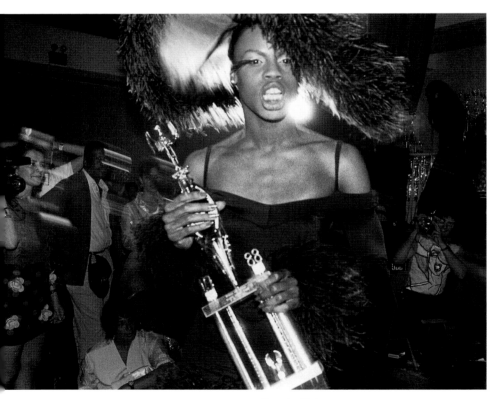

Connie Girl
PHOTOGRAPH © TINA PAUL

The kerfuffle with Susanne aside, the Grand Street Ball was a success. The competitions were fierce. Supermodel Veronica Webb battled for Face against Lysa Cooper, one of Keith Haring's darlings. In the Male Visual, Marc Jacobs walked against Harlem kids. Having just arrived from some other event, the designer was wearing a tuxedo. When he took to the stage, he left his tuxedo shirt and jacket on but took off everything else except his underwear. André Leon Talley didn't understand what he was doing, but Marc said it was one of the most freeing moments in his life.

Connie Girl was awarded Best Runway from the judges, one of whom was the fashion photographer Steven Meisel. Six months after he saw her walk at our ball, he shot her for Azzedine Alaïa's book.

Our ball helped push the underground culture into the open. Less than a year later, Susanne adopted the form when she started the Love Ball. Myra called it "a blatant rip-off," but Susanne turned the ball into an annual event that raised a lot of money for and awareness of AIDS. Anyway, what really took voguing mainstream was that Madonna's brother had attended A Ball to Remember and reported back to his sister. Not too long after, Madonna's people called the store looking for voguers, and the rest is history. The nineties were ushered in with the release of her hit pop song named after the dance, and everyone hopped on the bandwagon. I appreciated the talent that came out of the houses and thought their performances were beautiful. But true to form, my creative eye was already roving, and I was moving on to the next thing.

six

MINIMALIST
MEET
MAXIMALIST

'**M GENERALLY OPPOSED TO USING** labels, especially when it comes to people, but my girlfriend Barbara Dente was an undeniable *minimalist*. She was a minimalist before that was even a thing, and honestly helped to craft the aesthetic. A talented and successful stylist, she was the ultimate snob. Zoran was her uniform. The designer's clothes were completely free of adornment so as not to take anything away from the extravagantly luxurious fabrics he used. I'm talking not even a button or zipper. Expensive, unstructured, and pared down to the seams, Zoran's designs were described by the fashion critic Cathy Horyn as "Gap for the rich." When Barbara styled the Gap's campaigns, she elevated the mass-market clothes to the level of her favorite designer, who ironically refused to do any advertising himself.

Barbara brought that same exquisite taste and merciless attention to detail that made her the number-one stylist in New York—before the job of stylist even had a name—to all aspects of her life. She loved living fancy in her ultrachic apartment at 1 Fifth Avenue, where every piece of furniture, picture, and ashtray was deeply considered. She transformed her next apartment—a two-bedroom duplex penthouse in a prestigious prewar building on West Twelfth Street—into a minimalist one-bedroom marble palace, which inspired and was used for photo shoots by designers of the nineties austere look like Jil Sander and Calvin Klein. (Barbara put the apartment she bought for less than a million in 1987 on the market nearly two decades later for $7.5 million, breaking the record for the price of a one-bedroom. When the *New York Times* reported on the listing, Barbara justified the price by saying, "It's like buying a piece of art.") Barbara treated all her apartments like museum pieces, including hers at 1 Fifth Avenue, right around the corner from my shop on Eighth Street. There was nothing she didn't think needed elevating, and that included me.

We first met in the early eighties at the store, which she popped into regularly. Barbara was striking, with olive skin, big brown eyes, strong cheekbones, and a high forehead she accentuated by wearing her dark hair pulled back. Sophisticated, on the edge of severe, Barbara was a pioneer of the

With Barbara at *Paper* magazine editor Kim Hastreiter's loft party
PHOTOGRAPH © TINA PAUL

restrained look Calvin Klein made popular almost a decade later. She didn't smile much, either. I was intrigued.

One day when she came into Eighth Street, we decided to go out, and the next thing we were in a relationship that lasted almost a decade. At first I was surprised she was attracted to me. I am, after all, a maximalist. But as I said, she had good taste: she chose me.

Also surprised at our pairing were Barbara's friends, who included the Dutch renegade hairstylist Christiaan Houtenbos, his wife, Marianne, and their two sons. Known for making hair move in a way it hadn't since the advent of hairspray, the Holland native and youngest of twelve turned the lessons he learned cutting hair in his father's barbershop into gold when, at twenty years old, he arrived on the shores of the new world in a really tight two-button suit just like the Beatles wore. In New York City, he landed at Coiffures Americana, Bergdorf Goodman's famed salon, before becoming an editorial and celebrity darling. Christiaan not only logged twenty or so *Vogue* covers, but he also gave Grace Jones her famous flattop, Debbie Harry her choppy bob (which she started herself and he fixed), and Nancy Kissinger a softer side. He was a peripatetic guy who moved easily between very different worlds, so we hit it off instantly.

That was no small thing, since before Barbara and I became a couple, her partner was Steve, a tall, lanky photographer who happened to be Christiaan's best friend. It was Barbara, Steve, Christiaan, and Marianne. Then, all of a sudden, Steve was out and I was in. At first they were flabbergasted, since it came out of the blue, but they adapted. Instead of an aunt and uncle, their great kids now had two aunts.

At their house in Water Mill or their large, airy apartment near Carnegie Hall, we were hustling ideas for the world. We were all super opinionated and super into fashion—although

Barbara, Christiaan, and Marianne came from a whole different style universe. Marianne's first job after leaving the Netherlands and arriving in New York was at *Harper's Bazaar*. She was the assistant to Barbara Slifka, a fashion editor whose history at the glossy magazine went back to the days of Diana Vreeland. She had been the legendary fashion editor's assistant when, in 1947, Vreeland decided to include a bikini in the magazine for the first time. When some balked at showing so much skin, Slifka told the *New York Times*, her boss scoffed at their objections, saying, "With an attitude like that, you keep civilization back [a] thousand years."

At the *Harper's Bazaar* offices, Marianne sat opposite Barbara, who at the time was the assistant to another legend: China Machado, who had fled the Japanese occupation of her native Shanghai as a child in 1946, eventually landing in Paris, where she palled around with the likes of François Truffaut and started modeling for Givenchy, Balenciaga, and Oleg Cassini. Vreeland took note and put the great beauty before Richard Avedon's camera. Machado became the renowned photographer's muse and the first nonwhite model on the cover of *Harper's Bazaar*. Machado had been ensconced as an editor for years by the time Barbara arrived.

Barbara's close friendship with Marianne lasted long after both had left the magazine. They were part of a nest of undervalued fashion folks on the cusp of breaking out to become successful in their various niches. Christiaan and Marianne lived in the Wyoming, a grand prewar building on the corner of Seventh Avenue and Fifty-fifth. Although it was just two blocks from Carnegie Hall, the neighborhood was considered marginal. Proper folks turned up their noses at any address west of Sixth Avenue. So naturally all the cool people moved into the spectacularly big, run-down, rent-controlled apartments, which were perfect for parties.

Patrick Demarchelier and Debbie Harry lived within a three-block radius. It was nothing to find Giorgio di Sant' Angelo and Calvin Klein in one of those incredible apartments, sitting on the floor on one of those endless nights, exchanging ideas—some of which came true. I feed off other people's creativity, and this new group of inventive tastemakers energized and enchanted me.

Barbara and I were so different from each other, which was an essential part of our chemistry. Her happy place was the Zoran showroom; mine was the junk show in Las Vegas. I was always whipping up Greek food for her friends and mine. Meanwhile, Barbara didn't even know what an egg looked like on the inside. And yet we were both tastemakers, albeit of different sorts, challenging one another's perspective.

Opposites attract, but they don't always want to live together. Barbara and I always maintained separate apartments. Other than my dog, Sheba, a white French poodle she used to feed foie gras and caviar, she didn't care much for my lifestyle. My friends were too street for Barbara. She never enjoyed the kids from the shop or anyone else I hung out with. The one exception was the Grand Street Ball, where I was surprised to find her clowning around and letting loose in a way I had never before seen. Although she did stick to her minimalist aesthetic, characteristically understated in a black knit turtleneck, small stud earrings as her only accessory, hair pulled back, and subdued makeup. Me? I wore a bright purple gown with matching purple elbow-length gloves, oversized drop earrings, and my hair in a glamour-puss updo. It was a ball, after all.

I go high and low, not just in fashion but in all things. While Barbara might not have been interested in doing shots with JoJo or Armen, I was more than happy to embrace her haute couture gang, which included the likes of famed photographers Bruce Weber, Steven Meisel, and Arthur Elgort.

It was through this whole new social scene that I got my first job as a costume designer. The 1987 film *Lady Beware* was loosely based on something that happened to Candy Pratts Price, the fashion director of *Harper's Bazaar*, who was part of the Carnegie Hall gang living on Fifty-seventh Street. I love Candy, a positive and colorful person who remains a good friend today. She would spend Christmases at my loft, where I always hosted my Patricia Field family.

Before joining *Harper's Bazaar*, Candy had been a window designer, back when store windows were dramatic and interesting. She got her start at Charles Jourdan after a pair of yellow high heels she spotted in the window inspired her to ask for a job. It was no small thing for the French luxury shoe brand, which usually only hired French employees, to take a chance on a spunky little Puerto Rican from Washington Heights. After selling shoes for a while, she became the store's window designer, which she turned into an art form. (She literally borrowed art from the Museum of Modern Art for her installations.) In the late seventies, Candy was poached by Bloomingdale's, where, as display director, she had 150 staff members and an on-site team of union carpenters. Crowds lined up along Lexington Avenue every Wednesday and Thursday evening to see the unveiling of the best show in town, which could be anything from a taxidermy leopard pawing leather accessories to mannequins in diaphanous dresses, beneath a flock of white doves, inexplicably walking down a set of lonely train tracks. Apparently, people were interested in more than just the windows, because as it turned out Candy had a stalker, who watched her as she worked on the displays into the wee hours of the morning.

After Candy left window dressing to join *Harper's Bazaar*, Universal Pictures approached her with a movie about a window dresser in Pittsburgh, played by Diane Lane, who takes

a lot of baths by candlelight, cooks up ideas for sexually pro-vocative window displays, and winds up being stalked by a psychopath. Candy understandably didn't want to participate, but she did offer the producers a tip. She suggested they hire me to do the costumes, because, she explained, I would understand not only the fashion but also the culture that creates the windows.

The call for *Lady Beware* came out of the blue. I had never considered costume design before. When I was in my shop I styled all day long—merchandise displays, customers. In 1984, the first year of the MTV Video Music Awards, musicians came to the shop in droves, wanting us to make them look cool. They'd pull up in their limos and jump out, Molly and I would throw them in pimp coats from London and something we called sluggies, tight pants made out of some material that definitely ruined the environment, and back in the limo they'd go.

We dressed plenty of performers. Stylists would come in to outfit the backup dancers for the Video Music Awards and other big shows because we had the merchandise they needed to look wild and original. Lisa Lisa was a customer who brought the flash. Born and raised in Hell's Kitchen, the youngest of ten kids, she was working at Benetton—the height of mass fashion at the moment—when Lisa Lisa and Cult Jam was founded. She didn't need any help popping a collar on an iridescent oversized floral-patterned blazer or accessorizing the look with a chunky charm bracelet with large golden coins. Born with that New York girl attitude, she just needed the raw material, which we happily supplied. (Not all musicians were so graciously welcomed. When George Michael came into the shop, giving that whole Southern California, frosted-blond, cutoff jean shorts, and tan look which might have still been cool in England, Richard declared, "That is *so* tired.")

Other musicians were looking for stuff that was a little more theatrical. Boy George, a famously huge hat fan, came in all the time for new hats. At that time, we carried these fake-fur pimp hats that were a huge hit. We also had great straw pith helmets, like people used to wear deep in the jungle while hunting elephants or whatever. Now kids were wearing them on Avenue A. Jonathan Bressler, a talented painter who ran a trompe l'oeil studio and could paint anything, used to decorate some of the hats by hand. He was really into Egyptian afterlife motifs and glow-in-the-dark paint, so as you can imagine, these reimagined hats were not subtle. He also painted a lot of the walls in the store, including a massive image behind the counter of the iconic Richard Avedon photograph of Andy Warhol exposing the scars on his torso from when he was shot in 1968.

We bought many one-of-a-kind hats and other items from fire sales of theater companies that were dissolving. Every Sunday, I perused the last page of the *New York Times* help-wanted section, where the estate and auction sales were listed. I bought theatrical and costume pieces that I thought my clientele might enjoy, and hats were often part of the mix. I love hats to the point where I hosted a Mad Hatter ball at Area, where attendees came with creative, zany, funky, and elaborate chapeaux (many of which they purchased at Patricia Field).

Despite my theatrical bent, I'd never styled a movie, but because Candy had recommended me for the role, the director, Karen Arthur, was very supportive. She gave me a strong wardrobe department, with people who understood the operational aspects of filmmaking, which I had no experience with. I didn't know anything about the structure, but I soaked it all up like a sponge. Their organization let me be a creative dilettante with the luxury to concentrate on the clothes for the characters and set design.

For it, I used a lot of Carmel Johnson-Schmidt, a precision New York designer whose garments are versatility on steroids. I own many of her pieces myself, including a black-and-white full-length gown in matte shirting silk with buttons along the top and sides so that the neckline can be a boatneck or lapels. A series of buttons on the skirt can create slits on either side. Most dramatically, you can turn the whole garment upside down for a midi dress with a cape detail. Simple, classic, futuristic, this gown cannot be pinned down, and that's what makes it so fabulous.

For a scene where Diane Lane's character is being watched by her stalker, I found a Johnson-Schmidt white crepe de chine garment for the window she was working on. The clothes were displayed wet on the mannequins so they became see-through and sexy. Not bad for a first timer.

Candy opened up the world of styling to me, which I found invigorating and inspiring. The producers for *Lady Beware* loved the clothes and asked me to come to Hollywood and do their next movie, *He's My Girl*, an updated version of *Some Like It Hot*. I flew! Each wardrobe gig was leading to another. A producer—who saw a still from *He's My Girl* of the star, Jennifer Tilly, in a black tulle skirt and black matador-style brimmed hat riding on a motorcycle behind her costar, David Hallyday—then recommended me to executive producer Michael Mann for his NBC cop drama *Crime Story*.

NBC had given Michael carte blanche to produce another show after the wild success of *Miami Vice*, which he also made for the network. *Crime Story* took place in the 1960s, a classic good vs. evil drama between a veteran detective, Michael Torello, played by Dennis Farina, and his archrival in the mob, Ray Luca. I lived through the sixties, so I knew that period of fashion and loved it. But costume design isn't just about au-

thenticity. I wanted the look of the characters to translate for viewers in the 1980s.

When I was brought onto the show, it was already in its second season. The first, which was shot in Chicago, had been much darker. The writers had moved the action for season 2 to Las Vegas, a sunlit place full of flash. So I brightened up the clothes, made them a bit more fashion-y and humorous, all keeping in line with the sixties aesthetic.

I found great Robert Hall sharkskin suits in shiny blue and green hues as well as bold patterns like a large swatch plaid. I remembered Robert Hall, a national chain of menswear warehouse-style stores, from when I was a kid in Queens, where there were four locations. Their inexpensive suits, made in the United States, were quality merchandise. That was the selling point highlighted on the commercial jingle always playing on the radio while I was growing up:

When the values go up up up
And the prices go down down down
Robert Hall this season
Will show you the reason
Low overhead—low overhead

The Robert Hall suits I was lucky enough to source had withstood the test of time. They were beautiful, and paired with color-blocked or patterned skinny ties, moved the look away from the uniformly severe dark suits, white shirts, dark ties, dark hats, and dark overcoats that you'd typically see. And those were just the detectives.

For the mobsters I went real Rat Pack, even shinier suits with open-necked notched-collar shirts or black ones. I jazzed up Tony Denison, who played the head Mafia character, Ray

Luca. Tony was a young guy and loved it. I mixed a true-white jacket with a pale pink shirt, a matching pink pocket square, and a skinny maroon tie topped off with a jazzy tie clip. I like contrast, whether it's color or pattern. When I put Tony in a gray wide-pinstripe suit, I freshened up the look with a thin tie in dark and pale blue stripes. I'm always working those stripes! Mostly, though, I stuck with tones reminiscent of how the Vegas landscape opens up so beautifully when the sun sets—like the deep-pink shirt I paired for Tony with a tie in a strong graphic pastel print and thick gold chain bracelet. Everything looked good on him with the high pompadour he wore. At least that's what Tony and I thought. Michael was a traditionalist and a little bit afraid of what I was doing with his manly characters. He could have chopped me in a second, because he was a big producer, but he accepted my explanation: I was making the Mafia glamorous.

There was no shortage of options for me to choose from. I practically had my own menswear warehouse in the desert, thanks to *Crime Story*'s associate producer Brooke Kennedy. By the second season, NBC was spending upward of $1.4 million per episode. Shooting a period show on location with a big cast does not come cheap. For me, the network's largesse came in the form of a huge wardrobe office packed with gorgeous clothes, located in an undeveloped area not far from the airport. That part of town is now all hotels (Vegas grows so quickly that if you don't go there for six months, you get lost), but back then I watched roadrunners speeding across the desert horizon, their skinny bird legs carrying them up to twenty miles per hour, as I prepped for the day's shoot.

The other aspect that made *Crime Story* such a good experience was the people, like Tony, who I got to dress. Michael liked to use real ex-cops and crooks in his shows, which made

for interesting characters on set. Dennis Farina had spent eighteen years on the Chicago police force when Michael hired him as a police consultant for a project, then gave him a small part in his 1981 film *Thief*. Dennis continued to work as a detective with the PD even as he landed roles in TV, film, and theater, including the part of a mobster in *Miami Vice*. It wasn't until *Crime Story* that he quit his day job. I befriended John Santucci, an ex–jewel thief who Michael also hired as a technical consultant for *Thief*. (The movie's big heist, where a thermal lance was used to cut through a vault door, was actually based on one of John's robberies.) John, who played a mobster in *Crime Story*, stayed in the same apartment complex as I did in Vegas. He knew where to get good pizza (crucial knowledge) and I enjoyed his comical company. I guess he eventually returned to a life of crime, because about a decade after *Crime Story*, when the Chicago PD was investigating break-ins to vending machines, he was caught carrying burglary tools and pleaded guilty. He died of cancer in 2004. But regardless, John was a fun guy. I didn't ask for his pedigree; I never do.

I had discovered a whole new and thrilling world of putting clothes on characters—not the kind who shopped or worked at Eighth Street, but those created by writers and directors. It was a twist on dressing people for a night out in the clubs or to stand out on the street. When I was on set, I brought the same belief that clothes should be special, attractive, and entertaining. I always thought an outfit should tell a story, but with costume design it was a prerequisite of the job.

It was through Barbara that I found my way to this new world, but by the time I started *Crime Story* we had decided

we could no longer remain in the same one together. Her perfectionism began to grate on me. If I so much as moved an ashtray from its stage on the coffee table while I had a cigarette, she moved it right back. I felt stifled by the preciousness, no matter how pretty it may have been. It made me want to dye my hair blue just to be contrarian.

She wasn't just a control freak about her apartment. Barbara accused me of having affairs with every Tom, Dick, and Harriet, which wasn't the case. She thought I was having sex with everyone, including trusted employees like Molly. "Are you crazy?" I told her, but her possessiveness made her blind to reality. In the end, Barbara and I had almost ten years together—not bad for one freewheeling woman and one restrained one—and remained friends, seeing one another in Miami, where we both owned apartments, until her shocking death in 2021. She and her longtime partner Donna Cristina, with whom she started a successful advertising and marketing agency, were found dead together in their Miami apartment. They had apparently committed suicide. They didn't have financial problems and hadn't shown any kind of mental or physical illness. It came as a great shock to all of their friends, including me. We'll never know why they did it.

Barbara and I burnt down our relationship together, but meeting Rebecca Weinberg at the end of the eighties fanned the flames. Part of the club scene, she'd been to Eighth Street and knew some of the kids who worked for me. But I had never seen her before the night I hosted a fashion show at the exclusive restaurant Indochine.

Rebecca was strolling up Lafayette when she just happened to run into someone she knew from the shop standing outside Indochine, the French-Vietnamese restaurant famous for great people watching. On an ordinary night everyone from

Bella Abzug to Basquiat could be spotted nibbling spring rolls and sipping on citrus martinis. Tonight, however, we had taken over the eatery for a House of Field event. Rebecca's friend invited her in, and it didn't take much encouraging for her to accept. She was always up for anything that sounded fun.

I was sitting with Barbara at the end of the runway when Rebecca entered. I was focused on the show, so I didn't notice her, but apparently she did more than notice me. As she said later, she was overwhelmed with an all-encompassing feeling: "I want to be with *that* woman." In that moment, she decided to pursue me unapologetically. I was forty-seven and she was nineteen.

Originally from Houston, Rebecca left home for New York at fifteen. Her mother had brought her to Manhattan as a little kid, and ever since then she'd known that was where she was headed. As soon as she could, she flew by the seat of her pants to the city that offers the opportunity for reinvention and a minute in the spotlight. Rebecca's corner of New York at the time was the Palace de Beauté's Tuesday night party, Love Machine, run by the promoter and DJ Larry Tee, who would go on to write "Supermodel" for RuPaul. Rebecca was a go-go dancer at the party. My whole crew had rolled over to the enormous two-story, block-long club in Union Square (which is now a Petco) where Rebecca spotted Codie and JoJo from her perch and said, "Tell Pat Field to come over here."

I arrived to Rebecca go-go dancing atop her box, naked except for a tiny thong and pair of pasties, spinning in the strobe lights. She didn't wear many clothes back then. From that very first moment, she was exciting—a word I never ascribed to either Jo Ann or Barbara, no matter how much they meant to me. Tall and athletic, Rebecca was a great dancer with a great body. Her dark brown hair, ivory skin, pale blue-green eyes,

and full lips were as dramatic as the rest of her. She wanted to catch my attention, and she succeeded.

As if her gyrations and shimmying didn't deliver the message clearly enough that she was after me, Rebecca invited me to dinner. We went to the posh Thai restaurant Tommy Tang's, in Tribeca, where she gave me the abbreviated version of her life story as we plunged our black lacquered chopsticks into pad Thai and chicken satay. She had a brother, two years older than her, who passed away suddenly when she was very small. The heartbreak it created was too much for the family. The way Rebecca told it, her mom and dad checked out, permanently.

When we left, we walked the desolate stretch of Greenwich Street near the Hudson River to where I had parked my Pacer. The love of cars I developed as a child of the fifties has never left me. I've owned so many cool cars, but my Pacer was really special. Everyone loved the rounded two-door compact with so much glass it felt like you were cruising around in a spaceship. Think *The Jetsons* via the seventies. I gave Rebecca a thrill when I handed her the keys.

She drove east, all the way to the East River. We parked by the old Fulton Fish Market, right below the Brooklyn Bridge, and sat on the edge of the river. With our legs dangling over the water, the rumble of cars speeding along the FDR Drive overhead, and the crumbling piers of Brooklyn before us, we talked for a long time, the kind of never-ending conversation only possible when fueled by the curiosity of new love.

That was it. Rebecca fell really hard. Smitten as a kitten, as she put it. So did I, as we fell in love with each other immediately and started this hot and crazy romance. Rebecca was undeniably gorgeous, but she insisted I was the beauty. She would run her hands along my olive skin and fixate on my thick

hair that she described as "goddess-like." She loved the way I walked, square shouldered with a masculine gait. But she also appreciated my feminine aspects, my small waist, slim legs, and what she called "the most beautiful breasts you've ever seen on a woman." According to her, she had hit the jackpot.

I didn't know it in the moment, but I had also hit upon something new with Rebecca. Unlike my first two relationships, it was one adventure after another with her. My life had been missing that energy with Jo Ann and Barbara. Shortly after we met, she was cast in a film in Italy, so we met afterwards in Paris and jetted off to Spain and ultimately Mo-

PHOTOGRAPH © TINA PAUL

rocco. When we were in Miami, where I had an apartment, she got us to do bungee jumping off scaffolding set up on the beach. I would have never done it without her. She was full of enthusiasm, which was very attractive to me at that point. My store was an establishment in New York City, and I was steamrolling ahead with costume design. I was happy to be entertained by a fabulous dancer and much younger woman with a wild imagination.

PAT'S COLLECTION

Wherever we went together, we caused a commotion—by design. Ours was a smoldering and demonstrative relationship between a stunningly vibrant and raw younger woman and a hot, sophisticated older one. As I would roll up to the club in an outfit that highlighted my legs—say, a tailored lime-green pantsuit and pair of metallic heels—with Rebecca, my beautiful arm candy, the quiet and serious existence sequestered with other quiet and serious gay couples when I first moved in with Jo Ann felt like many lifetimes ago.

Rebecca was like a showgirl, a lesbian showgirl. She was active and fun but also glamorous. We used to go to a salon on Eighth Street, down the street from my store, where we would both get our hair done into finger waves like 1930s stars of the silver screen. Always half naked with pasties flying around, she kept me amused and happy.

She was up for anything, including riding a horse naked into a midtown Manhattan nightclub. The event was a ball Mother Princess Diandra from the House of Ecstasy staged at the Red Zone, a club in the west fifties that had once been a horse stable. When I heard the first category was going to be Famous Women in History, the idea hit me. Inspired by the late-nineteenth-century painting by the English artist John Collier of Lady Godiva riding naked on a white horse with long flowing hair, I thought, Rebecca would be perfect! All theatrics and no modesty (not to mention lithe and lovely), Rebecca was on board. She opened the ball by trotting in atop a white horse in a long wig—and nothing else.

Of course, we won, but the night didn't end in triumph.

"House of Field OUT OF THE BALLROOM!" the emcee roared.

Why were we being ejected from the ballroom?

"Because you chopped Mother Angie Xtravaganza," he explained.

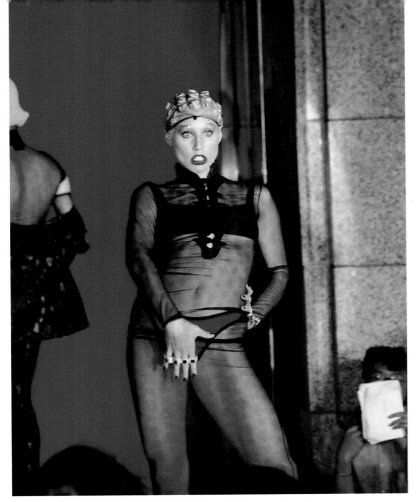

Rebecca in a House of Field fashion show in Tokyo
PAT'S COLLECTION

Mother Angie, walking the runway in the designer cat-egory, Yves Saint Laurent, had a big run in her black sheer stockings. Yves Saint Laurent would *never* allow that, and so yes, I chopped her! Diandra's boyfriend came after me, and I threatened him back with a lit cigarette. Then we really did have to leave.

Rebecca moved in quickly with me, and since she was an attractive twenty-year-old with great style, I suggested that she work for me in the shop. She was into it, and we developed a

Rebecca entering the Ecstasy Ball

PHOTOGRAPH © TINA PAUL

Christmas card from 1991, with my dogs Pri Pri and Sheba

PHOTOGRAPH © TINA PAUL

nice groove, starting most days with me, still in bra and pant-
ies, lighting a cigarette and pulling the coffee from one of the
1950s metal kitchenette-style cabinets in my loft and prepar-
ing it for us in the Chemex. We'd put on a little something ca-

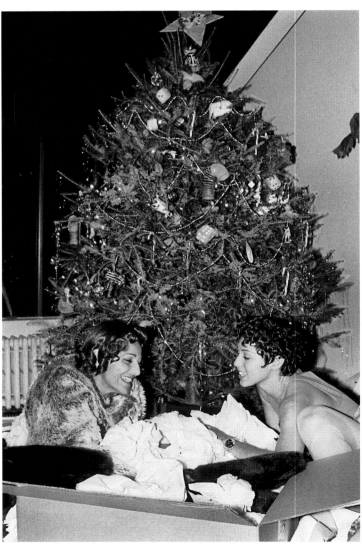

Christmas at home in 1991
PHOTOGRAPH © TINA PAUL

sual (or not so casual) and go walk the dogs, strolling through Washington Square Park holding hands.

The kids at Patricia Field didn't necessarily have the same glowing feeling about her. They didn't appreciate her taking too much position. "She's not my boss," a few bitched. The situation was completely different than it had been with Jo Ann, who was much more unassuming than Rebecca. And Barbara never had any interest in being a part of the volatile ecosystem of my shop. Neither woman posed any kind of threat. But Rebecca was very much part of the mix.

Some in my crowd were afraid for me, worrying that Rebecca viewed me more as a career opportunity than a love interest. They were jealous of the space she was taking up in my life, reminiscent of the politician Alcibiades in *The Symposium*, who envies Socrates because of how young men gravitated to the philosopher. Socrates was a messy hippie, but he was a masterful teacher in all areas.

Although I didn't hear about it directly (the kids knew better than to bitch to the boss, especially about her girlfriend), they complained Rebecca didn't really want to work and secretly thought retail was beneath her. To me, she was very enthusiastic about helping out at the store, and I appreciated her energy and ideas. She had great taste and brought a fresh point of view. I will admit that she came and went as she wanted, which was mostly my fault. I'd pick her up to take her out to lunch, and off we'd go, leaving the dressing room, or whatever section Rebecca was stationed at, unattended. Everyone at the store would take time on the clock to run personal errands, but Rebecca took it to another level, because she could.

I have found that most people, even ones as countercultural as those who worked at Patricia Field, don't like change. But to fight against it is folly. Change is inevitable, whether in fashion, relationships, or my shop. I have always gone with the

flow of change, sometimes as enthusiastically as a cheerleader, other times with the distant amusement of a benign father. It's another secret of my success and a way to combat the inevitability of sorrow.

In the nineties, we lost House of Field mother and shop manager Tim Bailey to AIDS. Despite being a gentle soul, he didn't go gentle into that good night. In 1988, he joined and became an active member of ACT UP. The grassroots organization, fighting against the epidemic through bold and theatrical activism, was a good fit for Tim. His final act of creative defiance was his funeral in the summer of 1993.

As a member of the Proud Marys—a group of about ten people within ACT UP, who staged public funerals to draw attention to the AIDS crisis—Tim requested they throw his body over the gates of the White House to protest the Clinton administration. But that was too much, even for his comrades, which they expressed before he died. Relenting, he told them during his last days, "Do something formal and aesthetic in front of the White House. I won't be there anyway. It'll be for you." And so they did—or at least they tried. In what the *New York Times* called "the most notorious" of the political funerals, the Marys drove Tim's corpse in an open casket through DC: "This is the body of Tim Bailey. He was a friend, a lover, a brother, and a son. He was also an AIDS activist—a hero in the fight against the epidemic. We're giving him a hero's funeral." They tried to hold the service in front of the White House, only to get into a violent three-hour standoff with police.

Tim had a flair for drama in death—and in life. It was on full display in his designs for my in-house clothing label, with a penchant for menswear and bodycon clothing heavily influ-

enced by fetishes. There was no replacing him, but I eventually needed another designer for my House of Field clothing line. David Dalrymple—who worked in nightclubs in a variety of positions, including (mainly) go-go dancing—had been making clothes in his apartment for himself, other dancers, and drag queens for years. JoJo, Connie, and Paul Alexander were among the many people who asked David to make clothes for them. Paul, who was a buyer for my shop at the time, encouraged David to bring some of his designs to Patricia Field and sell them on consignment.

Busy with my burgeoning costume design career, I had no knowledge of David or his merchandise in my store when I went to Boy Bar one night, where I was entertained by a lip sync extravaganza with the Beauties, including the legendary Mona Foot. All the members were wearing the most incredible outfits. When I learned that David was the mastermind behind the one-shoulder dresses with ostrich hem and the blue lace bell bottoms trimmed with feathers, I immediately ran up to him and said, "I love these clothes! I want them in my store."

"You already have them," the six-foot-plus designer said.

It was the start of a beautiful relationship. I went over to David's apartment to see more of his clothes and immediately bought twenty pieces for Sexy Pop, a store I "curated" for my Japanese friend Masuko Kato, who owned a boutique in the Harajuku neighborhood of Tokyo.

A graduate of FIT, David knew how to make clothes. But having earned the lion's share of his living dancing on top of a table, he didn't know much about the business of fashion. So when I hired him to design for House of Field full-time in 1993, I spent almost every day working by his side in my showroom on Thirty-eighth Street, which I really considered his factory. While I'm not so into trends, I sure can clock one. I had the benefit of seeing what customers were looking for

in my shop, which provided important intel for our wholesale business. I paid attention to the little moments—like when several women commented that they wished the pants they were trying on fell lower around their hips. Some even went and rolled down the waists on their pants automatically. Like an air-traffic controller, I would call David from the shop to give him the coordinates of where fashion was headed.

"I've lived through this before," I said. "I see the way girls are looking at their bodies in pants. They don't want to look like their moms. Lowriders are going to hit hard."

David got to work sketching these low-rise sexy pants that flared at the bottom. When he was finished, I made a one-page catalog of his line drawings and faxed it to all of our wholesale customers. These were stores that catered to Patricia Field–type customers across the country, like Playmates in Hollywood, a bunch of places along Ocean Drive in Miami, and the one shop where you could buy sexy clothes on Newbury Street in Boston. Then I followed up by phone. "I just sent you a fax, check it out," I told the store owners. "Order these pants. You won't be disappointed." They bought them because they trusted me, and the low-rise boot-leg pants that became all the rage during the nineties did well.

That wasn't the only trend we capitalized on from information coming out of my shop. The House of Field showroom, occupying all three thousand square feet of the sixth floor, became a mini factory as we brought in a total of eight sewers to produce an expanded line. When David's mom would come in on the bus from New Jersey to visit her son, I would tell her, "I wish I had ten Davids."

The rave scene brought an exciting new crew—in the form of both customers and employees. On the recommendation of some of the kids at that time, I added an Adidas-style stripe to

the same body-conscious pieces I had been doing since the late seventies. Leggings had always been a staple of my boutique and sold no matter what was going on in fashion. The ones we produced ourselves came in a wide array of colors of girdle fabric, like Spanx before Spanx existed. But we also had cotton leggings, which I sourced at the junk show and dyed black for cheap in Queens. All the rage in the eighties, the leggings were folded in a big circular unit in the shop where customers would grab them without any thought. We sold tons of them.

As the decade changed, the leggings were in need of a makeover. An athletic stripe down the side gave them a whole new life. Instead of layered under a crinoline or paired with a white tank top and lots of bangles in a look made famous by Madonna, they became a sexy sport pant. The leggings sold so well that we added the stripe to our tight dresses and hot pants. I styled them with high heels, baseball hats or Kangol caps, and big hoops. Hip-hop's influence had officially landed on my shore.

Puff Daddy's girlfriend, the stylist Misa Hylton, started to come to the shop after the rapper and record producer's label Bad Boy Entertainment took off. Misa introduced us to a lot of artists, like Mary J. Blige. Suddenly we were on the radar of a whole new network. I remember my horror when I read an item in the news that Beyoncé, a fan of the wig department, was supposedly kicked out of the store with the rest of Destiny's Child and her mother! I found out that a new employee feeling his shit had the nerve to make that story up to a journalist while drinking at a bar. I jumped into my Pacer and drove down the Garden State Parkway to the arts center where Destiny's Child was performing in order to apologize on behalf of my asshole employee. I begged their forgiveness, and luckily for me, they understood and the story ended on a happy note.

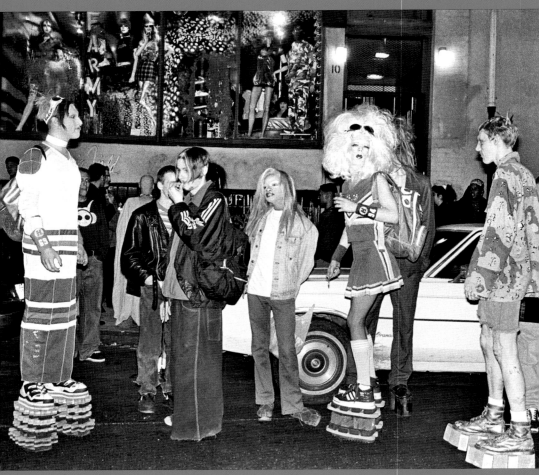

Club Kids outside the shop in 1994

Beyoncé was a good client, wearing House of Field clothes for her performances. For one concert, the cultural icon chose a one-of-a-kind House of Field bodysuit made with a deconstructed vintage Bob Marley T-shirt David found somewhere, maybe even a friend's house. David—wild for T-shirts as a particularly miraculous American invention—lined the shirt that he had cut into a camisole with the same girdle fabric that we used to make the leggings. That was the trick: it fit like a corset but looked like a T-shirt. Or, as David liked to quip, "Looks like a pump, feels like a sneaker." He complemented the bodysuit with a short, pleated tennis skirt made out of the Jamaican flag, over which he printed my name in red.

The Marley bodysuit was haute House of Field, but we really entered the cultural conversation when Beyoncé wore a House of Field tank top and hot pants for her "Crazy in Love" video in 2003. Her official solo debut single, featuring rapping by her future husband, Jay-Z, from her first solo album, *Dangerously in Love*, was the song of the summer. So many of the fall fashion shows that season blasted the power anthem while the models walked the runway. In the video, Beyoncé's outfit looks simple enough: a white tank with stretchy jean short shorts that she pulled off in all her fierceness with red high heels and a delicate gold body necklace. A lot of skill went into the appearance of simplicity. Not only was the tank girdle-fabric reinforced, but her stylist, Lysa Cooper, asked David to design a pair of hot pants that would cover her butt while the singer did all her acrobatic dance moves on camera. Those tiny shorts took a lot of expert engineering on David's part.

Almost every celebrity story in my shop, of which there were many, ended happily—a minor miracle considering the volatility of such big personalities (employees included) in such a small space. Take Foxy Brown, who started shopping with us

after she signed to Def Jam in 1996. Not exactly known for her even temperament, the rapper almost threw down with Dana, who had the misfortune that day to be working on the floor and not in the salon as usual.

Foxy had come to Eighth Street to find a look for a video shoot, but she didn't even need to come inside because she saw exactly what she wanted in the window: a chiffon jumpsuit with a brown velvet collar, trim down the front, and cuffs. Designed by David for House of Field, the jumpsuit was paired with a seventies-style floppy hat for the full Iceberg Slim look.

"I want that outfit in the window," Foxy said. And what Foxy wanted, Foxy got.

The last jumpsuit of its kind, it had to be taken off the mannequin. Paul, as the window dresser, handled removing the garment from the mannequin. When he handed it to Dana, however, she realized a button was missing. Trying to be helpful, she went downstairs to get someone to sew on the button so Foxy wouldn't think the jumpsuit was damaged.

It didn't take long for Foxy to wonder where her jumpsuit had gone. No one wanted to say that a button was being fixed, which only served to make the rapper paranoid. Having decided that Dana was hiding this jumpsuit from her, specifically did *not* want her to have it, Foxy started to curse her out.

"Yo, that's Foxy Brown," said one teenager buying a Juicy baseball cap to his friend.

Now she had an audience. "You better recognize!" she shouted at the increasingly anxious salespeople on the floor.

Finally Dana came up with the buttoned-up jumpsuit, only to be met by an enraged Foxy. A flouncy blonde who didn't know the first thing about fighting, Dana was about to get her ass kicked. Somehow—again a miracle!—the other people

working in the shop got Foxy out with her jumpsuit and hat and *without* beating Dana up.

The outfit was good, so good Foxy forgot all about the incident and wore it in the video of her song "Gotta Get U Home." She also continued to be a good customer, especially after she found Paisley.

The kids in the store were a lot, but Paisley—a skinny Black gender-nonconforming queen who looked like the king of the road warriors in *Mad Max*—stood out even among our band of freaks. He wore loud blue eye makeup that he streaked over the entire eyelid and continued way past his eyes, into his hairline, and into the sides of his head, which was shaved into a huge Mohawk cut. Blue makeup, feathers, dressed in black vinyl, skulls on his fingers—that's how Paisley got on the subway to go to work every day. And that's who Foxy wanted to help her. They got along so well that she copied his Afrofuturist *Blade Runner* aesthetic for her 1998 "Hot Spot" video, where she dons a silver metal bikini. Although she was pretty fierce, I was surprised that she went so hard core with her look. That was all Paisley's influence.

A lot of the celebrities had *their* person at the store. Paul used to work with Foo Fighters drummer Taylor Hawkins, starting when he was the touring drummer for Alanis Morissette. *Jagged Little Pill* had just gone to number one and Morissette's single "You Oughta Know" was on the radio all the time when the musician turned up in the store. He looked lost, so Paul asked if he could help. Taylor explained that he was performing at the MTV awards show at Radio City Music Hall. The mix of blond beach bum and grunge rocker needed something cool to wear on TV, and Paul helped him find it. Two years later, Taylor, now drumming for the Foo Fighters, returned to the store. He needed an outfit for another awards show, but

this time he brought the full band along. He led the whole troupe with an attitude that he was clearly proud to show them his favorite shop. Dave Grohl got to the middle of the store and stopped. Surrounded by rhinestones, pasties, feather boas, wigs, platform shoes, and pleather, the Foo Fighters front man immediately turned around and left. No matter how hip-hop, rock 'n' roll, or anything else we got, Patricia Field would never lose its drag history. Taylor—a good customer, great musician, and open-minded human—died tragically at fifty in his hotel room while on tour with the Foo Fighters.

It wasn't just styles and clients who came and went on Eighth Street; so did the stylists, as I liked to call my employees. Some lasted less than a day, others decades, but the scene was always shifting. I was often the person they looked to for advice when they were thinking about making a move, and mine was always practical. When JoJo began dating a guy from London who wanted him to move to England, he was torn. He liked the guy, but he also liked his job. "I know he loves you, you love him, and he wants you to be together, but you're going to pack up your entire life and move to England?" I said. "I don't know about that."

It turned out to be good advice for JoJo to date long distance, but if he had left the store, there would have always been a place for him if he wanted to return. That was true for everyone in the family. Armen, known for throwing tantrums when I wasn't around, quit and came back three times. We were out at a bar on Avenue A with Molly the last time he asked to come back. "I miss the store," he said. "It's so much fun tormenting people."

I put my drink down and said, "Armen. I love you. You bring beauty to my life. You bring beauty into my store. But every time you get a hair in your mouth you leave me with my dick in my hand."

PAT IN THE CITY

Armen, who had a comeback for everything, was rendered speechless. He had never heard that expression before, but he understood exactly what I meant.

By the late nineties, when it came to work, I might have become less charmed with the picturesque, and more satisfied with plain old competence. That was in no small part because I was leaving my business for stretches to do costumes for film and TV. I always enjoy the new, and costume design was new for me, so a lot of my energy and focus went into it. Just how much attention this part of my career was about to take, no one could have predicted.

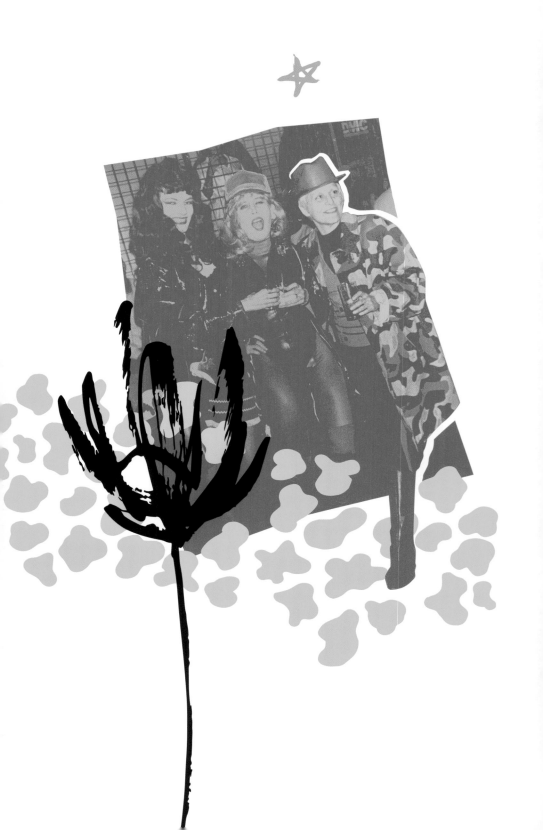

seven

SEX AND THE CITY ✦

WAS RUMMAGING AROUND IN THE FIVE-DOLLAR BIN at a midtown fashion showroom when I found it: the perfect piece for Sarah Jessica Parker to wear in the opening-title sequence of her new show on HBO. In the box of sale garments—trends from seasons past that died on the vine—a white tulle peeked out like the frothy crest of a wave in a sea of throwaways. I pulled and out came a sort of chic white tutu. I imagined pairing the short, tiered tulle skirt with a small tee or tank for a look that was both contemporary and cool. I also thought Sarah Jessica would be able to relate to this crazy skirt because of her background as a ballet dancer. Just as important, though, the tutu-style skirt was whimsical, adventurous, and unexpected—kind of like this show, *Sex and the City*.

Sarah Jessica loved the tutu immediately. That made me happy, in part because she was the one responsible for getting me the job. We had met a few years earlier on *Miami Rhapsody*. I had been hired as the costume designer by the movie's director, David Frankel, for the romantic comedy, which also starred Mia Farrow and Antonio Banderas. Sarah Jessica and I instantly hit it off, because our tastes were congruent. For that film, she wanted to wear the tight, skinny T-shirts that hit right at the waistline and were all the rage in the nineties. David didn't like the T-shirt, but Sarah Jessica knew what she was talking about. She ended up winning the argument and looked great.

There had been another costume designer when the pilot for *Sex and the City* was shot in June 1997, but nobody had been happy with the clothes—least of all Sarah Jessica. In the first episode of the show—loosely based on a newspaper column by Candace Bushnell about her own adventures around New York—Sarah Jessica's character, Carrie, is tapping out her column from bed in a sloppy oversized button-down and schleppy sweatpants. It was an outfit I wouldn't wear at home, let alone on TV.

Sarah Jessica approached the show's creator, Darren Star, about my taking over. Darren—who had a successful career in Hollywood creating hits like *Beverly Hills, 90210* and *Melrose Place*—knew that the pilot's costumes weren't cutting it. Darren wanted, first and foremost, to bring a new person with whom Sarah Jessica had worked and was comfortable. But he had to be comfortable with me, too.

Sarah Jessica called me up to see if I would be interested in meeting Darren, and the next thing I knew I was in Long Island City at Silvercup Studios, shaking hands with the creator and showrunner. I didn't have a script, just a basic understanding of the show, which followed the lives of Carrie and her three friends, Samantha, Charlotte, and Miranda. That was enough for me to cook up some ideas. I don't have a problem going into meetings cold, because I always have strong opinions—which, it turned out, Darren appreciated. After all, that's what *Sex and the City* was about: women with opinions, who weren't afraid to voice them.

In his office, I showed him a book of Bettie Page images and illustrations that I had brought along for inspiration. To me, the Queen of Pinups was a perfect reference for his show. It wasn't really about Bettie's iconic image, although I loved her black wavy hair, with its short, rounded bangs, and the voluptuous curves that she displayed unapologetically. It was more about her spirit and what she represented to women. In her sexy pictures, she brought humor, strength, imperfections, and, perhaps most important, a sense of freedom. She was an intelligent and empowered sex symbol. Instead of appearing submissive, more often than not she looked like she was having a good time. This was a woman ahead of her time; she liked to be naked (what she called "air baths") and made her own bikinis to ensure the right level of skimpiness. Bettie

Page might have gained a lot of male fans when she became a *Playboy* Playmate in the fifties, but her most enduring fans are women.

Darren liked that I was out there in terms of my ideas for the show from the very beginning. He wasn't looking for a lifer costume designer, who could be relied upon to produce predictable results. As he put it, he wanted *Sex and the City* to be "the kind of show that we'd never seen on television before." He wanted something that felt more like an independent film, in both its look and content. This was going to be an honest exploration about adult female sexual relationships, and so the fashion had to reflect that sort of open-mindedness. Carrie, Samantha, Charlotte, and Miranda were not stereotypes of women along the slut/prude spectrum but rather characters juggling the complex mix of careers, sexual desires, and real friendships. Because of that, Darren was pleased I was thinking outside the typical Hollywood box.

I strayed a little *too* far out of the box when I turned to the part of the book with photos Irving Klaw took of Bettie for bondage catalogs. Bettie was a woman ahead of her time, just like Darren's characters. Surveying the pinup bound in chains with shackles around her ankles and neck (and a fantastic little leopard bikini), or the one of her strung up with a ball gag between her perfectly painted red lips, Darren said, "That's a little much." I took the note. But it was clear that he appreciated my aesthetic considerations, even if this one took it a step too far.

Darren hired me on the strength of my vision for the characters and the fact that my store and personal history brought a lot of street cred for a show set in New York City. I still had to prove myself, however. Darren isn't a suit-and-tie guy. He's clean cut, with a typical uniform of sneakers, jeans, and a polo or T-shirt. His laid-back look doesn't make him any less

of a businessman. A showrunner's job is multifaceted. You have to be creative, a strong manager, and good with numbers, whether it's the production budget or viewers tuning in. Darren had to oversee every element of the show—including the outfit I picked for Sarah Jessica in the show's opening sequence, which was not an immediate thumbs-up.

Darren is very smart and has great instincts, but when he saw the look I put together—the tiered white tutu, a body-conscious pink tank top, and neutral strappy high heeled sandals—he was incredulous.

"I don't get it," he said.

"This outfit is original, and inherent in the actress," I said. "If this show's a hit, the opening will be memorable *and* stay fresh."

I knew anything less would be dated by next season. People want to see what they haven't seen before—not some trendy shift dress from Fall 199-whatever. From the opening credits to every single scene of the series, however long it might last, my overriding aim would be to make sure that while the clothes were expressive and helping to tell the story, they were never burnt with exposure.

"Who's going to understand this girl, in New York, in a tutu?" Darren asked.

"It isn't a tutu. It's a tulle skirt," I said. "It's the princess syndrome."

He looked at me skeptically. Luckily, I had Sarah Jessica on my side. She wasn't just *SATC*'s central character; she also held the title of executive consultant. For a show about sophisticated, honest, and contemporary women in New York City, she fiercely believed the look was just as important to its success as the writing or acting. SJP wanted the tutu and fought for it.

Darren compromised. He let us shoot it on condition that we shoot another option. I found a powder-blue, sleeveless

sheath dress. But in the end, it was the tutu. It was always the tutu. As soon as he saw a shot of Carrie Bradshaw getting splashed when a passing bus—with her image and the line "Carrie Bradshaw knows good sex" on its side—hit a street puddle, Darren loved it. "She's so prominent and original in this crowd of people," he said. "I got it."

That was hardly the last time Darren told me he "didn't get it," but what made him an exceptional showrunner, boss, and creative partner was that he recognized my outlandish ideas were stretching him past his comfort zone. Before *Sex and the City*, Darren didn't fully understand that clothes are as important a piece of the show as production design, cinematography, and casting, and later admitted that I helped expose him to the idea that fashion can be an art form.

When Darren created *Beverly Hills, 90210*, he was excited to show an early episode to some friends. But he was incredulous when their immediate reaction was to get into a heady discussion of the character outfits they hated and loved. "What do you mean?" he asked. "Why are you looking at their *clothes*?" The wardrobe of the rich and entitled teens of his long-running soapy drama had never crossed his mind.

Costume—indeed a big visual piece of any series—plays into the aspirational aspect of the viewer experience. People watching often identify or want to emulate the characters on TV, even if the clothes leave reality. *Especially* if the clothes leave "reality," because that's when the wardrobe actually becomes entertaining. But before I could concoct a frothy fantasy I thought women might enjoy, first there was a lot of technical work to get done.

The process started with Darren's basic description of the four main women. There was sex-crazed Samantha, played by Kim Cattrall; Miranda (Cynthia Nixon), the serious lawyer lady; girl-next-door Charlotte (Kristin Davis); and Sarah Jessica's

Carrie, who, oddly enough, was the only character in the beginning without a clear, precise identity like the others. I thought of her as the fashionable girl about town—with a personality.

Then I had to read the script and break it down to figure out the number of wardrobe changes each character had in the episode. The nature of the scene dictated the outfit: day or night, at work or at the park, etc. Once we had taken each actor's measurements and compiled a size chart, we had a template to go out shopping for clothes and accessories. We needed to create about fifty different outfits for each thirty-minute episode.

Thank God I brought Molly Rogers along with me from the store to be my assistant. When Molly first walked into my shop one morning in 1984, she was like Boy George by way of North Carolina. It was early, and the only other person in the place was Madonna's stylist, Maripol, who was looking at rubber bracelets while I tidied up. Molly bounded in wearing a paper dress, her blond hair in dreads, and introduced herself in a southern accent. She had just landed in New York from London, where she had been living after graduating from college. She only knew one person here, and he told her she should look for work at Patricia Field. I was folding T-shirts when she asked me for a job. "Do you know how to fold T-shirts?" I asked.

"No," she said, "but I could learn."

Almost fifteen years later, Molly was key to the success of *Sex and the City*'s costuming. In the beginning it was just Molly, Rebecca, and me doing all the shopping, fittings, and mundane administrative tasks that are a necessary part of the job. It was excruciatingly hard for such a small group to handle such a fashion-heavy TV show. I would return from a shopping trip to Century 21 with forty bags. All the merchandise needed to be checked against the receipt and logged in to a system we maintained to keep track of our expenditures. After

the fittings, whatever didn't work would be returned, and the final tally was deducted from our budget. I made poor Molly go through each and every receipt. It really was borderline abusive on my part.

With the characters and mapped-out scenes in mind, I looked everywhere for inspiration. I tore pages from magazines, scouted the streets, and once even stopped what I was doing to take a photo of a billboard with a pair of sunglasses that I thought would be perfect. As we compiled these images, we reached out to fashion labels to pull the items we liked for this quirky new HBO show. Unfortunately, most of them didn't return our calls.

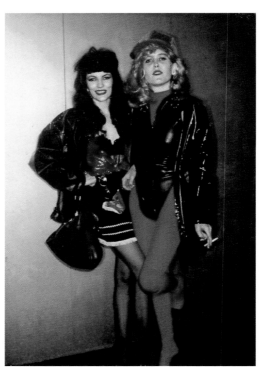

Pat's "Southern Crew," Melody and Molly
PAT'S COLLECTION

That was okay. I'm someone who can find fashion at a junk show; I didn't need luxury labels to dress Carrie, Samantha, Charlotte, and Miranda. Whenever I am designing costumes, my driving ambition is to find clothes that are stylish but not overdone. Even when I look through fashion magazines, I tend to choose ones that are five to ten years old to get different ideas than those in every boutique and on every body. For the same reason, I spent a lot of time at Century 21, where you never knew what you were going to find. Harking back to my youth sifting for treasures at Loehmann's in the Bronx, I had the patience and know-how to surf the sea of racks at the discount designer department store to find a Versace gown or Pucci skirt.

I went all over the place pursuing my styling philosophy that opposites do indeed attract. In mixing designer and off-the-rack, uptown and downtown, new and vintage, I went to What Comes Around Goes Around for vintage T-shirts and Ina, a designer consignment boutique that remains one of my favorite places to shop both personally and professionally. At the SoHo shop, opened in 1993 by Ina Bernstein, stupid trends that died with time have been edited out to leave the best of the best of modern fashion.

During prep for season 1 of *Sex*, Sarah Jessica and I found a full-length raccoon coat at Ina that was one part forties, one part seventies, and 100 percent timeless glamour. While the light-colored fur wound up becoming one of Sarah Jessica's costume staples for years to come, I wasn't sure if she would agree to wear it—in no small part because it stank. Ina allowed me to borrow the coat, which I brought to a fitting with Sarah Jessica, who needed no convincing. The rest is history; that raccoon, which I bought for two hundred dollars, was in constant rotation as a layering piece over everything from a silk skirt and crinoline to pajamas.

My search for the raw material to create costumes or style in general is never confined to shops or showrooms. I use whatever is stimulating and in arm's reach. This was the case with the gold nameplate necklaces I saw on my young Hispanic and African American customers. The glamorous golden name tag was self-identifying in a positive way and immediately brought Sarah Jessica to mind. This was a time in fashion when every market editor used to wear the same black Jill Stuart pants and black Prada backpack, so the idea of putting a sophisticated New Yorker in an accessory more likely to be spotted in Hollis, Queens, than on the West Village's Hudson Street was a leap of the imagination. But I thought, What the hell. I'm going to bring her one. Maybe she'll like it. For $189 I had the name "Carrie" made up into a yellow gold necklace at one in a strip of little jewelry shops on Canal. Sarah Jessica liked it—and soon made it famous. To this day, the Carrie necklace is the top-selling item in my gallery (followed by tutus, which I am happy to report that I also offer). People order them from all over the world.

The actress trying on the costume is a crucial moment in the process. The relationship between character development and the clothes is one thing; then there's the real-life person who has to wear the costumes. I never played with dolls as a kid and don't want to pretend I am now. The actor and I don't always see eye to eye, but my motto is: They are in front of the camera and have to feel secure. That objective has to be achieved first, before anything else.

Whenever I'm asked who I have enjoyed dressing the most over my career, I always say Sarah Jessica, and frankly it's because we did see eye to eye. Despite all the media coverage of what actresses wear, many of them are not so fashion-minded. Sarah Jessica, however, *loved* fashion. She would always come in with ideas that I respected.

The first time Molly, Rebecca, and I met with Sarah Jessica to get into the look of the show and her character, we met at my apartment above my shop on Eighth Street. From working with her before, I knew Sarah Jessica's DNA as an actress—including her aptitude for physical comedy, which was a lovely surprise for such a lithe and graceful figure. But I wasn't sure how she would interpret Carrie, a woman who could be found at a hot restaurant during any given brunch service, and yet whose frankness about desires was scandalous and fresh fodder for TV. Any concerns were buried with one of the first comments out of Sarah Jessica's mouth.

"I will always be bare legged," she said. "I don't care where my character is going, what temperature it is outside, or what kind of heels I'm in."

A decision like that might seem minor, but it was actually revolutionary. A little history lesson for those readers who aren't old enough to remember: In 1997, pantyhose were still very much an integral part of a woman's wardrobe. In the 1970s, as women entered the workforce in significant numbers, people would have thought a female employee was mentally ill if she showed up to her job without wearing hose. It would have been like if a man forgot his pants. Despite advances women made in the work world, those flesh-colored albatrosses were a mainstay of the eighties. Melanie Griffith famously illustrated the iconic professional look of that time in the opening credits of *Working Girl*, when she stepped off the Staten Island Ferry in her hose, socks, and sneakers, which she exchanges for heels when she arrives at the office. Stockings were as natural to a woman's life as breathing, and they were an absolute necessity on TV. Everyone wore them.

Sarah Jessica's statement—that Carrie was going to be walking down the street in heels and with bare legs—was more a manifesto than costume directions. We were going to

put pantyhose six feet under on this show. This kind of detail might seem minor, but it set the tone that we were going to break some rules, and I couldn't have been happier.

"And I want to carry clutches," Sarah Jessica said.

We found Carrie in the first meeting. The vision felt fresh and sexy; it felt right.

Sarah Jessica and I had a true collaboration and were both detail-oriented. She went on to ban not only pantyhose but scrunchies and butterfly clips as well from Carrie's costumes, and those of all the other characters. And she made an impassioned plea to the makeup artists to forgo foundation, seeing it as another vestige of a bygone era. Molly called us "control freaks." I called it good taste. Either way, the fittings we did for Carrie turned into marathons, often running as long as eight hours. Sarah Jessica was up for it, and so was I. The success of Carrie's look, the mix of unexpected and unusual items, wasn't all me. A lot of it had to do with her energy. Not to mention her body. I used to tell her all the time, "I wish I had your ass."

My relationships with the other talent on *Sex* weren't as immediate. As with Darren, I had to prove I wasn't nuts. At the same time that I was building my ideas for each character, I also reached out to the leading actors. I had a preliminary meeting with each of them individually, for which I prepared a few racks of possible clothes. We sat together and went through the script, scene by scene. They tried stuff on for fit and feel. I gauged their thoughts, comparing their vision to that of the producers and my own, hoping to meld them into one happy unified theory.

My shop was good training to be a stylist. I used to wait hand and foot on my customers. You build a successful business by paying attention and caring. The customer walks out, gets a compliment, and back she comes. As a stylist, the actors are your customers—and the customer is always right. Even

if they are wrong. That was the case with Cynthia. I admire Cynthia, who played the ambitious, hardworking, and good-hearted Miranda. A partner at her law firm, the character was, in Cynthia's own words, "smart and independent and determined." Did that also mean she had to look terrible? No!

Cynthia is a talented actress of stage and screen. A real smarty-pants: she attended Hunter College High School, one of the best public schools in New York City, and graduated from Barnard with a degree in English. (Many years later, af-

PHOTOGRAPH © TINA PAUL

ter the series ended, she made a serious bid for governor of New York.) When it came to her character, Miranda, however, I thought we dressed her way too seriously, a look that had been established in the pilot. We stayed as simple as we could that first season. For Miranda it was Bloomingdale's all the way. Poor Molly was always in there finding more lawyer-approved wear that was professional yet fashionable.

I wasn't in the business of saying no. I'm not a dictator. But my creativity is greatly improved when I have the trust of the actor. On the first season of *Sex*, I had to earn that trust. When I saw Kristin, I thought, "There's my Bettie Page!" The white skin, dark glamour-puss hair, and hourglass figure gave me major sexy secretary vibes. But Kristin wanted to wear A-line skirts, which she thought were more flattering. I went to the mat with her over the skirts. "You have a fabulous figure!" I told her. "We have to show it off."

In general I don't like shapeless coats or dresses without waists. I believe a silhouette has to be snatched with a belt, scarf, or any accessory—a bike chain if you like. The belt has a function. It gives you a waist. It does that for everyone, even if you don't have a waist. Put on a belt and then you'll have one. In Kristin's case, however, it was positively criminal not to see the entire hourglass.

Kristin admitted the show was a fashion education for her, and she had a real learning curve. When I chose body-conscious Dolce dresses and skirts to elevate Charlotte's lady-who-lunches look, she worried they were too tight. I practically had to pry the Ralph Lauren sweater sets from her hands to get some tailored Prada on her. When I tried to put a bang on her—pushing that Bettie Page look—it was just too radical. I had something to learn from Kristin as well. Raised in South Carolina, she understood the Southern/sorority girl style that transitioned easily into an Upper East Side preppy aesthetic.

She was right that bangs would have been absurd for the headband-and-pearls set.

It was important to me that all four women feel their character's sexuality—not a phony showbiz kind of sexiness but a more interesting, powerful, and truthful version. This was never more the case than with Samantha. Kim's clothes in the pilot didn't make the grade. I got that her role was the sex girl, and I was fine with making her the sex girl, but I didn't want her to be a cheap sex girl. I had to lay down the law with the straight types from HBO, who thought the only way to read sexy on-screen was by trotting out the old stereotype of big boobs, miniskirts, and high heels. The only women I knew who dressed like that were my trans employees at the shop. I didn't think that's what the male producers had in mind.

I wanted Samantha to be a designer sex girl, and I knew the perfect designer: Giorgio di Sant' Angelo. Before his death in 1989, he had been major. The stretch fabrics he liked to use even for evening dresses inspired the big designers of the nineties like Jean Paul Gaultier, Calvin Klein, and Donna Karan. The father of the bodysuit, Sant' Angelo made clothes that were body conscious and elegant. Perfect for a powerful, libidinous woman like Samantha.

I thought it would be a good idea to take Kim on a field trip to Allan & Suzi—the legendary designer consignment store where for thirty years everyone from punks to drag queens to famous designers came to find one-of-a-kind pieces curated by the couple famous not just for their unique taste but for a popular public-access show in Manhattan. The store also had a major Sant' Angelo collection. We could try on different styles and ideas, while getting to know one another.

For our shopping excursion, I decided to pick Kim up in style, pulling up to her apartment in my AMC Pacer. I knew it was a quirky and unusual way to start a relationship with an

actress I had never worked with before. However, I wanted a racy and exciting shopping trip for a racy and exciting character.

Today, Kim and I are very good friends. Over time, we came to respect one another. She understood that my ambition was for her to look amazing. And I appreciated her skill as an excellent comedic actress. She played the role of the insatiable vixen convincingly and with humor. Sometimes when I'd go into her dressing room, I would find her watching Mae West and other old-time comedians on her TV for inspiration, which I loved seeing.

In some ways, Samantha was the core of the show, at least the novel aspect of its depiction of female libido as a force of nature. Although her sexuality was heavily informed by the gay male experience, just as the show was conceived of by two gay men, Darren and Michael Patrick King. Looking for someone to fuck in every nook and cranny of the city, Samantha was the embodiment of Grindr years before the advent of dating apps. The gay guys writing her dialogue and one-liners put their unapologetic voices in her mouth. Samantha didn't judge herself or her friends for being brazen. She was free, so her clothes needed to be as well. Her story lines necessitated a fair share of lingerie—a black lacy ensemble to proposition a doorman, a silk negligee as creamy as mascarpone to recount her conquests while on the phone with Carrie. Of course, she couldn't spend the show in a bra and panties. There were many ways we marked Samantha as a woman of pleasure. At times, we swathed her in fabrics so soft and supple you wanted to reach through your TV screen and touch her. At other times, she was a goddess in metallics, a bright, shiny, and reflective object of desire. We also put her in halter dresses and spaghetti straps because Kim has the most beautiful broad shoulders. You can really hang clothes on them.

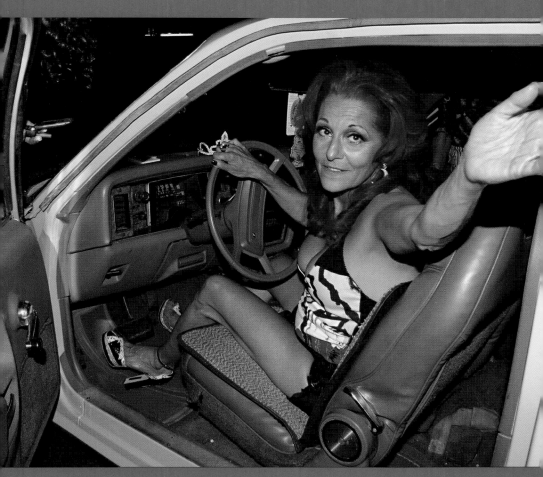

Kim is not Samantha; Sarah Jessica is not Carrie; none of the actors on *Sex and the City* were like their characters. Yet, when I began my work on their wardrobes, I always started with the human in front of me. The real-life person always came before the one on the page. I think that was the cornerstone of the respect and trust I built.

Not every relationship was a slow build. From the beginning, Chris Noth and I had an easy rapport. When we first started working together, I brought him to a suit maker in the East Village. Chris liked to wear suits that were a little fuller cut. But as time went on, I slimmed down his silhouette to more of a James Bond reference and cleaned him up. He trusted me to do my job to the point where he wouldn't put a tie on without asking me. That was saying a lot, since it was clear he wasn't that comfortable around women. When I asked him why he got along well with me, he didn't hesitate: "You're one of the guys."

Contrary to Chris's statement, I am a woman. But I did have opinions. Kim said I had such a strong vision, I should have been a director. I knew the story I wanted to tell with every detail from head to toe. Accessories are not to be overlooked or too glaring. If an outfit is a sentence, they are the punctuation. In one of Samantha's first sex scenes, we decided she should wear her stilettos. It harked back to the original inspiration I had shown Darren in my interview: Bettie Page meets Thierry Mugler. A man-eater like Samantha wouldn't take off her shoes for anybody. It wasn't only unexpected and humorous, but also in line with the portrayal of the character's sexual appetite. Molly and I stayed to make sure that those heels were on her feet when the action started. Shooting that first season was so hectic, and this day was no exception. The day kept getting longer and longer because of various delays and issues, so that it was 3:00 a.m. by the time they shot the scene. "Okay," I said to Kim. "Put the stilettos on."

Heels in general became a big part of *Sex and the City*, in no small part because of Sarah Jessica's ability to walk in them. Because of her ballet training and strong body, she could fly down the street, her feet barely touching the ground in the highest of heels. More specifically, they were Manolo Blahnik heels—at least in the beginning.

While I was working on season 1, before a single episode of the show had aired on HBO, I didn't have the best of luck with getting designers to participate. As I said, many didn't even return my calls. I already had a relationship with Manolo Blahnik through George Malkemus, who opened the Spanish shoe designer's Manhattan boutique on West Fifty-fifth Street. I had met the affable Texan through my ex, Barbara Dente, my conduit to the rarified. While Princess Diana, Bianca Jagger, and *Vogue* editors wore Manolos, they were not a household name. I always recognize quality, and these slinky, pointy, silky stilettos were quality of the highest order. After George and I became friendly, I made a deal with him. At the very end of their shoe sales, I would pick up whatever was left, basically headed toward the garbage can, and pay ten dollars a pair to take the remnants off his hands. He agreed, and I turned right around and sold them on Eighth Street for twenty or twenty-five dollars. The profit margin was slim, but I was happy to offer such great shoes to my customers at a price point they could afford.

George was more than happy to supply shoes when I began working on *Sex and the City*, and Sarah Jessica was more than happy to wear them. We were all happy. Little did I know that when the show aired in the summer of 1998, it would be the start of many things, but the end of Bargain Basement Blahniks at Patricia Field.

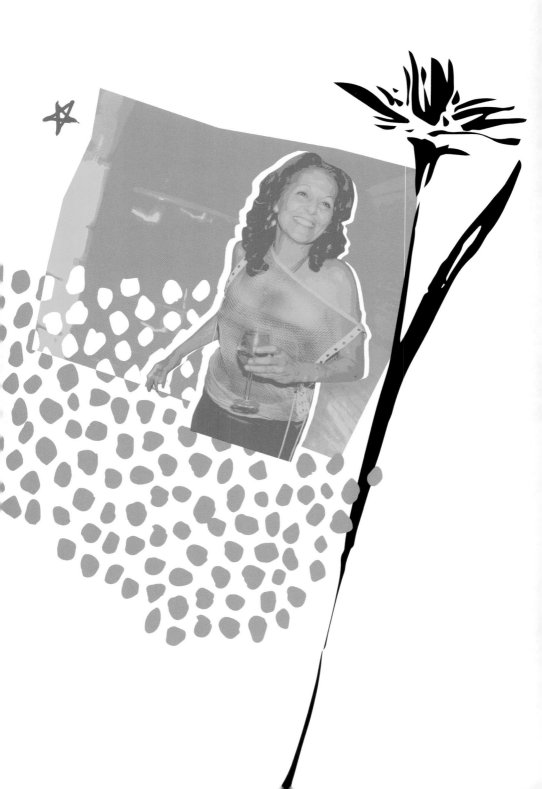

eight

LUX LIFE

WHEN I WALKED INTO FENDI'S SHOWROOM to shop for the second season of *Sex*, I didn't know what I was looking for. I never do, which is part of my recipe. Before the series premiered on HBO, on June 6, 1998, nobody knew we were alive. Other than Manolo Blahnik and Christian Louboutin—who made metallic mules in six different colors for Sarah Jessica that she wore nonstop—designers weren't interested in our little show. It wasn't until the first season was three-quarters through airing that I went to Fendi and noticed a shift.

The Rome-based Italian fashion house had introduced a "Baguette" bag as part of their fall collection, which they pushed during a sample sale in December by offering them at basement prices. They sold the small shoulder bags, which tucked under the arm like a loaf of French bread and normally retailed for five hundred dollars and up, to editors and other fashionistas for fifty dollars (one hundred dollars for the fur version). The luxury company, founded by Adele Fendi early in the twentieth century and known for its fur and leather goods, had brought on Karl Lagerfeld in the mid-sixties to modernize its look. The Baguette was fresh and cute. Its economy of size was much like that of a clutch: room for only the bare necessities, such as a wallet, lipstick, and cigarettes. The small shoulder strap, however, left your arms free to hail a cab and light a cigarette.

What struck me during that visit to Fendi wasn't just the Baguettes. To me, it was a bag; we used *a lot* of them in the show. No, it was the fact that they were throwing out the welcome mat for me. They told me I could have my pick of the many variations, from black nylon to mother-of-pearl, to use on the show. At the time of my visit, Fendi was in a temporary showroom that was basically nothing more than a large concrete square. To partition the space, they used curtains

of small, mirrored Plexiglas rectangles linked together. The curtains were very Pierre Cardin and to my taste, so I complimented them on my way out. Well, when Fendi moved into its permanent space, they sent them to me. They are still in my apartment to this day.

This represented a turning point, where people went from ignoring my calls to throwing their clothes at me—a phenomenon that only grew more outlandish as the seasons of *Sex* went by. I had picked a pretty simple brown leather Baguette for Sarah Jessica to pair with a daytime outfit that still would be totally valid today: cropped jeans with an oversized cuff, plunging and navel-baring spaghetti-strap top, and high-heeled sandals with an ankle strap. The bag became a huge hit after its TV appearance in late August 1999, later getting its own plotline in the season 2 episode where Carrie goes to therapy to get over her breakup with Mr. Big and starts dating a fellow patient played by Jon Bon Jovi. It was solely the success of the Baguette—which women lined up around the block to buy— that led the luxury goods conglomerate LVMH to purchase Fendi in October of the same year for $850 million. Despite the clear connection, I never got a thank-you note from Alda, Anna, Carla, Franca, and Paola Fendi, who had an even split of the company their mother founded.

It was clear that *Sex and the City* was defining culture in many ways. HBO executives were taken off guard by the success of *Sex*, which for its first two years was the highest-rated comedy series on cable, a trend that only continued as the show grew in ratings with every new season. And it wasn't just city slickers on the coasts who enjoyed watching four female friends engage in and talk about sex with all the unapologetic bawdiness of the gay men writing for them. Young gals from the suburbs of Atlanta to the heart of Houston, down in Baton Rouge and up in Chicago were loving the show's depiction of female

friendship and glamorous looks. While the suits at the network were surprised that there are people all over the country who like fun and interesting things, I wasn't. It was similar to what I had experienced in my shop, where customers came from everywhere and anywhere. Taste is not dictated by geography.

The cult following that developed around the show wasn't just about sex, either. It was also very much about the fashion. As one fan told the *New York Times* in an early article about the phenomenon: "I totally relate to the way they have real fun with the clothes. I'm all about fashion, and they are saying that anything goes."

She was right. Playing with and pushing the boundaries of style was a big part of the show's appeal, and simply my nature. No matter how popular *Sex and the City* grew, I never hesitated to try something experimental (like belting Carrie's waist on skin instead of the skirt, or accessorizing her bare bicep with a small tied scarf) if an idea came to me.

Sarah Jessica was up for almost anything, so when, in season 2, I put her in a dirndl skirt, she didn't blink. Not nearly as adventurous when it came to clothes, the producers were not happy when they saw Carrie in a vintage Alpine peasant folk dress for a picnic in a city park with the other women. She was in nature, so I gave her a Heidi moment. Sarah Jessica, who wore pigtails with the red-and-white dress, ran with the idea and drew freckles on her cheeks.

"Wait a second," said Darren while watching the dailies. "*What* is she wearing?"

"A dirndl," I answered.

"Why? Why!"

"She's having a picnic."

"I know. But it's so distracting. I don't want the clothes to speak louder than the dialogue. I can't hear what she's saying past the dirndl."

Fair enough. But unfortunately, the episode was already shot, and so the dirndl stayed. Sometimes, I'll admit, my imagination runs a little *too* wild.

Despite any small differences of vision Darren and I have in our long working relationship, we have a good dynamic in part because he appreciates my straightforward manner. He loves that I always say exactly what's on my mind and that I have strong opinions. Darren recognized that the wardrobe added another layer to the show and, early on, decided he would rather risk being too outrageous and getting it wrong once in a while than playing it safe. That was good, because I could never play it safe. And I wasn't usually wrong.

Sometimes I even surprised myself (though rarely). In the season 3 episode "Cock a Doodle Doo," after Carrie and Big fall into the pond outside the Boathouse in Central Park, she goes back to his place to change. And what does she come out with? One of his crisp white dress shirts cinched—naturally—with an Hermès belt to make the teeny-tiniest yet chicest dress imaginable. She didn't have many choices: Carrie would swim in Big's pants.

Fast forward sixteen years, when Rihanna reportedly went back to Drake's New York City hotel after both appeared at the 2016 VMAs. The next day, Riri was photographed leaving the hotel and going out for a dinner date at Nobu with Drake, wearing what looked like the same tuxedo shirt he had worn onstage at the awards ceremony the night before. Online sleuths noted the shirt was the same shape and buttoned on the right, meaning it was a men's shirt. The singer and fashion icon completed the look with a belt in what the Internet decided was an homage to Carrie's post pond style. While the web's memory is long, mine is short. Years later, while working on another Darren Star show, *Emily in Paris*, we were discussing doing a white men's shirt as a nightgown for the star, Lily

Collins. I was against it, because the shirt seemed too short, even for me. Erica Guzman, who was the assistant costume consultant on the show, argued that I had put Sarah Jessica in a similar shirt—on the street! With a belt! I couldn't believe I did that, but there was the proof in the form of video stills online. I can be forgiven for not remembering every outfit; there have been so many.

Over the years, *Sex and the City* was credited with starting or reviving so many trends that the show became known for it. Carrie's nameplate necklace and Fendi Baguettes were the tip of the iceberg. From Ray-Ban aviators to fanny packs to crop tops paired with maxiskirts, once Sarah Jessica wore something it seemed to be everywhere. By no means did I spearhead all the fads. For example, it was Sarah Jessica's idea to introduce the flower in season 3, which she first wore pinned to the vintage fur from Ina and went on to wear *a lot*. Because she was creative and into fashion, she always came with great ideas of her own. It was a wonderful collaboration.

I built meaningful working relationships with all the women on the show. Miranda was the character most in need of an evolution of her style from season 1. It was definitely a conscious decision, or my wish, to make her chicer. But you have to find a way where it works for the actor, the character, and the script. In the case of *SATC*, the writers didn't help Miranda during the first season when they scripted a plotline where her boss mistakes her for a lesbian and sets her up with a woman. What does a lesbian look like? Even though I am one, I'm not sure I have the answer. But in terms of TV at that time, it was a woman wearing men's or masculine clothing. We had Cynthia in suits and ties, buttoned-up shirts, boxy jackets. At one point I said to Cynthia, "I can't put you in another fucking suit." It's boring to do the same thing over and over.

I wanted to clean her up and throw a little fashion at her wherever I could. I don't like formulaic, and I felt like Miranda looked like a cliché of a lawyer. From the first episode of season 2, we made her character more playful. In a scene where the girls take Carrie to a baseball game to get her mind off Big, Cynthia looked rad in a black three-quarter Fendi puffer (with a belt), red turtleneck, and white clout-esque sunglasses.

Miranda had plenty of fun little fashion moments like that, but the real development of her style came when I started to put her in pieces that showed her shape. She got sexier as she got more successful and confident. Cynthia, whose comfort level increased as she grew to trust me, still wore suits. But they transitioned from masculine to feminine tailoring, accessories, and styling. I put her in pencil skirts with slim-silhouette jackets that were kept open to show her waist. High heels, drop earrings, all that fun stuff, and no more buttoned-up collars. Cynthia has such an incredible long swan neck that the world needed to see.

As the seasons went by, Miranda remained sophisticated and pulled together for the office, in the relaxed tailoring, muted shades, and understated elegance of Jil Sander or Calvin Klein. But off the clock, we took direction from her red hair and went a lot spicier. Molly unleashed all the shoppers to look for any and all strong patterns or prints for Cynthia. Dries Van Noten, Max Mara, or vintage, we pulled wildly vibrant colors that were pushing it for a lawyer. But that red hair was such a great frame and wanted a companion.

That red hair also took a lot of work. We tortured Cynthia when it came to her hair color. I was constantly fighting with makeup and hair over the shade of her hair. We would agree on a color, and then the hairstylist would phone it in and the result didn't photograph right. Bad hair color is like a bad wig

on camera; it looks amateurish and awful. I burst into the hair department and told them they were fucking up the whole look, not to mention forcing Cynthia to sit in a hair chair for hours and hours. "You can do better!" I said, which I believed or I wouldn't have said it.

For the good of the job, I will go to the mat. I will do lots of things I don't like to do, such as sit in traffic, wait around for other people to be ready, and dress men. Molly was surprised that I didn't enjoy pulling for men because she thought we did such a good job with them on *SATC*. Mr. Big was easy. As I told the costume department, "He's our Cary Grant." I wanted him to be a timeless leading man in a classic look that for the most part consisted of dark suits and white shirts.

If Mr. Big was on one end of the spectrum in men's fashion, then Aidan was on the complete opposite. The financier vs. the furniture maker. There would be no power suits or any suits for this earthy guy. For Carrie's new love interest in season 3, the showrunners cast to type, hiring John Corbett, who had risen to fame playing Chris Stevens, the poet-philosopher-DJ in a remote Alaskan town in *Northern Exposure*. When the actor showed up to meet with the costume department, he arrived loaded down in heavy pieces of turquoise jewelry, as if he'd been on a shopping spree at a Navajo Nation gift shop. The worst part, however, was that he wanted to wear it on the show. I think I saw Molly physically gag. "Are you a cowboy?" I asked. "Get that turquoise the fuck out of here." I fought him hard on the West Coast hippie vibe he was trying to insert in a cosmopolitan East Coast world. I negotiated him down to two pieces of turquoise, which I tried to bury in the Brooklyn artisan hipster look with suede jackets, flannel, jeans, and boots. When we got bored with that, we flipped the formula and put him in black leather pants with a denim shirt—but we couldn't move forward without a goddamn turquoise ring on his middle

finger. Even though we were absolutely brutal to John's face, there were no hard feelings. In fact, he said I was his favorite costume designer, because I let him take home Aidan's entire wardrobe—from the Calvin Klein underwear for a bathroom scene with Carrie to seven-hundred-dollar Prada shoes to the leather pants.

Molly was right; I don't dislike dressing all men. I loved doing the costumes for Willie Garson, who played Carrie's gay best friend, Stanford. We took inspiration from the many examples of real-life Stanfords, such as Barneys window dresser Simon Doonan or Hamish Bowles, a longtime *Vogue* editor and one of Anna Wintour's main walkers. These creative and witty men were bookends to their equally colorful gal pals. To cement their friendship on-screen, Stanford had to be as expressive in his aspect as Carrie. Luckily, Willie loved the picturesque clothes we brought him. I got lucky because at that time Ozwald Boateng had a rep in New York, and Willie was the sample size. That meant I was able to put Willie in a lot of the British-Ghanian designer, who is extremely expensive and would have been out of the question for a secondary character even with our budget. I got to put him in expertly cut, gender-fluid designs that were way ahead of their time because they fit Willie and he understood them.

In my experience as a costume designer, men box themselves in more than women. For the most part male actors push back more on color, fit, and accessories. When an actor is open to my ideas, I am motivated by that person's willingness to try new things and will go out to find those special pieces for him. Years later, I felt similarly about Samuel Arnold in *Emily in Paris*. We bathed his character, Julien, in checks, flowers, rainbows, and more. He was excited by his wardrobe, including a Kenzo suit with orange poppies and green leaves on a black background and an inexpensive ASOS white suit

jacket and pants with a blue floral print snaking up the legs, back, and arms, as if the body were a trellis. He said his character emboldened him to take more risks with his dress in real life. The person underneath the clothing is always the true inspiration. On *SATC*, nobody else but me was allowed to dress my Stanny. I even picked out his ties at the end of the series, because I really loved Willie Garson, who, tragically, died at fifty-seven from cancer. I will always miss his true sweetness.

Breaking and rebuilding constructs at will—whether it was a white pump after Labor Day or mixing patterns and prints—apparently made for exciting TV. When I first heard that people would gather for *Sex and the City* viewing parties, I thought, Really? In truth, I wasn't a superfan of the show, because having worked on it I already knew what it looked like. But in the pre-social-media age, when the press began covering *Sex*'s wardrobe as closely as the movements of the stock market, viewers tuned in with excited anticipation to see what unexpected getup their favorite gals might be in. It was like my feeling about the junk show in Las Vegas; the thrill was never knowing what I might find.

When the top brass at HBO saw how the show's styling resonated with millions of women, they gave us a bigger budget. The respect I'd earned from the network and also from the fashion industry meant that by season 3 we could dress Samantha, Carrie, Miranda, and Charlotte in pretty much anything we wanted. My bazaar became global. HBO would ship us off to the shows in Milan, Paris, and London, where we had front-row seats. I was able to call any place in the world to borrow whatever I needed to get ahead of the groove to dress Carrie.

I was grateful that the response to my work was positive, but I hadn't changed from what I've always done. It was the circumstances around me that changed. My mix of high and low, something I'd been doing my whole life, suddenly made me a genius of style. I was the Einstein—or maybe da Vinci—of highbrow/lowbrow, putting Sarah Jessica in a cheap pink Club Monaco sweater you could find in a mall with a cropped red Chanel jacket, all layered over a striped Nanette Lepore dress.

Michael Shulman, a friend I originally met through Armen and a self-described expert on all things luxury, told me that one of his favorite accessories on *Sex and the City* was a necklace I put on Kim for the season 5 premiere about when the navy came to town for Fleet Week looking for a good time. "Pat, that gold-and-turquoise necklace is gorgeous!" he said. "What is it? Boucheron?"

"Nope. Earrings Plaza."

"*Earrings Plaza?*"

A club kid from back in the day, Michael knew Earrings Plaza. EP, as the regulars call it, is a fluorescent-lit storefront on Broadway and Twenty-ninth Street, packed with cheap costume jewelry and a favorite spot for drag queens in need of a bauble or twenty.

Billy Beyond, an old friend of mine who I had asked to look for different accessories during that season, was the one to find the necklace. Billy was a DJ, makeup artist, jewelry designer, and model, who walked Todd Oldham's runway as a woman for eleven seasons along with all the supermodels like Christy Turlington and Cindy Crawford during the nineties—and he had impeccable taste. Once we had a decent budget, I liked to recruit friends when we needed more help.

In the following season, I turned to David Dalrymple for a downtown look for our uptown girl Samantha, in a scene where she takes the girls to a trendy new club. When David

finds something he loves, like sequins, he uses it in all different ways. That was also true of his beloved T-shirts, which he had started to cut into halters and lace-up corsets. He turned the T-shirts he sourced from overstock stores and street corners into fashion pieces. His "I love New York" halter top ended up in a famous image taken of Britney Spears by the photographer David LaChapelle. After Alicia Keys wore one of his creations, made from a Tupac T-shirt he had picked up on Fourteenth Street between Avenues C and D, on the cover of *Vibe*, David received a call from the Tupac estate. They didn't want him to cease and desist; they wanted a cut of the profits. They appreciated the work, but he had only made a few of the shirts—very bespoke. Similarly, when Farrah Fawcett learned we were selling stuff with her image, she came into the shop and bought out all the one-of-a-kind pieces.

For the scene of Samantha's downtown club experience where Carrie is caught smoking weed, we used a New York Dolls T-shirt David customized into a lace-up halter top for the House of Field runway show. In fact, she wore House of Field jeans decorated with—what else—T-shirts.

Billy was like David, and so many of my friends or kids who had worked in my shop. He had incredible taste and an underground sensibility that often brought fresh new ideas to the show. In this case, it was a cheap necklace on fishing line from Earrings Plaza.

Michael laughed when he heard where Samantha's necklace was sourced. "I was sure it was going to be a $150,000 piece," he said.

"It cost seven dollars and eighty cents. Well, actually, the bib Kim wore is a set of three necklaces for twenty dollars," I said.

After they finished shooting the scene, we removed the necklaces with scissors and threw them in the garbage, be-

cause (1) they were covered in glue and (2) everything from Earrings Plaza breaks after you wear it for an hour.

While Billy could go low—really low—he could also go very, very high. For the same season, he designed with Kwiat a quarter-million-dollar diamond brooch specifically for Carrie.

In Tupac shirt with David at Fashion Week
PHOTOGRAPH © TINA PAUL

The veteran diamond jewelry company had reached out to see if they could participate with the show in some way. So I sent Billy, who, having been a supermodel himself, is very comfortable around luxury goods.

Sometimes choosing extravagant elements and sometimes not, I never look at price tags in my wardrobe work. Instead of taking my inspiration from labels, I conjure up a world based on ideas. The concept could be as simple as a few words. "LUX LOOK" was something I came up with when the characters had a seasonal arc that, as Kim put it, was all about: "I love you, but I love me more." The result was a lot of gold and white.

Sex and the City was a fantasy that shed light on reality. That was true for the sex, the city, and the clothes. Who wouldn't want to drip in diamonds or Dior? The riot of color, whimsy, and—yes—gold and gems that hung off Carrie and her pals as they traipsed through life entertained the fans. And yet, one of the media's favorite features on the show they glorified was a deep dive into how much things cost and the impossibility of any of the characters' ability to possess them. *Sex and the City* wasn't a documentary; it was about escapism.

I thought it was ridiculous when *InStyle* tabulated the value of the Bulgari jewels Carrie wore, including a $182,000 eighteen-karat gold watch. Some of these journalists liked to get aggressive with me. I guess the people have a right to know, but it still felt outlandish.

"How can a freelance writer afford Chanel, Gucci, and Dior purses?"

"Is it realistic that none of the characters ever wear the same thing twice?"

When a reporter asked me, "How is it possible that Carrie lives in such a small apartment and has all these shoes?" I answered, "I don't know. Maybe she has a storage locker in Brooklyn. You don't know her life."

Highly amused by the whole exchange, Molly added, "Maybe Carrie Bradshaw did have a storage unit in Brooklyn. Of course, that makes totally plausible sense. I would've assumed she would've been with Moishe's Moving & Storage downtown myself. But you never know."

Women all over the world who came to idolize these gals and find a personal sense of freedom through them would have been let down if the characters didn't display an elevation of style. Plus, what was I supposed to do when almost every designer under the sun offered us fashion? It seemed like every day boxes and boxes would arrive with clothes we hadn't requested. Every designer wanted their stuff to be in our show.

By season 6, we had become a bona fide juggernaut. Each episode was like doing a weekly version of *Vogue*. In addition to Molly and me, there were two assistant costume designers and two shoppers, as well as a half dozen or so production assistants who spent most of their time picking up and returning pieces. (They traveled in pairs because parking is a nightmare in New York City, so one would jump out of the car and go into the store while the other drove around the block.) We were all working crazy hours. It was nothing to have an eighteen-hour day when we were shooting. People were so tired we put them up in hotels in Long Island City, near Silvercup Studios, where we shot, so they didn't kill themselves driving home. We had a couple of tailors just for our department and an accountant assigned solely to code every item over one hundred dollars into the computer. With stuff coming in and out all the time, the data entry was more than a full-time job.

We called in anything and everything for those girls. We had to devote an entire room just to the jewelry call-ins. No matter how big we became, however, the network kept us in the same square footage. That meant that our racks of clothing, which seemed to grow by the day, began muscling in on

The Sopranos' territory down the hallway. No scenario was too extravagant if we felt something was *needed*. When we flew the Chanel couture chiffon camellia-flower fascinator for Carrie to wear to the baptism of Miranda's son Brady, it got its own seat! It was the perfect hat for Sarah Jessica in a church, but why it earned a plane ticket I have no memory.

Once we missed a scene with Mr. Big and Carrie where she is brushing her teeth, still wearing a tie-dye dress from earlier in the episode. When they were ready to shoot the bathroom scene, unfortunately, the dress was already gone. We had returned it to the label, which had sent it on to Mexico for a *Harper's Bazaar* shoot. At first, the producers thought we should just copy the dress. The art department did their best, tie-dyeing fabric, but it wasn't going to match. So we threw an intern on a plane to Mexico to get the dress back. "Shoot that thing today, because we are ripping it out of your bony fingers," Molly told an unhappy *Bazaar* editor. Later that day the intern called from the airport to say she had the dress and was having a margarita. "Great," said Molly, who by then had become more like a taxicab dispatcher than the supervising costume designer.

There's no other way to say it except that we exploded. *Sex and the City* style became a global sensation, the effect of which was keenly felt on Eighth Street. Tourists would come by busloads as if they were going to Disneyland. Armed with *Sex and the City* maps, much like those for the homes of Hollywood stars, tourists trekked through the places associated with the show. After grabbing a cupcake at Magnolia Bakery or taking photos on the stairs to Carrie's apartment at 66 Perry Street (even though she was supposed to live on the Upper East Side, that's where they did the exterior shots), eighty women would get off of a bus, come into my shop, and buy something from the racks of boas, nameplate necklaces, hot

pants, and wigs. In the morning, there would be people waiting for our doors to open. There was a change in the customers. Middle American moms began outnumbering club kids. I happily welcomed them all. All day long, it was just nonstop foot traffic.

Although the shop was definitely busier than ever, in late September 2002 I had to close Eighth Street after thirty-six years in business. I didn't want to leave the Village. Sure, the area was no longer what it once had been, a district for small independent boutiques, bookstores, and restaurants. Thanks to changing tastes, the advent of fast fashion, and rising rents, soulless chain stores had started to take over. But Eighth Street was my home, literally and figuratively.

When New York University, which owned the building that housed my shop and apartment above, decided to double my rent, I tried to fight it. Having bought up most of the real estate in the neighborhood, my landlord and alma mater did not feel the need to negotiate. I had a good relationship with the old real estate guys, who used to stop by the store to see if I wanted to go to lunch. Real relationships are important to me, and this was no different. Then the university got a new president who brought in all these corporate guys, who I *didn't* like. The death of my little shop was indicative of the high-octane gentrification sweeping the Village. The name of the neighborhood described its appeal: nice cafés, friendly folks, buildings on a human scale, a *village*. The large apartment towers eclipsing walk-ups and national chains wiping out mom-and-pop places had a whole other feeling.

On the heels of the news that the original Patricia Field was shuttering, I issued a statement through my spokesperson: "In 2002, NYU kicked her out and all the other business followed. NYU killed Eighth Street. This is all she has to say about it." We had going-out-of-business sales, shut the door,

and that was it. Those poor ladies seeking out a *Sex and the City* adventure were so confused when they got off their buses and found a dark, empty storefront instead of the rollicking style emporium they had been promised.

The blow was softened by the fact that I had opened Hotel Venus, another store, in nearby SoHo. Just like my Eighth Street shop, Hotel Venus was a world unto itself that you entered to find interesting things before online shopping and Instagram took over. In a baby-blue building right on West Broadway, Hotel Venus was a fun house with realistic Adel Rootstein mannequins glamorously beckoning shoppers in from the window. Inside, there was a black patent leather sofa, a photo booth that turned your photos into stickers, a hair salon, and lots of fashion. The SoHo store had a crazy mix of cultures and flavors, enhanced by a Japanese buyer and Brazilian manager. A case of rhinestone jewelry and nameplate necklaces might be flanked by butt-baring Brazilian bathing suits and Japanese blow-up furniture.

Hotel Venus also ushered in a new generation of celebrities, for whom the line between reality and entertainment was growing fuzzier by the day. When it came to the trends of the early 2000s, pop stars and the new genre of "reality" stars needed look no further than down the stairs of my shop. From ultra-ultra-low-rise jeans to micro-miniskirts to crop tops of all kinds and belly chains, we had everything you needed to satisfy your dot-com-driven fantasy. We had always reveled in sexy clothes that incorporated sheer fabrics, laces, and cutouts. The only difference was that now they were in fashion.

Performers like Beyoncé and Britney Spears wanted to be super sexy, and we had the goods. Britney was introduced to House of Field by her stylists, Kurt Swanson and Bart Mueller. The pair, better known as Kurt and Bart, who met in the early eighties at the University of Colorado in Boulder, started a

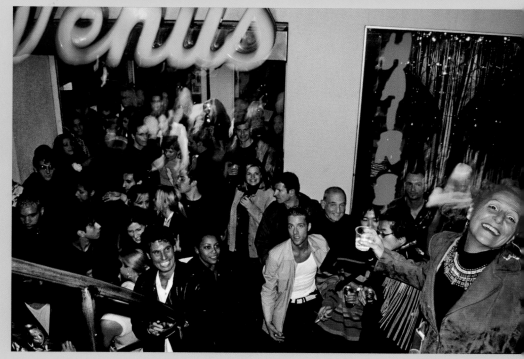

Party at Hotel Venus
PHOTOGRAPH © TINA PAUL

small label, Design Asylum, which they sold at my shop when they arrived in New York City. The main inspiration for their fashion was the club scene. In the end, though, they realized they much preferred making clothes for themselves and their friends to churning out a clothing line. So they transitioned to a successful career in styling, in particular with musicians, including David Bowie, Courtney Love, and Pink.

Kurt and Bart, who walked in my Grand Street Ball back in the eighties, were also friendly with House of Field designer David Dalrymple.

They were with David when Candis Cayne wore one of his creations in the Miss Continental pageant. For Candis, performing a Bob Fosse number in the drag queen competition, David had made a real showstopper of an outfit: a pinstripe tear-away suit held together with Velcro, and underneath a nude-illusion bodysuit covered in crystals. As Candis brought down the house, Kurt and Bart looked at one another and agreed that this would be perfect for Britney.

They showed the young performer pictures of Marilyn Monroe singing "Happy Birthday" to JFK as inspiration and explained, "We just want you to look like you're naked and covered in diamonds." Britney was just an eighteen-year-old kid, but she had the confidence and ambition to go for it. Kurt and Bart collaborated with David in the making of a piece of pop culture history at the 2000 Video Music Awards, when Britney ripped off a sparkly pinstripe suit and fedora to a shocked crowd that for just one second thought she might actually be naked. She performed her hit "Oops! . . . I Did It Again" in a Dalrymple bedazzled nude-illusion low-rise boot-leg pant and bra top, to much acclaim. Billboard called it "a master class in delivering a televised performance that says *I have arrived.*"

It was also a master class in costuming, which David pulled off with grace, despite the pressure of turning a teenager into

the Princess of Pop. While he was pinning the outfit on a basically naked Britney, her father, Jamie Spears, who would later become infamous over his daughter's conservatorship, walked into the dressing room. While David's head was in Britney's crotch doing some delicate tailoring, Jamie joked, "What are you doing with my daughter?" That wasn't the only grief he got. To this day, Candis still lets him have it that he snatched her winning pageant look.

Britney—who also wore a plunging black gown with a thigh-high slit by David to the red carpet of the 2000 VMAs—became a bona fide House of Field fan. In 2003, she donned a black micro-mini with my iconic signature in red emblazoned across her butt for a comedy roast of former *TRL* host Carson Daly. Opening the celebrity-studded bash, which aired on MTV, Britney paired the low-rise miniskirt with a T-shirt with the logo of Page Six (*New York Post*'s infamous and long-running gossip column) altered to read "Page Six Six Six." The shirt was cut around the neckline to fall off the shoulder, revealing a cute rhinestone bow-tie necklace, and around the bottom so that it turned into a crop top with the ends of the hem tied tightly in back. She accessorized to perfect punctuation with Patricia Field pop-art leggings with a red polka-dot background, black pumps, and a jaunty black fedora. I call the look "muckraker gone wild."

When Britney attended the House of Field Spring 2003 fashion show—wearing low-rise jeans, a plunging jean vest, denim newsboy cap, and multicolored sparkly bangles up her arm—it was the height of the *Sex and the City* craziness. David had always felt that we should have a show during New York Fashion Week. Out in clubland our clothes were putting on a show almost every night. "They need to be out for Seventh Avenue during the day," he argued, and I didn't disagree. In 1995, we took a slot on the fashion calendar, when Fashion

Week was a lot smaller than it is today. There were maybe a hundred brands that put on shows, mostly comprised of New York mainstays like Ralph Lauren and Donna Karan. Now there are countless events. Still, we were given the smallest, most out-of-the-way venue available in Bryant Park, the New York Public Library's Trustees Room. In the show—featuring a collection of "Halloween costumes" in a nod to the important place the holiday had for our brand—I modeled a black cat costume alongside Betsey Johnson in a leopard one. For the finale, I escorted David out in a white patent leather nurse's outfit to an exuberant front row of friends such as RuPaul, Susanne Bartsch, the photographer Nan Goldin, and *Paper* magazine editor in chief Kim Hastreiter.

By the time we presented the House of Field Spring 2003 collection, the front row was a fusion of all types: people I worked with; artists like Eve, Lil' Kim, and Britney; and, as always, my friends who never missed the opportunity for a good time. The singer-songwriter Mýa walked the runway wearing the Bob Marley ensemble that Beyoncé later used for one of her performances. Her runway look included an oversized black-and-blue flower in her hair—a nod to my work on *Sex and the City*. David had gone to a guy in the garment district who for decades made beautiful silk flowers with the same flower dyes used in the Victorian period. His studio was one of the many special places that used to dot the garment district but don't exist anymore. Instead of using his mold to make silk flowers, per David's instruction, the craftsman used T-shirt material.

Britney didn't just wear David's designs for big events; she also shopped for herself regularly at Hotel Venus. Despite the fact that she was arguably one of the biggest stars on earth, it was nothing for her to show up alone on a slow weekday afternoon when the store was empty. She would walk around,

House of Field presentation at New York Fashion Week 2003
PHOTOGRAPH © TINA PAUL

looking at short, pleated plaid skirts and silky camisoles, while little by little other customers began to notice the "Toxic" star and follow her around, pretending they just happened to be interested in the very same racks as her. If Britney noticed it, she never let on. Instead she ignored the growing, gawking crowd and went about her business. She refused any special treatment from the staff, including privacy while she tried on clothes. The dressing room curtains were made from a sheer turquoise fabric with gold zebra print I brought back from Brazil. Paolo—one of my stylists working at the store that day, whose family's custom drapery business in Detroit made the

Brazilian material into the dressing room curtains—worried that people would stare at Britney through the gauzy material as she undressed. So he asked her, "Do you want me to kick everyone out?" No, she said, and tried on clothes like any other customer, and then, again just like any customer, paid for them herself at the register. As soon as she walked out the doors of Hotel Venus, though, her regular-customer status abruptly ended. Although this was before smartphones could capture people anywhere, the paparazzi would always get wind of Britney's whereabouts. Photographers and fans would gather outside and scream her name as she raced out and into a car.

Perhaps no one symbolized that particular time in pop culture more than Paris Hilton, one of TV's first bona fide reality stars with her show *The Simple Life*. The hotel heiress, who used to come in all the time with her Chihuahua, Tinkerbell, would sit on the floor and make piles of stuff. There was always two of everything. "This is for LA," she'd say, "and this is for New York." She told the press that my store on Eighth Street was the first one she ever went to on her own and that Hotel Venus was a mainstay of her style. For a girl who received her first Chanel bag for Christmas at five years old, my shop was retail rebellion. Eight-inch heels, tiaras (apparently she had over two hundred, which she kept in crystal cases), four-fingered gloves, Philip Treacy bucket hats silk-screened with Andy Warhol's image of Debbie Harry, and a pink cropped bomber jacket with my Patricia Field signature logo on the back were the kind of clothes that drove her socialite mother crazy. What made me crazy was how the merchandise, which she would leave for an assistant to pay for and pick up, sat for a couple of weeks in the back of the store.

I was fond of all my stores—they were, after all, like my children—although for different reasons. Eighth Street was

the firstborn. Hotel Venus, however, was where I found my be-loved Sultana and Putana. One Sunday on my way into work, I had found a parking spot on Broome Street and was walking over to my store on West Broadway, when I passed a Jeep with a sign that said, "Poodle puppies for sale." I had recently lost my sheepdog, Pri Pri, who had been such a sweet companion. In the middle of an apartment renovation, I wasn't looking for another dog. Unfortunately, I got a glimpse at the puppies and couldn't help myself. "Which ones are the girls?" I asked the puppy woman, because I think girl dogs are better and easier. I went over to the two she pointed to, and Sultana gave me a kiss. Then I went over to Putana, who played with me. "I'll just have to take them both," I said. I'm a sucker for dogs.

My renovation was no small interior design job but a mas-sive construction project. Two years before I closed Eighth Street, I had the opportunity, money, and mind to buy a piece of commercial real estate on the Bowery. The neighborhood had a long, colorful history. "Things are in their working-day clothes, more democratic, with a broader, jauntier swing, and in a more direct contact with vulgar life," Walt Whitman wrote about the Bowery for the *New York Leader* in the spring of 1862. In a rapidly gentrifying city, the area was still famous for its flophouses and dives, like CBGBs, the biker bar that proclaimed itself the "birthplace of punk." I'm not persuaded by fancy things; I like to be where the life is.

I had a lot going on, but I never let it interfere with my work. Darren didn't even realize I continued to run a boutique until several years into *Sex and the City*. "Wait a second," he said. "This whole business is still happening?" Thinking retail was in my past, he was amazed that I had what he called "an-other side" to my life. While I was happy to impress, I didn't view myself as a multitasker, since all my tasks flowed from

First party at Bowery apartment
PHOTOGRAPH © TINA PAUL

the same interests and influenced each other in a positive, congruous way.

I remained forever on the hunt. New designers continued to get their start at my shop—such as Alice Roi and Richie Rich, the Limelight fixture and founder of Heatherette—while *Sex and the City* also put a lot of talented people on the map. A perfect example was Faraone Mennella. The jewelry brand was the love child of Roberto Faraone Mennella and Amedeo Scognamiglio, who first met while high school students in Torre del Greco, a suburb of Naples famous for a

centuries-old tradition of coral jewelry sourced from surrounding waters. While Torre del Greco might have been good for coral, it wasn't great for gays. So the two left for New York City, where Roberto studied at Parsons (which he told his family was a business school) and Amedeo (who hailed from six generations of cameo carvers) hit the pavement from Macy's down to Chinatown to sell cameos. Sarah Jessica Parker was the one who wanted to use their jewelry on the show and called the men late one night in 2001 to see if they'd be interested. They said yes but never got in touch. About six months later, Roberto and Amedeo were taking a midnight walk on the Upper East Side, where we happened to be doing a night shoot. One of them knocked on my trailer and announced himself. "Where the hell have you been?" I said. Turns out they had misplaced Sarah Jessica's number after their conversation. We didn't hold it against them and instead called in their entire line. The Stella earrings I used on Samantha, which dangled like sculptural mobiles, became instantly iconic and a perennial bestseller for them.

The romantic and professional partners built a small jewelry empire that ranged from tony boutiques on the Upper East Side and Capri to an affordable line for the Home Shopping Network. I wasn't doing anyone any favors; if someone came to me and I believed in their product, I gave them a chance. It was a simple formula that always seemed to work for me.

"If a Manolo Blahnik pump with a three-inch heel was the definitive 'It' shoe for a generation of urban professionals raised on a diet of 'Sex and the City,' its jewelry equivalent was a sexy gold earring known as the Stella," Guy Trebay wrote in a *New York Times* obituary of Roberto, who died tragically from cancer at forty-eight. We were all heartsick when we heard the news. His influence was felt widely.

My entrepreneurial spirit meant I seized opportunities whenever and wherever they arose. A year before Roberto and Amadeo knocked on my wardrobe trailer door, Molly and I decided to go to Las Vegas for an HBO Sports event with British featherweight champ Naseem Hamed. "Do you like boxing?" asked Michael Shulman, when I called to tell him we were coming to Las Vegas, where he had relocated. "What do I care?" I said. "It's a trip to Vegas."

Having flown in on HBO's jet, we met Michael in the lobby of our hotel, where jaws dropped, while small children pointed at the spectacle that was us. My floor-length, gold-lamé trench coat and poppy-hued hair were enough to light up the room. Michael also shone in his long Shanghai Tang cheongsam in royal blue with gold dragons. Molly was her usual pretty, blond self, surrounded by weirdos. I don't remember much about the fight except that Hamed descended into the boxing ring on a "flying carpet," which I thoroughly enjoyed.

The next day we hit the Forum Shops at Caesars, where I didn't find anything special. Instead I hit the mother lode at Walgreens. Michael had driven me to the pharmacy because I needed razor blades. He and Molly stayed in the car while I ran inside. Except I never came back out. "I'm going to see what's keeping Patricia," Molly said after I'd been gone for more than forty-five minutes. Molly is the only person who calls me by my formal name.

After wandering the aisles, she found me—at the tchotchke counter. By the time Molly and I exited Walgreens, I had two shopping carts of large garbage bags filled with kitschy tourist trinkets. I wound up selling the gold plastic dice, "Las Vegas" rhinestone iron-on, and other items that I had bought for $2.99 each for $25 at my shop. As Michael, who had waited in the car for an hour and a half, remarked, "You're always working."

Work, play, costume design, retail: again, these divisions were meaningless to me. People in the TV industry were surprised that I brought a bunch of my staff over from Hotel Venus to come work with me when the wardrobe department started to grow. They had never seen that before on any other show. But Darren didn't hire me because I did things like everyone else.

Whether the venue was my shop or the wardrobe department, I always had the same criteria for hiring. I chose the people who I thought had the most talent and never asked for their pedigree. I gave them a shot, and if they did well, great. If not, they weren't asked to return. The good ones, like Kabuki Starshine, made names for themselves all on their own.

I brought Kabuki to *Sex and the City* because he was a stunning makeup artist. He is really a painter, with the face his canvas. Before I hired him, he had long been creating alien, bejeweled, beguiling, and mind-boggling looks on club kids and drag queens. Unfortunately, Sarah Jessica had a problem with the extremely heavy hand he took to applying her foundation. It was a little too drag queen for her. However, the issue that finally got him fired after a few years, he told me, was that, apparently, he didn't clean his brushes. I remember when Matthew Broderick was once asked what it was like to be married to Sarah Jessica Parker, he answered, "It's like never running out of toothpaste." She was definitely a clean human, and Kabuki did not pass the clean test. There were no hard feelings. His time on the show provided him enough of a professional jump start that he went on to have a major career in film and fashion, including Michael Jackson's last two photo shoots before his death (which were also the first ones that Jackson had done in a decade). "I want that," said Jackson, pointing at Kabuki, who didn't understand what the pop star

meant until the two men stood side by side in the mirror. He wanted contouring to give the appearance of Kabuki's cleft above the lip.

I used whoever was useful from the store: Artie, Atshushi, Tracy. Even Armen once earned seventy-five dollars as an extra. In the cast of characters who migrated from behind the sales counter to the set, my girlfriend Rebecca continued to play an outsized role. From the very first season, she helped me on the show. She had great taste and a young, modern eye. Whether it was thrifting in Miami, where we traveled often, or using the newsboy hat Carrie wore in season 4 that was ripped from the headlines of Rebecca's look, she had a big influence on me and the show.

As she approached thirty, Rebecca decided that my world was no longer the world she wanted to be in. According to her, she fell out of love not with me but with my lifestyle. Dressing up and going to clubs, once a beautiful expression to her, felt like it was a route to, at best, nowhere or, at worst, her demise. When she wanted to stay in, I teased her, "You're so old." I didn't want to stay in with Jo Ann, and I didn't want to stay in with her. I'm not domesticated like that.

Even when we stayed in, however, more often than not the party followed us home. The kids from the store or the show came over, and out would come the vodka and whatever else, as well as some music and stories from the day. Rebecca complained that she was exhausted and just wanted to watch TV, but that we were never alone. She thought I was a pied piper, the gang thought she was a killjoy, and I was stuck in the middle.

I took care of Rebecca and gave her a career, but she wanted something else. She wanted a home and children, and that was not me. I already had all those things. Splitting up

is usually hard, but my breakup with Rebecca was especially painful when she realized she had broken up with not just me but a whole family. I have always embraced the concept of "the more, the merrier." With me, you throw yourself in and become a part of my world. It's a constant show and a force of community. The players are far from perfect, myself included. When we're gone, however, it's awfully quiet.

nine

MAKING A NAME FOR MYSELF. AGAIN.

WHEN *SEX AND THE CITY* ENDED, on February 22, 2004, many of us who worked on it asked ourselves, "How do we follow that?" It was a good question. Six seasons and many, many outfits later, the series had inspired a devotion that bordered on religious fervor. And it wasn't just in the US. Italy apparently had a talk show exclusively devoted to Carrie, Miranda, Charlotte, Samantha, and their clothes.

I experienced firsthand the reach of the show when I brought my aunts Les and May to set one day. My family never understood my work for film and television. "What's a stylist?" my mother asked more than once. I invited them to watch a scene we were shooting in Rockefeller Center, so they could see what I did. They were happy enough, as they always were to see me, but not particularly impressed. That is, until Aunt Les saw Chris Noth. My little elderly Greek aunt lit up like a teenage fan and, looking up at the tall actor, said in a loud voice, "I love you, Mr. Big!"

At risk of sounding ungrateful, *Sex and the City* was like an in-law who won't get out of your life. It's hard to move on from a show with that kind of reach, and where the costumes were so central. So when I called Molly to tell her that our next gig was a movie where Meryl Streep played the villainous editor in chief of a *Vogue*-style fashion magazine, she accused me of practicing Greek witchcraft.

Dressing one of the world's greatest movie actresses as a sadistic style fashionista was certainly a soft landing after saying goodbye to Carrie and the gang. But ancient spells didn't get me *The Devil Wears Prada*. No, it was earthbound relationships—in this case my longstanding friendship with *Prada*'s director, David Frankel. We knew each other from Miami, where we both had places. I have always loved Miami, from the time I

visited there as a kid inspired by my friend Karen and her family, who went every winter. I finally convinced my mother to go to Florida when I was fourteen. First we had a stop in a city on central Florida's Gulf Coast. Tarpon Springs was once known as "the sponge capital of the world," when Greek immigrants who settled the area and dove for the sea creatures in the Gulf of Mexico created an export industry that was at one point greater than citrus fruit. My mother enjoyed the tavernas and historical facts about the brave divers, but I was itching to get to Miami. We were staying at the Nautilus, which ended up being too wild for my mom, who moved us to the fancier Eden Roc. The wildness, though, was exactly what I liked about Miami. It is gorgeous and alive. The sun is out; palm trees are swaying; music is playing. You cannot be unhappy there.

During *Crime Story*, Michael Mann was producing *Miami Vice* concurrently. A lot of his crew on our show were also in Miami. So when I went down there, I immediately knew people, who hooked me up down there with TV and movie work. I wanted to put down roots in Miami, which at that time was like the Village by the sea, an affordable and picturesque place full of artists, creative young people, and fun. After I did *Miami Rhapsody*, I bought a building with an Eighth Street devotee, my friend Michelle Saunders, on Española Way and Jefferson. Trying to maintain an old, crumbling South Beach building proved to be a lot of work. But even at the height of our landlord days, we never let it get in the way of our pursuit of fun. We went out clubbing the night before a roofer arrived to patch its many leaks, barely making it back to the building before he showed up. When he announced he had patched all the leaks, Michelle was ready to pay the guy, but I wasn't. Still in our getups from the disco, heels, makeup, and all, we went to the roof, where I scoured every inch and found many spots

left unattended. I have never let partying interfere with good business or getting what I pay for.

Although I decided being a landlord was not for me, I didn't abandon Miami. Instead I bought an apartment on Ocean Drive, where I could soak up the sun, sea, and palm groves right from my terrace. When Miami stopped giving tax breaks for TV and film productions around the same time that *Sex and the City* started, there was no more work to be had in the city. Still, it remained my second home and source of sunny inspiration. In those days, there was a store in the Design District called Bazaar Bazaar, run by a wonderful Italian lady with impeccable taste. She had unusual pieces you couldn't find anywhere else and was a delightful person to visit. Rebecca and I would always stop by when we were in Miami, to shop for work, ourselves, or whatever excuse we conjured up.

Although South Beach has become so commercial and lost a lot of its spice, I still find Miami an uplift for the eye. When I arrive from New York, off come the warm layers and the dark tones in which New Yorkers like to hide themselves. In Miami, people like to put on a show, roller-skating down the boardwalk in hot pants or sipping mojitos at an Ocean Drive bar in barely there dresses. Even the high-end designer boutiques one finds in any major city these days have a hint of tropical flair. You'll see Chanel ballet flats in bright pink cotton tweed and lambskin rather than black patent, straw bucket hats by Dior, or white linen at Lanvin. Gucci suede loafers in pistachio are the kind of optimistic luxury that permeates most of my costume design.

I always enjoyed my visits to Miami, especially after getting to know people like David Frankel, who I worked with not only on his film *Miami Rhapsody* but also when, later, he directed six episodes of *Sex and the City*. So we had plenty of professional experiences together before *The Devil Wears*

Prada. Although the movie, based on Lauren Weisberger's bestselling novel of the same name, had a tight budget and David hadn't directed a feature since *Miami Rhapsody,* the script was so good and the cast even better. In addition to the Oscar-winning Meryl Streep, there was also the fresh-faced Anne Hathaway, then-unknown Emily Blunt, and Stanley Tucci, who is one of my favorite male actors.

Although the book was loosely based on the author's experience working as an assistant to Anna Wintour, all of us were committed to the fact that the film wasn't going to be a send-up of *Vogue.* I certainly didn't model Meryl's editor in chief character, Miranda Priestly, after Wintour, because anything interesting has to be original. Nobody wanted to see a poor man's Anna traipsing around the big screen.

I took David with me to the shows in Paris to loosen him up a little and inspire him for the world he was about to shoot. But when it came to dressing Miranda Priestly, I dove headlong into the archives of Donna Karan, who was gracious enough to share them with me. Donna revolutionized workwear for the modern woman. She replaced the absurd pussy-bow blouses and overcompensating shoulder pads of the eighties with classic silhouettes in muted fabrics that stretched to flatter busy, important women trying to get shit done.

The Donna Karan reps at her New Jersey warehouse were astonished that I was the one climbing ladders and unzipping garment bags. No matter how much success I had achieved, I was not made to sit at a desk. I pored through her designs from the eighties and nineties, which was when Donna introduced the world to what was known as her Seven Easy Pieces: bodysuit, skirt, tailored jacket, dress, leather element, white shirt, and cashmere sweater. Her tailored feminine clothes flattered women without being difficult, and they stood the test of time.

Timelessness is a very important quality in everything I do. It's fundamental to my work that the pieces I use—whether it's a tutu or Donna Karan wrap skirt—be classic, which means not pinned to a specific time. When enjoying the sublime, the eye doesn't want to be distracted by pedestrian markers like current trends.

We wound up using a lot of those Donna Karan pieces we hauled over the bridge from New Jersey. They served as an elegant and flattering foundation to more expressive jeweled jackets, bold accessories, and, of course, that marvelous white hair.

That hair was a great moment. White, high-style, and shocking: I knew Meryl and her longtime hair and makeup stylist, J. Roy Helland—who had worked with her on all her movies since *Still of the Night*, more than two decades earlier—had thought a lot about how the look could serve the character. Their references were a mix of the octogenarian model Carmen Dell'Orefice and the president of the European Central Bank and former managing director of the IMF, Christine Lagarde.

Their idea made perfect sense to me, and I could do a lot with it. "White goes with everything," I approved. "It's such a good palate backdrop." But when the producers heard white, they went into a frenzy. To them white equaled old lady. Producers are business types. They are not the fashion guys. A lot of them have wives who tell them what the actresses should wear. So when they see something that looks odd, they are afraid of it.

"Did you talk to Meryl?" a hysterical producer said to me. "White will kill us."

I did my best to talk them off the ledge, explaining she'd have a stylish haircut with killer clothes to match, but they couldn't see it. Finally, I had to relay their concerns to Meryl.

"They won't stop bugging me about this white hair," I told her.

"I'll take care of it," she said.

She told them: "My hair is going to be white, and that's the end of it."

You can do that when you've been nominated for dozens of Oscars.

Hair was also very important in the transformation of Anne Hathaway's character, Andie. She's a writer. Bangs and a shaping up of her shaggy hair went a long way toward signaling Andie's embrace of fashion. Even more helpful, however, was a closetful of Chanel. Anne became a "Chanel girl" on *Prada*. The famed French fashion house was keen to see modern iterations of its iconic tweed jackets and quilted bags on a young woman, and I was happy to have the luxury brand solve all my problems in a way that was believable for her character.

Well, maybe not all my problems. There is a montage of Meryl entering the office and throwing a series of coats and purses on Anne's desk while barking orders at her. (We used such heavy coats, like richly colored Dennis Basso furs, that I thought she was going to keel over by the end of that shooting day.) We didn't think we were going to see Emily Blunt's character in the shot, but we were wrong. At the last minute, David ran in to say Emily was in the scene, sitting at the other assistant's desk. "I need twenty-six more outfits for her!" he said. "Not a problem," I answered, before Molly and I hit the road to do what she wryly termed "drive-through costuming." We got it done. We always do.

When *Prada* wrapped, everyone knew the picture was good. But just how well it would be received, we had no clue. It was the sleeper hit of the summer of 2006, crushing what was supposed to be the summer blockbuster, *Superman Returns*. For context, *Prada*, which cost $41 million to make, grossed

$326 million worldwide. Meanwhile *Superman* made $391 million on a budget of $204 million.

An instant classic, *Prada* not only proved financially successful, it also received the industry's highest honors. The Academy Awards nominated Meryl for best actress (her fourteenth nomination, but who's counting?), and me for best costume design. Neither of us won, but if I had to lose to anyone, I was glad it was my favorite costume designer Milena Canonero for *Marie Antoinette*.

I might not have gone home with a statue, but I did stand out on Oscar night 2007. At that time everybody was wearing either black or neutral. I didn't want to join the sea of beige—that's not me—so I had David Dalrymple design me a bright red strapless dress that nearly matched my hair. On the long shots of this whole big theater, you could always spot me, a vision in scarlet.

To complement my gown, I designed my very own pair of Payless shoes. Yes, *Payless*. Toward the end of *Sex and the City*, the discount footwear chain approached me about helping with its image. In the meeting, they gave me these shoes that looked like brown bricks. I didn't know what I was going to do with those lead shoes. But David, Molly, and others who worked on the campaign with me threw themselves into the project.

At first, there was a bit of a culture clash. At one of the early advertising shoots, executives lost their minds when they arrived on set and found a model in a zebra-patterned skirt and blouse with a green floral print. I have spent a lot of time correcting people when they tell me things "don't go." I don't just throw different textures, colors, and patterns together to be quirky or crazy. There's a certain logic there. I'm a very big believer in logic and rational thinking. There has to be a foundation behind everything, even in fashion, otherwise it's just

PAT IN THE CITY

198

chaos. A common misperception is that red and orange clash, but look at a bowl of raspberries, strawberries, and oranges. If nature says these are the colors of fruit, who am I to argue that they don't belong together?

I tried my best to open up the minds of the Payless execs.

"It's a zebra running through the jungle," I said. "Think about it."

From print to TV to in-store advertising, we did really big things for Payless. They started to attract customers who would have never considered stepping inside the store before. They were a great account for us, including when the creative director who hired me offered to make a pair of shoes for me to wear to the Oscars. Inspired by London-based shoe designer Terry de Havilland, I designed a platform shoe with an ankle strap and peep toe in a green-and-silver snakeskin-patterned metallic. From that shoe I created a capsule collection sold in the stores.

That was just one of many temporary collaborations I did with brands, from punk-inspired prints for Crocs to a limited edition for the luxury leather brand MCM to a fabulous collaboration with Barbie. "Patricia Field turned her shop here into a Barbie dream house Tuesday night to showcase her new Barbie-inspired clothing and accessories line with Mattel Brands," *Women's Wear Daily* reported in the fall of 2007 about the party I threw to celebrate the line of leopard capelets and pencil skirts, patent crocodile wallets and bowling bags, and more. There was some irony in my interpreting the Barbie doll look for real-life women, considering I never played with dolls when I was a little girl. For me, however, Barbie's aesthetic was more glamour girl than doll. My inspiration was not nostalgia for prepubescent play but rather living dolls like my former employee Amanda Lepore. The clothing line was similarly humorous, wicked, and sexy.

One of the most opulent collaborations was with Bulgari. I was tasked with the styling around a new collection of stunning necklaces at a private event in Venice for the high-end jewelry company's top five hundred global clients. The assignment was kind of like the opposite of the Payless gig, where we dressed models in designer clothes to make their thirty-dollar cork wedges look like a million bucks. Here we needed to find the right gowns and accessories to make Bulgari jewelry, which ran into the tens of thousands of dollars, look cool. Only my crack team could achieve the magical expression of high-low we brought to Italy. David made ten couture pieces with a baroque and luxurious quality, in keeping with the 450-year-old palace on the Grand Canal where guests arrived by boat for the dinner. Molly and I—who shopped for the footwear, hosiery, gloves, and headpieces—styled the regal fabrics and expensive jewels in a fun-loving and creative way. On one model, we complemented her hanging multicolored chandelier necklace with a sparkling jewel-toned motorcycle helmet and stunningly blended green eyeshadow and dark lips by my friend and makeup artist Kabuki.

Sex and the City gave me a reputation far beyond the downtown New York fashion and art scene in which I originally made a name for myself. It took me places I never pictured myself, from the corporate offices of Coca-Cola, for which I designed limited-edition Diet Coke bottles, to the set of the Home Shopping Network, where I sold a fifty-piece sportswear and accessories collection to women in their homes all over the country.

I even had international renown that stretched to the most conservative reaches of the Middle East. Several Saudi princesses found me through *Sex and the City,* despite the show's permissive take on women's sexuality. One client would come

for three weeks in April to shop until she dropped. Her entourage of family members and staff was so big, they took up the entire top floor of the Ritz-Carlton.

When Scooter LaForge, an artist whose work I sold at my boutique, came along with me during a royal shopping trip to Chanel, he couldn't get over the scene. Chanel itself was an ironic setting to be in with Scooter. One of my employees had

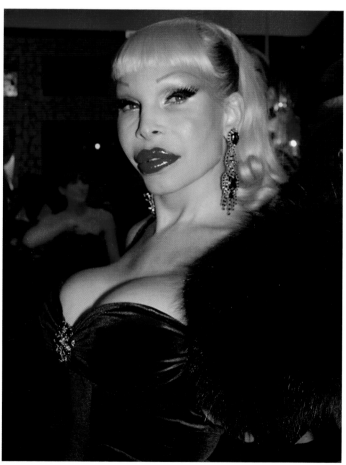

Amanda Lepore at Bowery store party for Barbie collection
PHOTOGRAPH © TINA PAUL

discovered him in a nightclub, where he was silk-screening and giving out T-shirts bearing punked-out versions of the Chanel logo accompanied by phrases like "fuck you." People loved them in the club, but the ones he made for my shop didn't take off. It took a while for the customers to understand his whimsical and loud one-of-a-kind garments, wearable paintings really, but eventually they did. He claims it took me three years to say hello to him in the store. I don't remember that, but either way, we became good friends.

Back to the princess and her crew, I had five of them that day and not one listened to a word I was saying. "Can we look at hats?" I practically shouted. But they were all talking over each other, while the boutique's salesperson was running back and forth a million times trying to get them all these pieces they wanted in their size. It was a scene of utter confusion, luxurious mayhem.

This was par for the course with the Saudi royal, who the day before had plopped herself down on a sofa in Bergdorf Goodman and got on her cell phone, not even glancing up at or trying on all the clothes I brought to her. They all were shipped to the Ritz, where there were three or four rooms filled solely with racks of clothes.

"Pat, God, how do you do it?" Scooter said, as the sweaty saleswoman ordered a pair of pants to be custom made. Chanel hadn't produced them in the right size for the princess, who wanted the pants to match a blouse in the same silk collection. All the women wanted everything to be matching from head to toe, which is the exact opposite of my counsel. But if they wanted to pay me to disregard my advice, that was their prerogative.

I received a call at the store from a member of the Moroccan royal family (who also found me through *Sex and the City*), but

whoever answered thought it was a crank call. Thankfully, an envoy from the embassy reached out again, and this time, he was passed through to me. The princess or cousin of a princess wanted to fly me out to Rabat to style her for a special event. When I learned she had alopecia, I suggested that I bring along Perfidia to do a pop-up wig salon.

By that point, Perfidia no longer worked at the store. After thirteen years, he left to become part of the hair and makeup department on Amy Sedaris's TV series *Strangers with Candy*, which was the start of a successful career styling wigs and hair for the stage. In 2011, I went to see the Broadway musical *Catch Me If You Can*, based on the movie. After the show I was standing outside, where I ran into Perfidia, who had done the hair. "I'm really proud of you," I said. "Look what you did." From the look on his face, I could see he was still one of my kids, happy to get praise from the father of the house, who doesn't dole out compliments often.

The salon in the Bowery store had shifted away from wigs to the point where we really didn't have them anymore. One Halloween, I called Perfidia and said, "Why don't we try wigs again?" Halloween is like gay Christmas. The seasonal wig bar was a phenomenon. The phones rang off the hook for weeks, and there was a line out the door for custom-made corsets, wigs, and makeup.

I called Perfidia out of the reserves again for the three-day trip to the Moroccan capital, where he set up shop in a palace teahouse. He styled a wig for our benefactress that she loved and wore to a dinner that we were also invited to as guests on our last evening in Morocco. At the end of the night, the rep came over to where we were siting and handed Perfidia and me each four thousand dollars in cash. I nodded politely to the rep but whispered to Perfidia, "That's not what we agreed on. I

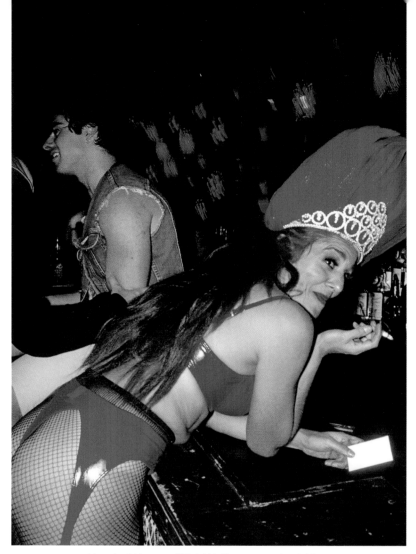

Haunted House of Field Halloween party at Mars
PHOTOGRAPH © TINA PAUL

don't know what they're trying to pull here." I got up from the table and called the shop back home; the payment for everything else had already gone through. The cash was just a tip.

I got to return to Morocco in November 2009 to shoot *Sex and the City 2*. In the sequel to the first *Sex and the City* movie, the four women were supposed to go to Abu Dhabi. But the United Arab Emirates blocked the production because of

204

the scandalous content of the movie, not to mention the word "sex" in the title. Little did they know women all over the Emirates were already crazy fans. Anyway, Morocco welcomed us with open arms.

While prepping for the shoot, Molly and I traveled to in Egypt, where it happened to be Ramadan. They hang decorative lanterns, called fanous Ramadan, to signal the holy month, and I fell in love with one particular modern fiberglass version. Unsure of how I was going to get it home, I didn't buy it and almost instantly regretted the decision. But when I tried to return to where I had originally seen the lamp, I couldn't find it. I dragged poor Molly all over Cairo looking for this damn fanous Ramadan. At one point during my search, I passed by a little alley and could sense that something was going on back there. I told Molly I wanted to check it out, and my instinct was correct: we landed at a rollicking trans bar smack in the middle of Cairo during Ramadan. "Only you, Pat," Molly said. I never did find the fanous Ramadan, though.

As my reputation grew, I had no one to share it with—but I was okay with that. After dating Rebecca for ten years, I found myself single for the first time in thirty-five years. Just as I had taken after my mother in business, I also followed her lead in love. She married (and buried) three men and loved each one. I also loved three women in succession, with just as much commitment.

I went through an adjustment period when I first began single life because it was something new. Soon enough, though, I started to feel good about my relationship status. I had flings, but they never lasted. Part of the problem was that my being established both financially and professionally attracted young women, who saw me as their fairy godmother. I was a human being, not the answer to all their prayers. Plus, I didn't want anybody at my apartment every night. After three and a half

decades, I was free. That was true in more ways than just my domestic habits. In retrospect, I realized I had a habit of giving credit elsewhere. It had annoyed me how my mother used to look up to and dote on her husbands, particularly her last one, when she was so much more competent than any one of them. I saw something of myself in that pattern, too. Many people would have been shocked to learn that for a long time I didn't have the self-confidence to go it alone. It might have taken me until my sixties, but I was finally my own woman.

While we waited in the Nomad Hotel to meet the actress Sutton Foster, the costume designer Jacqueline Demeterio and I were unsure about the setup for Darren Star's new show, about a suddenly single forty-year-old mom who pretends to be twenty years younger to reenter the workforce.

The 2014 TV series *Younger* was my first as a costume consultant. Darren approached me about becoming the costume designer. But after the flurry of activity post-*SATC*, I was wary of taking on the task of running the costume department of another Darren Star production that I assumed would be a success. So I made up the position of costume consultant for myself and got away with it. In that role, I offered guidance to the costume designer. I first met Jackie in 2000 while working on *SATC*. She had moved to New York from Detroit in 1996 to attend the Fashion Institute of Technology, after which she received an internship and then a full-time position in Barneys' personal-shopping department. I went in there all the time to shop for the girls and hit it off with Jackie, who is also Armenian. Although she thought the way I put a paisley Etro tie with a striped shirt was wild, she also understood I

had a very traditional side, from the stories I shared with her about my father and growing up. We connected on that level. Plus, Jackie is extremely organized. When we had the chance to staff up on the first *Sex and the City* movie, Molly asked Jackie if she would join our team as a coordinator. She had no

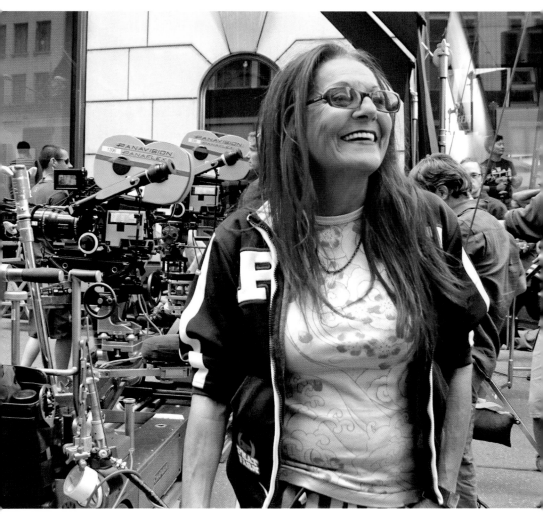

PHOTOGRAPH © TINA PAUL

previous film or television experience, but we knew it wouldn't take much to show her the ropes. By the time she signed up for *Younger*, Jackie had racked up a number of costume design credits, including the Showtime dramedy *The Big C*, with Laura Linney, and the film *The Intern*, with Robert De Niro and Anne Hathaway.

Now, as we waited for Sutton to arrive for a first coffee meeting about her character, Liza, the big question for us in the costume department was, how could we believably make this actress appear like a kid? "I'm a costume designer, not a magician," I said.

Then Sutton walked into the lobby of the hotel, and just like that we knew everything was going to work out. The accomplished Broadway singer and actress's youthful, light presence is very Mary Tyler Moore. Sutton wore very little to no makeup, and her smile was as wide as a child's. She wasn't going to have any problem selling herself as younger to the audience. Jackie and I relaxed. We could do this.

We pushed the idea of what the character Liza thought young people wore to such an extreme that it bordered on the ridiculous. We layered a trend on a trend on a trend—all at once. I pictured her character walking into Zara or H&M and buying everything, the fashion equivalent of protesting too much. So knee socks and boots, a leather jacket with a denim vest over it, and always a beanie and knit fingerless gloves. Sutton has really great legs, so I kept shortening her skirt and pushing the thigh-high socks. As the skirts got shorter and shorter, Sutton laughed. "Come on, guys!" She wouldn't be caught dead in this getup in real life, but as a good sport she let us go for the loud and embellished look. It helped us distinguish her from the other, older people in the publishing house where Liza lands a job.

That included Miriam Shor, who plays the head of the marketing department and Liza's boss, Diana Trout. When Miriam arrived for her first fitting for *Younger*, she looked uncomfortable. The stage and screen actress—in the role of the consummate difficult boss—said she wasn't a fashion person. "Neither am I," I said, making her laugh.

Having recently given birth to her second kid, she was thirty to forty pounds heavier than her usual weight and still breastfeeding. Exhausted, with boobs leaking, she had to get it up to play Diana, the power boss who delivered one-liners like "The only way a good review by Michiko Kakutani could sell books is if her twerking ass caught fire." We had some work to do. Luckily I was prepared.

"Let's put big necklaces on Diana," I said, leading Miriam to a table of jewelry. To call what I had pulled "statement" necklaces would be an understatement.

Necklaces became a signature of Diana—along with leather, animal prints, pencil skirts, and hardware of all kinds. "She really brings the dungeon to the office," said Miriam, who shared my wicked joy in bringing to her character a bondage element in a beautiful way. In season 1, she donned a dramatically oversized Josie Natori necklace over a simple black dress. The enormous gold links around her neck, more shackles than chain, had a very clear message: just try and judge me. This was the armor her character wore for the battlefield of the office, and that Miriam could use as protection and inspiration while she was in a vulnerable and exhausted state. I proved to her that no matter what shape she was in, physically or mentally, when entering the costume department, we could have fun.

And we did have fun, because Miriam was a great collaborator. As *Younger* progressed through its seven seasons, I kept

trying to outdo myself by bringing ever more outrageous accessories. From a charm necklace with oversized dice and lock and key to a series of butterfly breastplates to two birds that met—beak to beak—around her neck, she always brought the attitude and energy needed to pull off those big-personality pieces. The only time she denied me was when I presented a pair of six-inch-long earrings spiked with shards of gold. They looked like mini medieval weapons and were about as heavy. "Oh, how I'd love to wear this," Miriam said, "but I'll end up in the hospital." I accepted it; boundaries are important to fearlessness.

Miriam, who had previously pooh-poohed fashion as another weapon to turn girls into pretty objects, learned that it can also be a tool for transformation. That lesson wasn't lost on her daughter Ruby, who, while visiting the set, tried on a hand-painted cape by ThesePinkLips from Diana's wardrobe. The eight-year-old recognized the power of donning a black cape covered in the phrase, "She's the Boss."

All the characters on *Younger* experienced their own style evolutions. Liza began to shed the trends and look less clownish and more cool. As the millennial junior editor Kelsey, Hilary Duff started out as the party girl, always up for fun after work. We translated that into really tight skirts, off-the-shoulder tops, leather pants, and other pieces that would have certainly turned heads in a publishing office. The little shorts with high heels might have been less HarperCollins and more Hooters. As Kelsey moved up at work to become the boss, her wardrobe followed. Jackie, who came from the tailored and fashion-forward world of Barneys, made her a lot more polished. When she wore high-end pieces like a Gucci double-breasted wool coat with striped grosgrain trim and gold double-G buttons or a Saint Laurent black cape coat, it was clear that her

days of slumming it in a ruffled miniskirt and shiny shrunken tuxedo jacket were over.

The same sensibility that had always put bread on the table in my retail life was met with similar success when I applied it to conjuring up wardrobes for fictional characters. Whether it was for Faith Ford or Kelly Ripa on *Hope & Faith*, Candice Bergen on *Murphy Brown*, or *Ugly Betty*'s America Ferrera, I never relied upon trends or labels, price or pedigree. Instead, I held fast to my original philosophy that the world is my bazaar where I have my pick of designer clothes, thrift-store finds, throwaway fashion, and found objects.

Perhaps most important, this ethos kept *me* entertained. So I took it with me everywhere: merchandising my boutique, dressing actors, and decorating my apartment. Even when the shopping mall Crystals, on the Las Vegas Strip, asked me to organize a fashion show for a charity event, I brought my madcap sense of adventure to the enterprise. I ran through the mall, pulling whatever caught my eye and making it my own, like a Donna Karan skirt that I turned upside down and draped over a model's head so it became a snood. Fashion must be, above all, interesting.

I can't be successful in anything that doesn't interest me. As I got busier with costume design, I began to lose interest in my shop. After moving to the Bowery, I increasingly relied on my staff to manage the shop I rented, two doors down from the former refrigeration mechanics shop that I'd gutted after purchasing to turn into my apartment and private workspace. In 2011, when the Elizabeth Street building behind mine became available, I jumped at the chance to buy it and embarked on a massive renovation project to combine the two lots. A year or so later, the result was a four-thousand-square-foot boutique as fluid and open as the styles it contained. I knocked down

the walls between the two buildings, connected them with a glass roof, and ripped out the ground floor, to create an open bilevel space from ceiling to basement with a catwalk running along the inner perimeter. I continued to push the envelope with young designers such as Ash and Diamonds Japan, Hysteric Glamour, O.K. Citizen, and White Trash Charms. And of course, I continued to throw parties.

At the Bowery we could hold barbecues because there was outside space. Yes, I carried one-of-a-kind items by well-known artists, and kooks and cool kids from all over continued to come to the salon to get that look, but for me one of the highlights of the Bowery store was my farmers market. Michelle knew a bunch of farmers in upstate New York, where she had moved with her son. Surprised at forty-five to find out she was pregnant, Michelle said she was very unprepared to be a mother, but as I told her, "It's the last call for doing something like this." She made me Zack's godmother.

One of Michelle's farmer friends used to drive down and deliver fresh produce that I sold right outside the boutique. If you had passed by 306 Bowery in the summer of 2013, you would have found bushels of corn and baskets of heirloom tomatoes under an umbrella. Never mind the leopard-print latex one-piece behind the stand, people in the neighborhood were crazy for the fresh produce.

Despite the change of location, the shop remained a family—a dysfunctional and rowdy family. I had some excellent employees, self-starters like Gianni, who I used as an example for the other kids all the time. Gianni, who kept a book with all his customers' information, was meticulous—and wasn't critical of every person who walked in the door. His shtick was to call up clients when an item came in that he knew they wanted and say, "We have it, but we only have one, girl, and

I can't hold it. Come in as soon as you can!" And if we didn't have it, he'd sell them on something else. I liked that.

Then there was Erica, who I initially brought on in 2012 to do the accounting but eventually became my right-hand woman. In the course of her interview, she said she wanted to help her dad in his business, but he wouldn't hire her. "Really?" I said. "You're hired!" His loss was my gain. Erica arrived at the shop before everybody else and left after closing. She didn't miss a detail and was always on point, which irritated the hell out of some of the others who were not quite so professional.

When I arrived at the shop one morning just as it was opening, I heard screaming and walked in to find one of my employees reading Erica to filth. *Filth.*

"Your job is to do what I tell you!" he yelled.

In a calm voice and with a steely gaze, Erica replied, "No, my job is to handle the books."

This guy was feared by everyone in the shop. Now this new girl from Long Island, dressed in office-appropriate casual separates, was talking back to him. All the other kids silently cowered, waiting to see what would happen next. Papa had to step in.

"Don't yell at her," I said. "You want to yell at somebody? Yell at me."

He stomped out of the shop like a little kid, and for the rest of the day it was all anybody could talk about. That was a normal Tuesday.

In my seventies, I thought to myself, What do I need with this shit anymore? By the fall of 2015, I no longer wanted to spend as much time in the boutique. But when I wasn't there, things inevitably fell apart—or at least slowed down to unprofitability. One time, Michael Shulman—who was in town for business and picked me up at the shop for dinner at one of my

213

favorite spots, Il Cantinori—got a small taste when he walked in on me tearing my hair out telling one of the kids, who had royally screwed up a delivery, why it was crucial to report missing and back-ordered items.

Over vodka, grilled calamari, and cavatelli cacio e pepe, Michael offered up some tough love. "Why are you still sitting there, trying to explain to people how to do the buying?" he asked. "You've proved yourself decade after decade, career after career, expanding your reputation. You don't need to be doing a nine-to-five data-entry job. Be the wealthy woman you've earned the right to be. Enjoy your life. Sell the fucking store."

He wasn't wrong. The shop always made enough money to keep itself in business. But it wasn't like I was getting rich off Patricia Field, and the energy it required to run had begun to feel like it took more than it gave back.

"I'll think about it," I said to him cagily.

The truth is, I had already started thinking about it. A very handsome offer to buy the building was the true incentive. When I moved here, the area was completely undeveloped. My location, between two big commercial thoroughfares, East Houston and Bleecker Street, had become prime retail real estate in an area that had gentrified on steroids over the past fifteen years. CBGBs had shut down almost a decade earlier. The winos followed the punks a few years later when the White House Hotel, the last of the flophouses, closed. In their wake, Whole Foods opened on the corner of the Bowery and East Houston and myriad boutiques popped up where it was impossible to find something to wear without going to the bank to get a mortgage. I was ready to move on.

Three months after my dinner in Greenwich Village with Michael, the *New York Times* published an article announcing the news with the headline, "Patricia Field Hangs Up Her

Retail Wig." It followed my announcement three days earlier that I was closing the shop in early 2016, or as the article put it: "No more bedazzled hoodies. No more rhinestone bustiers."

Oddly enough, the reporter whom I granted an interview was a *different* Michael Shulman—a fact that did not escape *my* Michael Shulman's attention when he read the news in the paper. "Who is this Michael Shulman guy?" he asked. "When he called me, I thought it was you for a while," I answered.

The Shulman mix-up aside, the information was accurate: I decided that fifty years in business was enough. My retail career was fantastic and had opened up many avenues, but I was satisfied.

MAKING A NAME FOR MYSELF. AGAIN.

ten

PAT IN PARIS

'M ALWAYS HAPPY TO WORK WITH DARREN STAR. He asked me over dinner to style a new show he was working on, *Emily in Paris*. The challenge was that, as the title suggested, they were going to shoot in Paris, where I didn't know my way around. I had a few friends there, but to staff up a wardrobe department and pull clothes for a cast takes a lot of local connections and knowledge. As I walked into the office the next day, I told Erica, "I don't know about going all the way to Paris."

One of the open secrets to success is not giving up, and Darren is one of the most successful people I've ever met. He took me out to dinner again. "You have to do the show," he said.

"All right, I guess I'll do it," I said.

I signed on to *Emily in Paris* as the costume consultant. In this job of my invention, I set up the department, including hiring the costume designer, and analyzed the characters with her to come up with a road map of the style and fashion story for each. It's a wide road, but I like to stay involved to keep the looks from veering off. But I'm not responsible for any of the administration or accounting, and best of all, I don't have a call time. I get to walk in when I want, tell everybody that there are too many meetings, tell the gaffer the lighting is too dark, and then walk out.

My age and résumé give me the permission for such a position, but I wouldn't be able to accept if it weren't for the many talented costume designers who have come up under me. My "stable"—a term coined by the Bergdorf Goodman personal-shopping phenomenon and my longtime friend Betty Halbreich—are the kids I plucked from the store or the streets and corralled into working for my various theatrical productions. Strong and high-spirited, they are all master's-degree graduates of the Pat Field School of Costuming, who have gone on to make their own big careers in film and TV. The

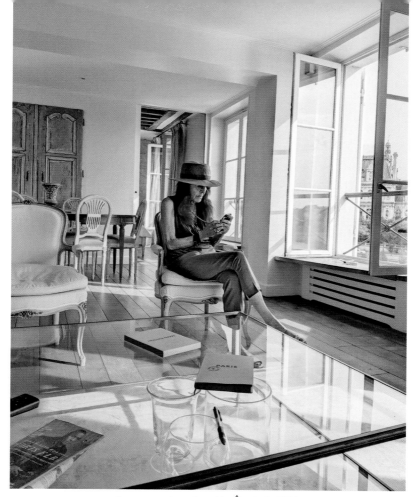

In my apartment on the Île de la Cité

first was Molly Rogers, my right-hand woman who took up the mantle on the *Sex and the City* franchise as the costume designer for the reboot *And Just Like That* . . . But there are many others, including *Younger*'s Jackie Demeterio, *Run the World*'s Tracy Cox, and Eric Daman (*Gossip Girl, The Carrie Diaries, Billions*).

I lured one of my valedictorians, Paolo Nieddu, into my stable as I had with so many others—with the alluring promise of health insurance. His story echoes those of most of my protégés. The Detroit native started work at Hotel Venus the

third week of October in 2003. Having recently graduated from the International Academy of Design and Technology in Chicago, where he studied fashion, Paolo had only been in New York for two weeks when a friend of his working at my shop said we needed extra help for the onslaught of Halloween. Paolo enlisted and stayed on for two years. Busy with *Sex and the City*, I didn't become aware of his presence until I noticed the meticulous and interesting way he was gluing Swarovski crystal tattoos around the eyes of mannequins for a window display.

Not long after, I called the store and asked to speak to him, which I know freaked out the kids, like getting called to the principal's office. I needed an assistant for a job styling a DKNY presentation at Pastis, using mannequins lounging against and sitting at and on the bar of the meatpacking-district restaurant that was a mainstay of Carrie, Miranda, Samantha, and Charlotte. Paolo was an excellent stylist. He left Hotel Venus in 2005 to spread his wings in various roles from PR to intern at *Interview* to celebrity stylist until 2007, when I called him again. We were starting *Sex and the City: The Movie*, and I needed someone I could trust and who knew the showrooms. It was a big opportunity for a twenty-six-year-old to be part of a famous legacy. Plus, he would become a union member and get health insurance.

Like starting out in retail by working at Patricia Field during Halloween, beginning one's career in costume design on the first *Sex and the City* film was truly a baptism by fire. Paolo's very first fitting in production was with Sarah Jessica Parker. He was familiar with fittings for shoots—as were most of the other kids like Jackie when they started with me—but my fittings when I'm finding a character were like nothing he had ever done before. Add Sarah Jessica, and we were staring

down a marathon discussion and debate over every last detail of what Carrie would look like at this point in her life.

Before Sarah Jessica set one Louboutin-clad toe inside the office, a huge organizational effort was underway that would provide that scaffolding for everything we went on to do. We combed through the script to count the costume changes for each character, and that information was broken down further into the look needed for each scene, pieces for the look, shooting schedule, et cetera. The data filled binders before shoppers fanned out to fill in the blanks on the page with real items.

No stone is left unturned in my world. If you are looking for a white T-shirt, you get *every* white T-shirt. If you need a necklace you go to Goodwill *and* Fred Leighton. That in itself is a Herculean effort. But when the shoppers return, their haul then has to be organized for the fitting, with every bangle and Chanel bouclé suit photographed, labeled with a return date, and put into a binder. On a shoot like the *SATC* movie, you have so many balls in the air, only precise and thorough tracking will do. My assistants lived in fear of getting the call that a luxury design house didn't receive something that was supposed to have been sent back. To my knowledge, it never happened. Fear can sometimes be an effective tool.

For Sarah Jessica Parker, we brought in everything. The volume was mind-boggling. The first meeting was a general fitting, where we walked the racks to begin to understand what appealed to Sarah Jessica and me. Paolo had been tasked with shopping at boutiques in Brooklyn and had returned with a haul that included some pieces from Lanvin, many, *many* T-shirts— each with just a slight difference—and a green floral dress.

Perhaps the most distinctive part of my process is my inclusivity. I work through the whole look from head to toe with the actress. More often than not, actors get so into the process

221

when they feel involved. The thoughts and feelings of the person going in front of the camera are of paramount importance, but I also expect everyone who contributed to the fitting to offer input. In costume design, a shoe is more than a shoe. There must be an idea behind it. And so I wanted to understand the thinking behind the pulls of everyone in that room, including young people working with me for the first time, like Paolo. My approach is not top down. I'm open to everyone, including assistants, throwing out options. In fact, when they bring in their shopping, I typically want to see what they personally bought and why.

It's harder to bring in different points of view than to work autocratically. But I believe the end product of a group decision—made with leadership—is always better than what any one person can achieve on her own. I like fittings to be a symposium where different voices come in to build the character layer by layer.

If a typical Patricia Field fitting is a marathon, then Sarah Jessica's first one for the movie was an ultramarathon, with assistant costume designers stooping to put shoes on feet, stretching to grab a turban or scarf off a top shelf, and rummaging through drawers of accessories for the perfect earring or two or three. Amid the sea of clothing, there was a green strapless vintage Betsey Johnson dress with a large rose print that caught my eye. For me, it gave off the happy vibe of clothes from youth. But I wanted to see what it was giving the kids around me.

"What do you think of this?" I asked Paolo, who looked nervous. "Too cocktail cunty?"

"I love it," he said.

"Don't just say you love it. Why do you love it?"

"I love fifties glam, and who doesn't love roses?"

The next lesson in the School of Pat was how to put the look together. Some costume designers get the basic pieces down and then set the accessories later. I like to nail down every detail: every belt, every earring, everything. The costumes I'm known for may appear wild, but there is an order behind them. I believe in being as prepared as possible. It was Sarah Jessica—and me—so naturally the dress required a belt to cinch the waist. "Let's look," I said.

We ran through the belts and found a wide, studded black leather one by Streets Ahead, a husband-and-wife company that manufactures all its products in Southern California. Paired with an unlikely punk-esque accessory, the fifties-style cocktail dress was suddenly quirky, sexy, and very Carrie Bradshaw. We were onto something.

Sarah Jessica ended up wearing that belt so much in the film, she gave it a name: Roger. (Molly also brought the belt back for a cameo in *And Just Like That . . .*) The dress wound up as the cornerstone to her outfit in the first scene of the film. To go apartment hunting with Big, Carrie wears the vintage Betsey Johnson belted with Roger, a contrasting short-sleeved floral overcoat (because more is more), Dior stacked sandals, and a hand-painted acacia-wood Eiffel Tower bag by Timmy Woods, adorned with over seven thousand Swarovski crystals—a nod to the romantic city where the couple reunited at the end of the HBO series.

Paolo was exhausted after that fitting, but reflecting back on the experience years later, he understood this was my way of understanding his perspective as an emerging designer as well as teaching him what I know about cut, fit, and color in the context of wardrobe. Like all the kids who I've worked with, Paolo took the lessons he learned at the Pat Field School of Costuming and put them to good use as the costume de-

signer on such projects as *The United States vs. Billie Holiday*, *Empire*, and *The Equalizer*, with Queen Latifah. He said that he now asks the same questions to his team that I asked him.

My new role as costume consultant only worked if I had a costume designer I could collaborate with—as I did with Jackie on *Younger*. With only six weeks of prep, the first thing I had to do on *Emily in Paris* was find a French costume designer. The French production office sent us a dozen résumés, and out of everyone, Marylin Fitoussi was the most experienced and organized. She would be the anchor when Erica and I arrived in Paris, but for the present the producers allowed us to spend the first few weeks of prep shopping in New York and ship the clothes over to Paris.

In the beginning, the script had Emily being an average midwestern girl who gets the chance of a lifetime when she accepts a marketing job in Paris. But after Darren cast Lily Collins—often compared with Audrey Hepburn—they changed the script. So when I read in the script that this young midwestern woman wore a lot of "floral patterns," I asked for a rewrite as well. I don't like the kind of poor man's Laura Ashley or Cacharel I knew they were referring to. I don't tell a writer how to write a script; they shouldn't tell me how to dress a character. Emily is from Chicago, not the prairie.

In thinking about Emily's character, I was reminded of Anne Hathaway in *The Devil Wears Prada*. Lily Collins, petite and light, gives a very young energy and aesthetic. You have to go with some of the natural components of the human being. Meanwhile, Emily is a motivated young professional. She's a smart one, just like Andie. I took all of that into the creation of this wide-eyed character, who starts out in awe of Paris—only to find out that the toilet doesn't work and she has to climb multiple flights of stairs to get to her apartment.

My crack team—which included Erica and ArtFashion's gallery manager, Michael—did a huge pull from Bergdorf, Saks, and Barneys. Following my own method, I left no stone unturned in those three stores. I found a button-down sheer blouse with a dreamlike photomontage of the Eiffel Tower with the Seine behind it on the clearance rack at Saks. The light-blue sky is dotted with hot-air balloons. The image on the shirt is as much a fantasy as Emily's notion of Paris. "What do you think?" I asked Erica. My intent was intentionally cliché style, but I wasn't sure if the joke would land.

Lily flew to New York from LA to do a preliminary fitting. With natural grace and elegance, the actress is a great model. Her proportions are terrific for clothes and, just as important, she knows what she likes. She approved of the Eiffel Tower shirt, so in the pile for Paris it went.

When we began shooting, we paired the blouse with a green Ronny Kobo fake-snakeskin miniskirt, Christian Louboutin multicolor patent ankle boots with "Paris" streaming across like a police-line tape, and a satchel handbag often associated with French women. Except this one was from Aldo. I found it when I went into the retail chain looking for a pair of inexpensive white tennis sneakers. We gussied it up with a silk scarf tied around its handle. The ensemble was consciously trying too hard, just like Emily. Her outfit for her first day of work was an unequivocal, if not slightly misguided, love letter to France's capital.

I was still a little worried. I was trying to convey that Emily didn't take herself too seriously, but I didn't want her to look goofy or ridiculous. Something wasn't right. But what? Then it hit me. I buttoned the top button of the blouse and left the rest open so that the white tank top we had layered underneath was exposed, along with Lily's midriff.

Lily's dresser, Sarah Nakhlé-Cerruti, gasped in that way French people do when they've taken notice of something. She was in charge of logistics related to Lily's wardrobe, which meant everything from assisting costume designers with fittings to making sure Lily wasn't too hot or too cold while on set. A French national living in the United States, Sarah blended or bridged the perspectives of the two very different countries, which was a bonus. "That changed the whole silhouette," Sarah said when I buttoned the top of the blouse. "It adds sophistication."

We shipped all the clothes Lily liked at the New York fitting to Paris—except for a skirt I bought at Brandy Melville on West Broadway. I shop anywhere, including this fast-fashion chain targeted to teen girls, which I passed after going to a lunch with a friend. I told Erica to add it to the stuff we were sending to the show's costume designer, Marylin Fitoussi, but she had already sent all the rest. So I brought the green plaid miniskirt in my suitcase. I'm committed to my work.

The skirt wound up being part of one of the most commented-on looks of the season when it peeked out from under an oversized green Chanel jacket. When we got to Paris, we went to Chanel's headquarters, where they kept saying they wanted to develop a younger clientele. But when I looked around the showroom everything was for *ladies*. And not young ones.

In many ways, the iconic French fashion house was an important element for *Emily in Paris*. A totem of aspirational style, the interlocking "CC" logo is an instantly identifiable symbol the world over. But I needed to figure out how to incorporate the staid pieces in a youthful way for Emily, in the same manner in which I had paired a Chanel jacket with jeans on Carrie Bradshaw, which was considered revolutionary at the time.

Perusing garments in Chanel's showroom, I was thinking about how boxy many of the pieces were when it hit me: I'll make it oversized! Lily is so petite that having her swim in clothing was a snap. I picked a jacket in the brightest green and largest size—and voilà, a classic instantly became cool.

Chanel featured prominently in season 1, but probably not in the way the luxury house ever could have imagined—for example, featured as a layer on top of a Dope Tavio dress I brought from home. The frock in question was a patchwork of camo, hot-pink lace, disco iridescence, red stripes, and more strips of fabric. But Dope Tavio designer and former *Project Runway* contestant Octavio Aguilar makes androgynous drama dresses for six-foot-tall men, not mini actresses. Not one to shy away from a challenge, I had the piece recut and reconfigured so that it became a minidress with a completely different neckline. I paired it with a vintage teal Chanel jacket and round Chanel cross-body purse in a matching color. A fashion blogger called this look "one of the most controversial outfits of the season."

That was debatable, especially considering the white Chanel shirt with crochet and eyelet work forming interlocking C's, which I used for Emily's jogging outfit by altering it into a crop top. "Shorter! Shorter!" I kept telling the incredulous tailor.

"While it would be a really cute top for a run to la boulangerie, she wore it on a run around les jardins of Paris. Twice!" a style editor wrote in *People*. "There's no excuse for ruining Chanel during a sweaty workout. . . . Someone, please point Emily in the direction of the nearest Lululemon."

I couldn't disagree more. First of all, I have never and will never guide anyone to a Lululemon. I don't even know where one is. Also, I love that gag about wearing Chanel to go run-

ning. I still laugh whenever I think about it. This is how I have kept the job interesting for myself all these years.

In our two weeks of Paris shopping before production began, Chanel was just one of many stops we made. Although the pieces we brought from the States made up the basis of Lily's wardrobe, and Marylin had done a lot of shopping as well, there is always more to discover—especially in Paris.

The City of Lights was our oyster. We could and did go anywhere we wanted to. Thanks to the French team, which included Marie Davenport—a French costume designer, who went on hiatus from her show to work with us—we went on a tour of the best places for high-end fashion, vintage nuggets, and edgy streetwear to get that mix. We shopped at the small modern boutiques of the Marais on the Right Bank and grand old department stores. We also visited private showrooms, costume-rental houses, and flea markets. No matter what the venue, I was always looking for the same thing as I sped through racks and shelves: quality of cut, fabric, or concept.

Greek by blood, I love a good agora—and there is probably none better than the Marché aux Puces. The flea market affectionately called Les Puces (fleas), covering 750,000 square feet just north of the Eighteenth Arrondissement, has been selling stuff in various forms since the Middle Ages. I haggled a lady down for a pair of beige Margiela Tabi split-toe boots (haggling is my hobby). At another vendor, I found a beautiful lace shirt that I thought might be interesting with a red-and-white fedora from my favorite vintage store in Paris, Les Merveilles de Babellou. But I couldn't decide whether to keep the French cuffs that came with the blouse. I had the tailor take them off and put them back on. I kept going back and forth. Attached to the blouse, the cuffs were too much. Off, the blouse needed them. Thankfully, when I layered a sporty black mesh tank dress over

it, the cuffs landed once and for all. Otherwise the tailor might have come at me with her fabric scissors.

I even shopped at touristy street vendors. Erica and I were staying in an apartment on the Île de la Cité, a gleaming gem in a jewel box of a city. One of two islands in the middle of the Seine, the Île de la Cité is the birthplace and historic center of Paris. It's also tourist central, with thousands flocking to see Notre-Dame, the Pont Neuf, and other must-see sites on the

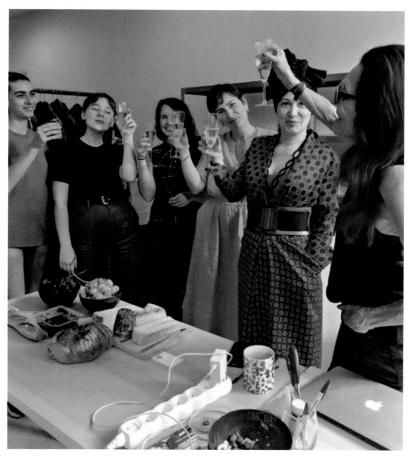

With my Parisian team during one of our champagne Fridays
PAT'S COLLECTION

island. Passing a typical tourist-area vendor on the way back to our apartment after a long day shopping, I bought a tote bag with the image of the *Mona Lisa* for one euro. Marylin had picked out a Veronica Beard black-and-white-check double-breasted blazer and matching shorts for Emily, which I wasn't sure about, because what girl wears shorts to work? The *Mona Lisa* tote, however, gave the short suit the comical touch it needed. I guess it worked, because you can now buy totes online with "Emily in Paris" superimposed over the *Mona Lisa*'s image.

Another element of the look, which also became iconic, was the red beret Lily wore with the shorts and blazer. I found a red beret that was too small because it was for a child. But I liked the way it sat on her head, so we cut it. That meant every time they shot Lily from the back, we had to turn the beret to hide the slit. The red beret made such a big impression on audiences that Peyton Manning wore one in a send-up of the show on *Saturday Night Live*.

Still, I didn't want to put Lily in another beret when Marylin pulled a pink one for her. "We can't tell the same joke twice," I said. I had the same concern when I read the description of Ashley Park's character, Mindy, whose father is the Zipper King of China. The film *Crazy Rich Asians* had just come out when we were prepping. I didn't want to tread on familiar territory. Even if an idea isn't stereotypical, if someone else has thought of it first, I'm turned off by it. One of the first things Ashley said to me was, "I like to show my shoulders."

I thought, Okay, girl! Taking my cue from the actress, I barely gave her a shoulder all season. We pulled the puffed sleeves down on the Zara crop top she wore with a pair of jeans. Her neckline got a double boost in another off-the-shoulder white crop top accentuated by a black neckerchief. Even a plaid jumpsuit had shoulder cutouts.

The berets were a different matter. They were so specific, in part because you don't see them very often. But when I fell in love with a floral print puffer jacket and matching spaghetti-strap dress from Off-White, the pink beret found its place. Mimicking the pink of the print's roses, it suddenly looked edgy against the puffer-dress combo's black background. I'm a huge fan of pink and black together. It's punk heritage.

In general, I'm a sucker for hats. It harks back to my childhood, when women wore hats. But cinematographers loathe them because brims throw shadow on the face (except for berets, *naturellement*). If I've heard a DP shout out, "Lose the hat," once, I've heard it a thousand times. My success as a costume designer with a close working relationship to Darren meant that, more often than not, I got to override the lighting guys. The first season of *Emily in Paris*, Lily wore many hats: a Christian Dior Diorissimo newsboy cap, a Burberry check wool cap, a variety of Kangol bucket hats, and the cutest vintage striped straw hat from Les Merveilles de Babellou, which was perfectly perched on her head.

Dressing Emily in hats and colors was an attempt to convey the great optimism of her character. That's why I never put her in black unless the script called for it, which it did in the episode where she attends *Swan Lake* at the opulent Palais Garnier. This was an opportunity to pay homage to Audrey Hepburn, whose movie *Funny Face* also filmed at the opera house. In the 1957 film, the legendary costume designer Edith Head turned a Cartier necklace into a tiara to complement Hepburn's Givenchy gown. For Lily, who wore a black off-the-shoulder Christian Siriano gown to the opera house, I turned a tennis necklace that I borrowed from a French costume house into a headpiece. Lily expressed the look, which she called one of her favorites, as beautifully as any star of Hollywood's golden age.

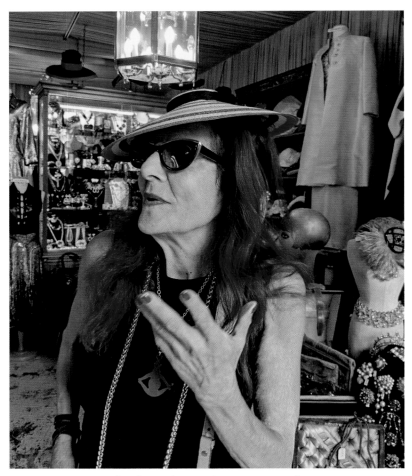

Trying on a hat for Emily in my favorite vintage shop in Paris
PAT'S COLLECTION

When Erica and I landed in Paris in the spring of 2021 to prep for the second season of *Emily in Paris*, France was in the middle of its third nationwide lockdown as a surge of COVID cases threatened to overwhelm the health-care system yet again. The daily case rate linked to the new, more contagious variant that had rolled in from nearby Britain was

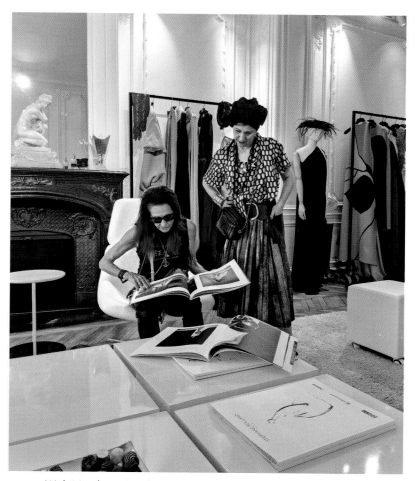

With Marylin at Stephane Rolland's couture house, discussing the
custom look for Lily in the first season of *Emily in Paris*
PAT'S COLLECTION

more than 1,000 percent higher than in the spring of 2020. Spirits were gloomy in the city, which felt more like a military state than the romance or fashion capital of the world. Thousands of police officers were deployed to enforce the rules of the quarantine, which included a ban on restaurant dining, a six-person limit on gatherings, and a curfew that ran from 7:00 p.m. to 6:00 a.m.

Because of our work, we carried around papers that allowed us to be out past curfew. But there was hardly any point. None of the department stores, vintage markets, or boutiques were open. Most of the showrooms were shuttered as well. Where we could make appointments, we were greeted by terrified and exhausted employees. The pandemic made it hard to get excited about a dress. Paris felt like a prison.

We were hardly alone in that sense of confinement. The difference, however, was that we were following the wave of infection across the globe, as opposed to the more logical action of running from it. When we left for Paris, New York was just opening back up from its own harrowing battle with the pandemic. So, as Erica said, "This is one long year of just terrible."

Paris was completely different during coronavirus, and so was shooting there. The first season of *Emily in Paris*, a beautiful, grand experience to work on, was a success. Netflix, which reported that fifty-eight million households internationally watched the series within the first twenty-eight days, named it the most popular comedy series of 2020. "*Emily in Paris* is *Sex and the City* for the Instagram Age," wrote a reviewer at *Glamour*, adding, "It will sweep you off your feet."

If season 1 was raiding the Chanel showroom by day and nibbling on moules marinières by night, season 2 was presenting identification to gendarmes and continual COVID testing. While it was much harder to be a health-care professional during the pandemic, costume design was no picnic. On set, COVID-compliance officers with broomsticks with tennis balls on either end shoved anyone standing within six feet of one another. And it was hot. Parisian summers are not meant for masks.

I had trouble doing my job, which requires physical proximity. I have to pull and gather, button and buckle. I also have to

see, and my glasses kept fogging up my mask. Without thinking I would pull it down, which got me in constant trouble on set. I wasn't doing it on purpose, and yet it was a problem to the point that Erica had to concoct a crazy contraption of hat and enclosed veil, like a beekeeper. She tried to make light of the whole thing by attaching the visor veil to a pink hat that read, "Fuck off." In retrospect, it was funny, but at the time I was not laughing. I snapped at people on set. My frustration came in part from a place of anxiety. Like everyone else, I was nervous about this mysterious new disease. But I was also old enough to remember epidemics past. The distance we had to keep from one another because of the coronavirus evoked the memory of saying goodbye to my father from a distance.

While I'm not one to dwell on the negative aspects of life, I can have a temper. My anger is intense but fleeting. Like a rainstorm in a tropical climate that moves quickly from tempest to blue skies, once my rage dissipates it leaves no trace. For good and for bad, emotions are at home in my projects. I channel a lot of feelings into costume design, which is why it can be hard at times for me to articulate the thought process behind my decisions for a look or character. I just feel it.

I say I love "happy clothes," but how is a black-and-white dress happy? Why one kind of yellow has me declaring, "I don't like yellow," when in reality I love yellow, I can't explain. Is it the saturation? The hue? Often it doesn't make any sense to others. I love classic color palettes and silhouettes, quality fabrics and construction. But a black-and-white-checkered bucket hat made by a Chinese manufacturer of warp-speed fashion has been known to lift my spirits. It's not about the clothes themselves, but the feeling they exude for me. The reason may not be identifiable, but I'm moved by their presence. It's what tilts my work into the realm of art, even if I chafe at being placed in that category.

I remember the first time someone tried to call me an artist. I was in therapy for the first time, after an incident on Halloween 1980 brought on a panic attack. After going that night to a party, I was back home in my loft on Eighth Street, above my store, when I went into the closet and tripped on something. It was a piece of my stereo equipment—which was when I realized someone had broken into my apartment.

From then on I worried someone was going to hurt me. I couldn't shake the feeling, even though I knew it was irrational. This was a very new feeling. I had always been the fearless one. I policed my shop against thieves when all the kids working there were too scared. When a group of young men jumped out of a car on the Upper East Side and demanded that I give them my bag (which happened to have a lot of money in it at that moment), I took note of the license plate on the vehicle and snapped, "Go back to New Jersey." One of the guys pushed me, but they left me alone and drove away.

Now, something was bothering me, and the worst part was that I didn't know what it was. I got so depressed that a friend arranged for me to see the top doctor at NYU's psychiatry department. In the doctor's office, I picked up the pen on his desk to illustrate something and could tell by the way he was watching me that he thought I was going to pocket it. I ran a store; I knew that look. I was out of there. But the anxiety didn't go away. In fact, it got so bad that it landed me in the emergency room with a full-blown panic attack. The psychiatric resident on call suggested I go to Bellevue's walk-in clinic, where they would find me a therapist.

I followed his advice and was referred to an analyst at Gouverneur hospital on the Lower East Side. My therapist was a Cuban woman, who I liked and grew to trust over a year of seeing her every Wednesday at 9:00 a.m., for seven dollars a visit.

She was the one who told me that I was an artist.

"I am not an artist," I said. "I am a businesswoman."

For all my visual whimsy and peripatetic iconoclasm, I identified with my mother—a no-nonsense, get-it-done merchant.

"All this time, the things you tell me," the analyst said, "no, you are an artist."

I had always been attracted to artistic types but never put myself in the same category, until that moment. I didn't consider myself creative, but I guess I am.

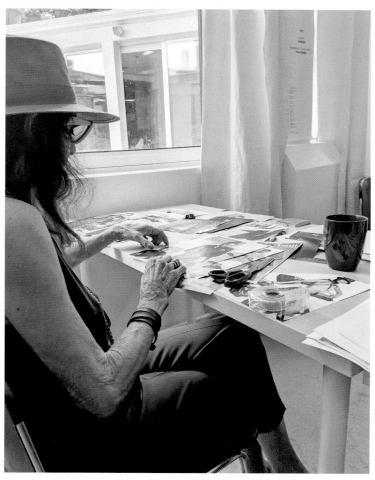

PAT'S COLLECTION

eleven

ON THE HORIZON

THE DRIVE FROM THE LOWER EAST SIDE to Harlem was trying. "Take Second Avenue!" I barked at Erica, behind the wheel. I have very strong feelings about which routes to take to beat traffic, which I loathe. She complied, but we hit traffic anyway. Further proof that there are too many people in this city, and on earth, for that matter. Erica mumbled something.

"What?" I asked.

"I'm just complaining," she said.

"That's my job," I said.

As soon as we pulled up to Lenox Avenue and 122nd Street, the air shifted and so did my mood. We were meeting Tracy in Harlem on this sunny cold February morning, a few days after our failed trip to a Manhattan department store to shop for the men in *Run the World.* Our first stop uptown was Harlem Haberdashery, a boutique run by the Harlem-born husband-and-wife team behind 5001 Flavors—a design and styling business whose custom-made pieces have been worn by the likes of the Notorious B.I.G., Beyoncé and Jay-Z, Lady Gaga, Aerosmith, David Beckham, LeBron James, and CC Sabathia.

Walking up the wide avenue of stately nineteenth-century brownstones with heavy window enframements and impeccably maintained roofline cornices, we couldn't find the shop at first. Tucked away below the stoop level and behind a wrought-iron gate, an elegant and understated sign was the only announcement of its presence. Good things are always a little harder to find. This was a positive sign. As it turned out, the shop's location is Malcolm X's former home—another positive for me as a lover of history and revolutionary thinkers.

Inside, Harlem Haberdashery did not disappoint. A mash-up of proud family parlor, uptown speakeasy, and cool clothing store, the boutique was immaculately merchandised. Framed photos of Harlem luminaries from Cab Calloway to Malcolm X,

as well as portraits of this fashion family in all their finery, adorned the dark wood-paneled walls. A fully stocked bar of liquor bottles with ornate labels sat atop the fireplace mantel. A baby carriage, hunting horns, and other antiques punctuated the racks of harem pants in denim, delicate printed blouses, matching sweatsuits in jewel tones, and other pieces you couldn't find anywhere else on the planet.

Tracy was already busy at work. "I like this satin shirt paired with these," he said, rushing toward me with a bright blue monochromatic ensemble. "But who's it for? Anderson?" When he held the look up to his own body, I saw the pants were short.

"Aren't we saving cropped for Ola?"

"Oh, yes. This is perfect for Ola."

"I didn't think he was that spiffy, but I'm glad. You know me; I'm into spiffy."

Picking up a pair of basketball shorts in blue sequins that I would have definitely carried in my shop, I knew we scored. This environment, filled with personality, was much more my vibe than the antiseptic merchandising in the department stores, where we had shopped a few days earlier. Louis Johnson Jr., who was assisting us, explained that all the lines were designed by relatives. As Tracy slipped on a full-length kimono, a young man walked into the store. It was Louis's nephew, and he was clearly late for work. "You're fired!" Louis said. Both men broke out into laughter. You can't fire family. Yes, this was just like my shop.

"What do you think of this for Matthew—while he's cooking?" Tracy said, doing a twirl in the gray silk robe with a Japanese-style painting on the back.

"I don't know if he'll go for it," I said. "But that's what we are here for: to give fresh ideas."

Fresh ideas are how I stay young, at least in mentality. Throughout my fifty years in retail, Patricia Field always remained young. I kept going through the decades, but everyone around me stayed in their twenties because I never lost interest in new ideas. Whether it was hip-hop or blow-up furniture from Tokyo, I kept a conduit to youth culture by staying open-minded. What more can I expose myself to? Where are the new places to go? Who are the interesting people to meet? These are the questions I've never stopped asking myself. When I came across something I liked, I shaped it and made it meaningful to myself.

Anything cool I've encountered—from a dance club to a new career—began with a friend introducing me to it. That's why I include all different types of people in my life, from all places, segments of society, and ages. I don't discriminate against the young because they typically don't have money or experience. On the contrary, I embrace them. Their energy fuels me.

I also champion underdogs—some of them irritating but no fools. I have given a lot of people a lot of chances, and most have flourished. After I closed my shop in 2016, I continued to find so much talent that it was hard for me not to find a space in which to showcase it.

After the massive undertaking that was the Bowery, I was ready for a big change. I decided I would move to my own interpretation of a little hotel suite in the sky. Even though I had just come from living in thousands of square feet of a gutted warehouse, I knew I'd be fine in a small space. My Miami apartment was a one-bedroom, and I was perfectly happy there. As long as I had a balcony and sky, I would be able to breathe.

Despite my eclectic style and ability to find jewels at a junk show, I'm the opposite of a hoarder. Remaining open to new possibilities and ideas means not holding on to whatever no longer interests me. I never cling to clothing, apartments, jobs, because I have confidence that there's always something new on the horizon. Even my trademark poppy-hued hair isn't sacrosanct. I would change my color in a second, but I can't land on a color that is as good as red against my olive complexion.

I found a decidedly un-chic neighborhood on the edge of the Lower East Side that still felt like the New York I recognized and loved, not the sanitized version where everyone is young, white, rich, and wearing expensive leggings. In a utilitarian high-rise from the sixties, I found a one-bedroom with an enormous balcony facing south-southwest with sun all day and a view of the East River. I brought along a few pieces that went with my sexy décor theme, including cobra-skin ottomans given to me by Roberto Cavalli (I also upholstered my desk in another of his gifts, leopard-print silk) and a metallic palm-tree floor lamp that came from the French Riviera. Most of my stuff, however, had to go.

The apartment was big enough that my aunt Les was perfectly happy as my roommate for the last two years of her life. Les never married. Nobody in our family, myself included, asked her why, because nobody cared. Marriage wasn't the end-all-be-all for anyone except my mother. My youngest aunt lived with her eldest sister, May, for her entire life, even when they retired and bought a condo together in Clearwater, Florida. When May died, I convinced Les, then in her seventies, to come to New York and stay with me. I loved living with her, having breakfast on the terrace and sleeping together in the same bed just like we did when I was a girl.

I love to have people around, no matter the space: in my mother's dry-cleaning store before school; in my own store; in my apartment after work; and finally in the gallery I decided to begin.

Painted clothing or one-of-a-kinds had always been part of the weave of my shop, ever since Jean-Michel Basquiat scribbled all over Tyvex suits. But with what I observed as the authoritarian rise of normcore, dominating style from the eighth arrondissement to the Dubai Mall to SoHo, I felt that providing wearable pieces of art was more important than ever.

Fashion is an art form like painting, sculpting, writing, or music. As an art form, it tells the story of the culture of the time. As I've said many times, clothes reflect the zeitgeist. Today the state of fashion is depressed in that it's limited and standardized for the majority of people. "Athleisure" is a cheap commercial churn-out of sweatsuits and sneakers that through the magic of marketing is passed off as "in fashion" by the style industrial complex. When I walk on the street, everybody is in jeans, leggings, sweatpants, T-shirts, and sweatshirts. *Everybody.* The truth is, that is all ordinary people can afford these days. Again, in a mirror of society's larger issues, for the most part, clothes fall into two extremes: cheap and exorbitant. If you follow the Instagram accounts of celebrities or the wives of oligarchs, you'll see luxury that would have made Marie Antoinette blush. As a follower of history, I can see echoes today of the Great Depression, when Hollywood offered the masses a break from their drudgery with glamour. Movie stars at the Oscars wear gowns with beading done by countless hands. For the average American—who can't even afford college, let alone couture—those dresses are as much a fantasy as donning a cape and flying through the sky.

History, however, is cyclical. New York City's garment district might be gutted of nearly all the craftsmen dyeing silk

flowers, tatting lace collars, or doing any of the other unique handiwork that used to make clothes special. But that only means I need to look farther and in unexpected places to find a gem. They are out there. Special people always find a way to be creative.

I found another member of my tribe at Art Basel in Miami, when I met Octavio Aguilar, the designer behind Dope Tavio, who started making his own clothes to wear to the clubs out of his New Jersey bedroom after his Puerto Rican single mom gifted him a sewing machine. His self-described "genderless avant-garde streetwear line," which I used in *Emily in Paris*, couldn't be more different from the colorful and classically elegant silhouettes of Vassilis Zoulias, a Greek designer whose clothes I also used to dress Lily in the second season of Darren's show. From his atelier in Athens, he creates pieces fueled by memories of his mother and her girlfriends, who were the types to dress for an afternoon game of gin rummy back in the sixties. Produced in Greece, his "bon chic" cocktail dresses, short coats, and limited collections of pumps and clutches are popular with Athens's society set. For Emily I took his high-end pieces on a plunging roller-coaster ride by pairing one with the lowest of the low. For an afternoon shopping trip with a Ukrainian woman from Emily's French class, I dressed Lily in Vassilis's Vertigo jacket—an oversized yellow floral brocade jacket with three-quarter-length sleeves and extreme lapels that harked back to the cropped A-line mod jackets of the sixties—with Zara's bright yellow Studded City bag and a four-dollar black-and-white-checkered bucket hat from Shein.

While costume design was an outlet for showcasing the wearable art produced by my circle of artist friends and new ones I made in my travels, I missed the contact I had with everyday customers after closing the Bowery store. So in 2018 I opened the Patricia Field ArtFashion Gallery at 200 East

ArtFashion runway show at 2019 New York Fashion Week
PHOTOGRAPH © TINA PAUL

Broadway in a former dentist's office located near my apartment. "This is just so you and so bizarre," said Scooter LaForge when he saw the space for the first time. Just as I sold Scooter's one-of-a-kind pieces in the Bowery—like the custom-painted army trench coat, featuring a "Cyclopsbear" on the back, which Beyoncé wore to sit courtside at an NBA game in Madison Square Garden—so I represented him and other innovative, unique designers at my new gallery. "You certainly keep it real," Scooter said, eyeing an outdoor hanging shingle where I had swapped out the dentist's nameplate with one that still looked like it announced a doctor's office but instead read, "Patricia Field ARTFASHION." As a fan of dollar-slice pizza who has never cared for phonies, I don't aspire to being fancy.

For some, the gallery hiding in plain sight is a destination; for others it's a marvelous discovery. A woman who used to shop on Eighth Street and on the Bowery was out with her husband for bialys from Kossar's around the corner when she spied my shingle. "I'm shocked," she said, entering the cavernous space with its painted platform boots, hoops as big as dinner plates, turbans studded with spikes, and the classic Patricia Field T-shirts in black, cut just the way I like them (sleeveless) and my name in hot-pink script across the chest.

A couple of weeks later, the woman returned, this time with her two teenage daughters, who she set loose on the gallery.

"Where would I wear this?" said one daughter, in a tight microdress adorned with brightly colored flowers.

"In hot weather," I said.

Her sister fell in love with a pair of bleached purple sweatpants with various patches, including "One love," "I love NY," and "Shut the fuck up" along the tush.

"You can't get those," the mom said.

"Why?"

"I will lose my parent license."

The daughter moved on to an off-the-shoulder jean top by Seks Fifth Avenue, worn by Mindy in season 2 of *Emily in Paris*. I complimented the girl's elevated taste. Her mom asked me how I liked working on the show. I was honest. When we were shooting in Paris, I missed everything about my life: my friends, my neighborhood, my routine. Not that Paris wasn't fine, but home is home. And a big part of home is my gallery.

"Well, I'm so happy you were here when I came," she said. "This has been such a treat for me."

"The treat is all mine," I said, not just because she was leaving with a haul that included a David Dalrymple tank top, Keith Haring–print dress, and Iris Bonner "Fuck you, pay me" bag.

Like I have said many times, I find satisfaction in the truth of retail. Did the customer put their hard-earned money on the counter or did they leave empty-handed? There is no gray zone, no spinning it, only a pure moment of reality. Either they wanted what you were offering or they didn't. Retail's cut-and-dried certainty has been an antidote to the mercurial nature of my individual truth.

My aesthetic, the source of my fortune, was never calculated. If I paired a Fendi baguette with a five-and-dime tube top on *Sex and the City*, it was just because I liked the combination. The same was true of my personal life's long history of friends and lovers. There was no plan. It just unfolded as I was doing my thing.

I've come to a place where people want to know my story, forcing me to look back on my life, which is something I'm not used to. I prefer to keep looking ahead. But that's the back-patting nature of success.

I continue to rail against labels that are attributed to me, no matter how well-intentioned they are, because they imply a

self-consciousness I don't see in myself. When I won the Maverick Award at the 2017 Village Voice Pride Awards, I made it clear: "I'm not a maverick. A maverick is someone who thinks differently or independently from the norm. I don't try to be a rebel or provocateur."

As zany as whatever comes out of my mouth or the clothes I throw on people's backs, my aim is never to be contrarian for the sake of it. I'm not a big believer in going against the tide. Instead, I like to get on my surfboard and ride it. From fun come good things. Whether it comes to hiring drag queens as employees, sleeping with women, or merchandising my shop with unknown designers who went against the zeitgeist of the time, being a calculated rebel was never the intention. The methodology I've applied to every aspect of my life is the same: haphazard. The result is an authentic independence, and I like it that way. It's good for your mental health.

Real happiness is being your own natural you. In my experience, finding out just what that means is a process that requires staying open to new discoveries. I earned the free spirit I've been lauded for, not with superiority but with curiosity. Also, I followed the sage advice of my longtime accountant Irving Wexler: "Just pay your bills and you'll be fine." That has been equally important for my mental health.

I don't sell garments; I sell ideas, and one was brewing right now in Harlem. Tracy was still pulling items, but I asked him to weed out a few—like the double-breasted woman's jacket he thought might work for Renee. The actresses were not coming to set until the following week for fittings, so it would take some time to return the items we wouldn't wind up using. Knowing full well how thin the margins are in a little business

like this, I didn't want to take advantage. I loved the blazer and its bright brass buttons, but I was still bothered by the idea that she would dress up to work at home. I understood that they didn't want her to be in sweatpants and a T-shirt, but this wasn't *Designing Women*.

While Tracy replaced the blazer, I admired a very cool poster of President Obama with the images of civil rights marchers, portraits of Lincoln and JFK, and mug shots of Martin Luther King Jr. and Rosa Parks superimposed on his face. I like all of those people, although Kennedy was a little spoiled. Louis, noticing me looking at the image, said, "We found the artist who made this poster outside your old store in SoHo. He sold them on the street."

I smiled at Louis and said, "That makes me so happy." But the conversation on the poster didn't go any further, because just then my eye moved from the picture to the floor below, where I spotted a beat-up pair of roller skates spray-painted gold, including the laces and toe stoppers.

"Wouldn't it be funny if Renee wore roller skates in her apartment when she was working?" I said to no one in particular.

"Yes!" Tracy shouted, jumping out from behind one of the racks holding his phone out to me. "I took a picture of these roller skates at Bergdorf the other day."

He showed me an image of quilted-leather, high-top sneaker roller skates in peach.

"With that Chanel skirt!" I said, thinking about a piece we'd pulled a few weeks earlier while shopping for the women. Now I was getting excited. Like all things, this job is only fun if it's fun.

"I wonder if we can get away with it?" Tracy asked.

"I don't know," I said. "But we'll try."

acknowledgments

IN THESE NOT SO HAPPY DAYS, I thought it was time for more lightheartedness. The eighties and nineties were a time that artistic creativity raised its head. I was so happy to be able to be a part of this expression.

I would like to thank all the unusual characters who filled my life with shenanigans. Whether you were named in this book or not, you know who you are.

I continue to nurture and inspire the young generation to move forward. I receive their energy in return. It is all around me. How can I not feel it? It is a gift. As time rolls on, I find myself as the perpetrator of originality and thank God that I am happily living through it.

"If it is interesting and imaginative, I go for it."